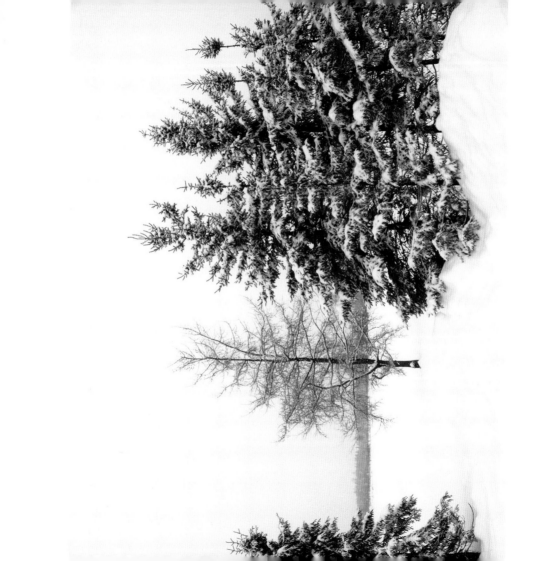

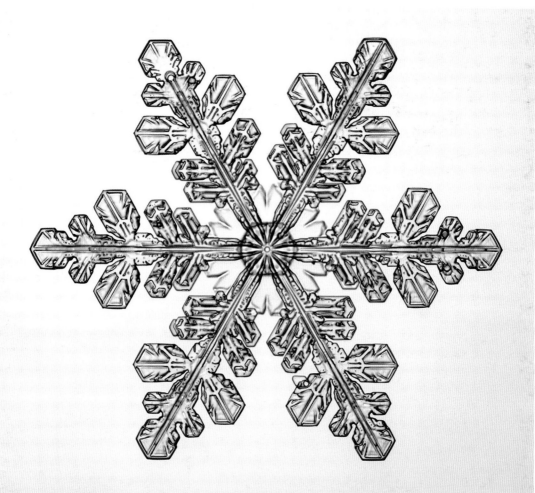

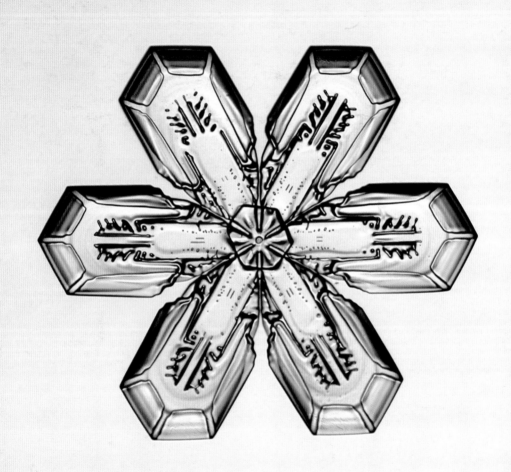

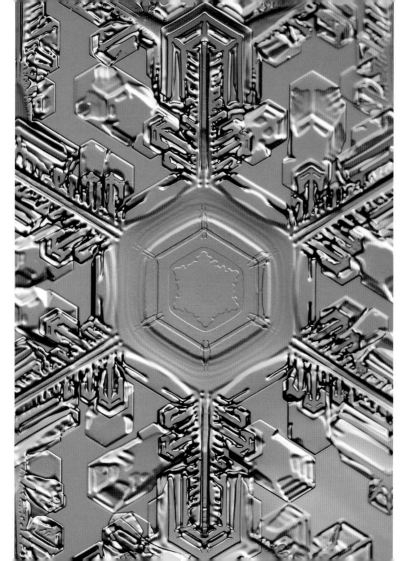

SNOWFLAKES

Featuring the Amazing Micro-Photography of
Kenneth Libbrecht

Voyageur Press

First published in 2008 by Voyageur Press, an imprint of MBI Publishing Company, 400 First Avenue North, Suite 300, Minneapolis, MN 55401 USA.

Copyright © 2008 by Kenneth Libbrecht

Voyageur Press titles are also available at discounts in bulk quantity for industrial or sales-promotional use. For details write to Special Sales Manager at MBI Publishing Company, 400 First Avenue North, Suite 300, Minneapolis, MN 55401 USA.

To find out more about our books, join us online at www.voyageurpress.com.

ISBN-13: 978-0-7603-3498-0

Editor: Michael Dregni
Designer: Steve Mueller

Printed in China

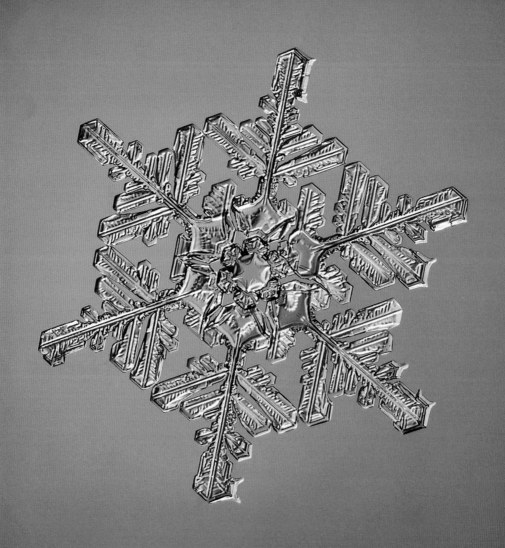

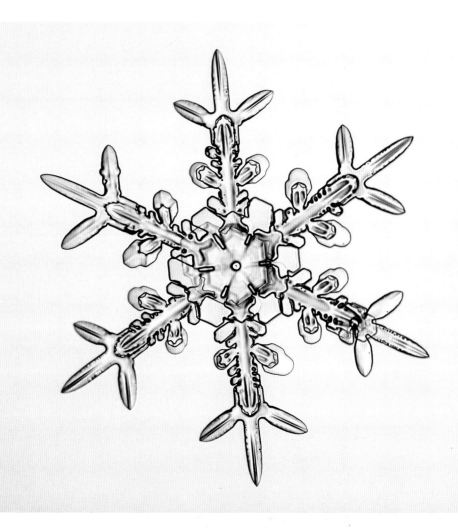

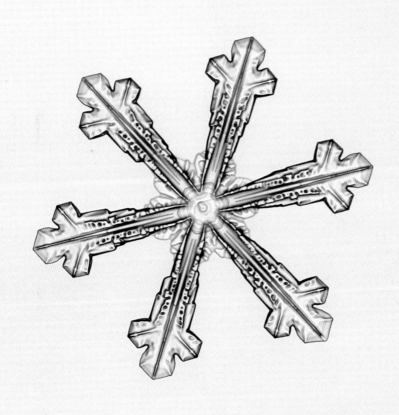

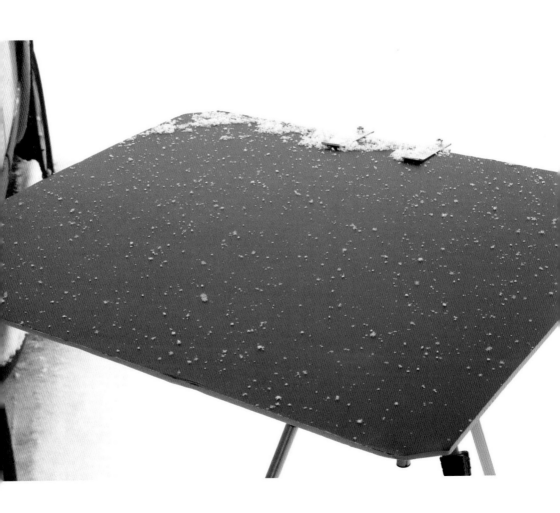

Capturing Snowflakes. The images in this book are of real snowflakes, created in the winter clouds and captured as they fell to Earth. I begin by letting snow fall onto a collecting board, which I then examine to find interesting specimens. One of the challenges of snowflake photography is finding the best subjects. Although large, symmetrical crystals can be wonderfully photogenic, these are also somewhat rare. The most perfectly formed crystals are usually found during light snowfalls, with little wind, when the weather is especially cold.

When a promising snowflake appears, I carefully pick it up using a small paintbrush and place it onto a glass slide. I then examine the crystal under a microscope I designed especially for snowflake photography. Everything must be done outdoors and quickly so the crystals do not melt.

Each snowfall is a photographic adventure, because each brings different crystals. And it's true— no two are exactly alike.

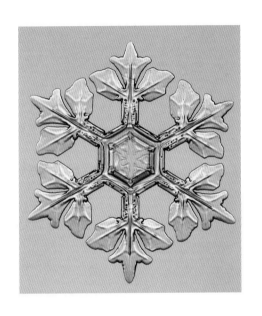 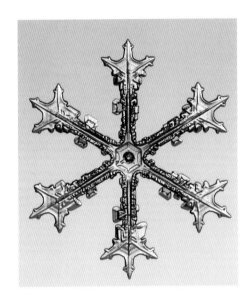

AND HERE COMES THE SNOW, A LANGUAGE IN
WHICH NO WORD IS EVER REPEATED.

—William Matthews (1942–1997)

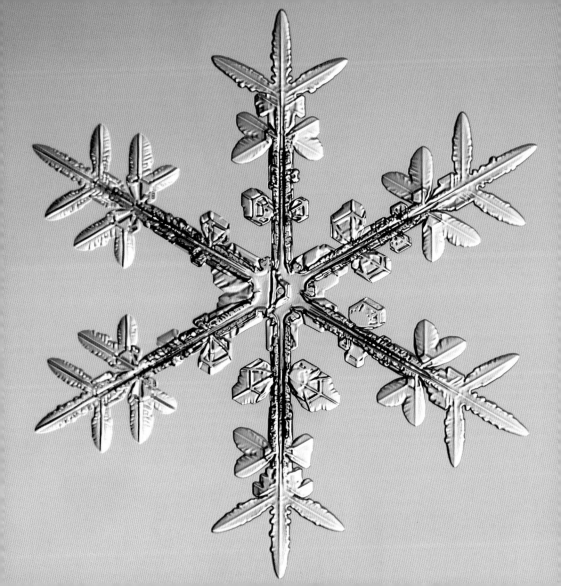

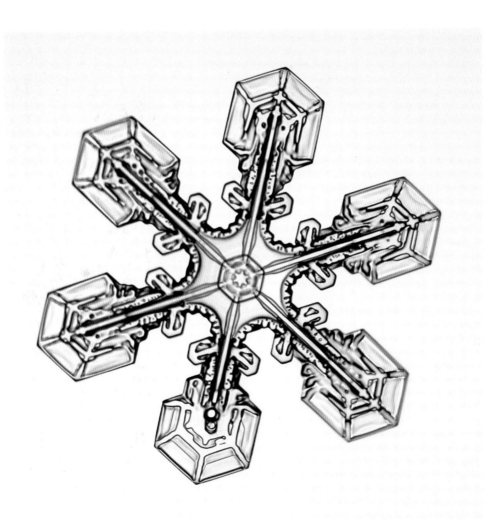

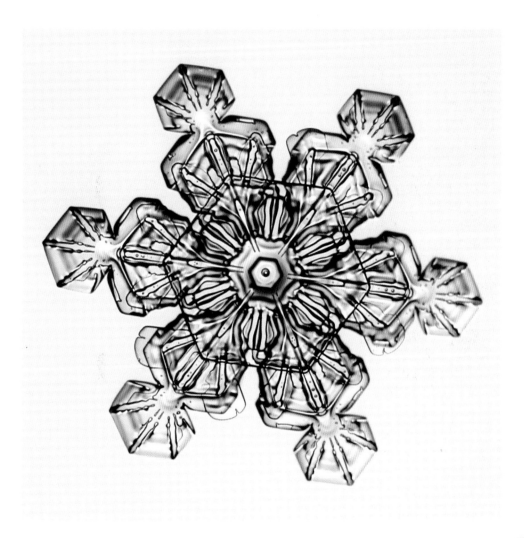

Under the microscope, I found that snow-flakes were miracles of beauty, and it seemed a shame that this beauty should not be seen and appreciated by others. Every crystal was a masterpiece of design, and no one design was ever repeated. When a snowflake melted, that design was forever lost. Just that much beauty was gone, without leaving any record behind.

—Wilson Bentley (1865–1931)

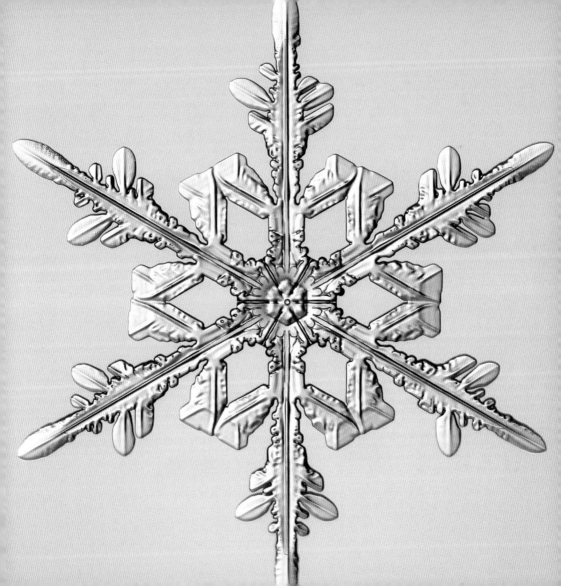

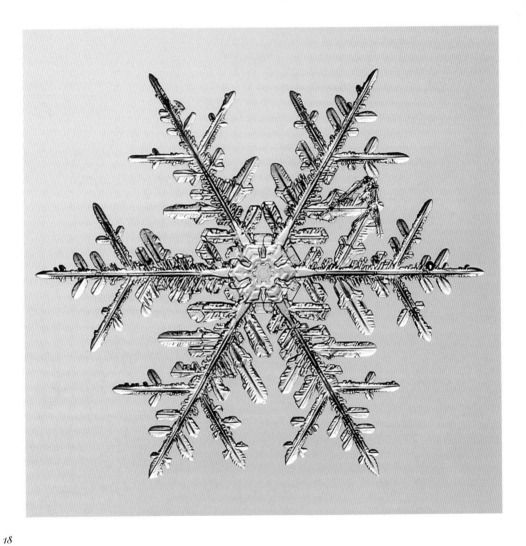

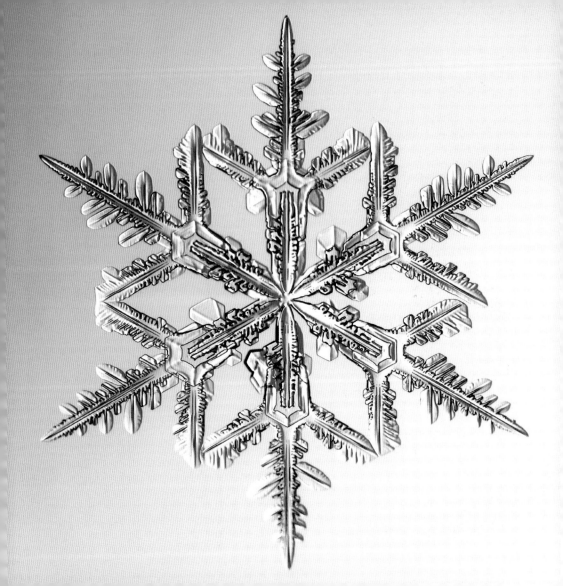

Creating Color. Snowflakes are made of ice, which is clear and colorless. Most of the photographs in this book were taken using colored lights shining through each crystal from behind. The ice refracts the light like a complex lens, highlighting the curves and giving a wonderful view of each snowflake's internal structure. Illuminating a crystal with different colors from different angles can produce a variety of eye-catching effects.

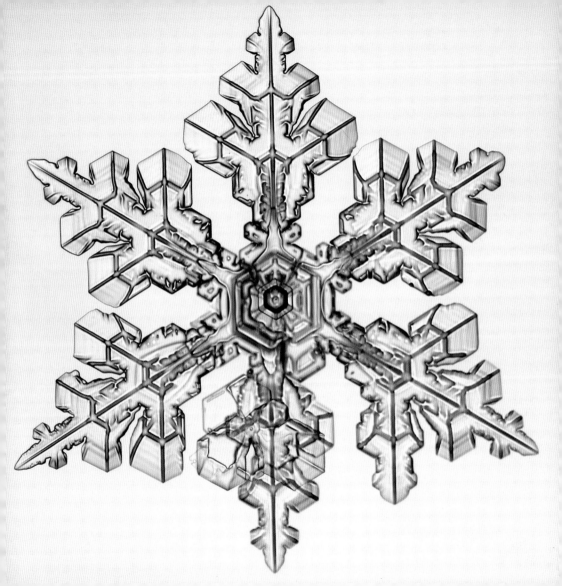

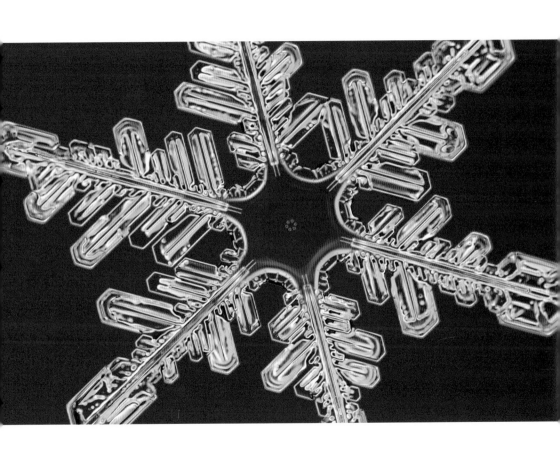

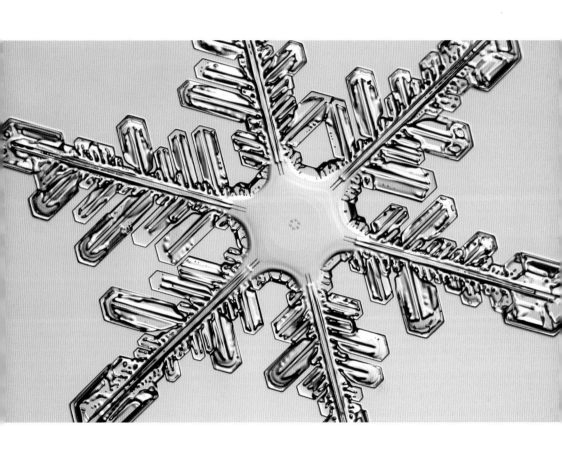

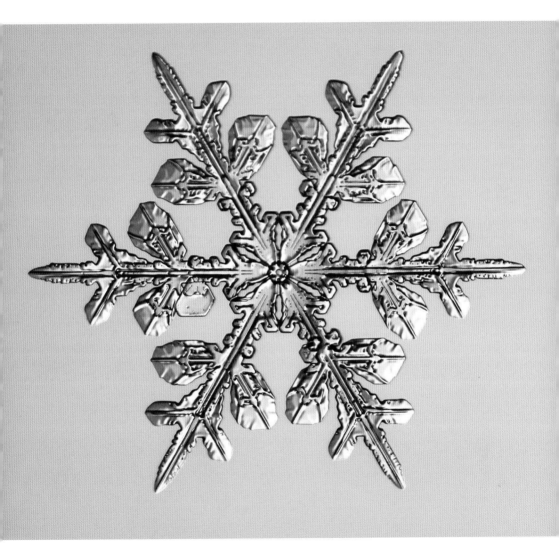

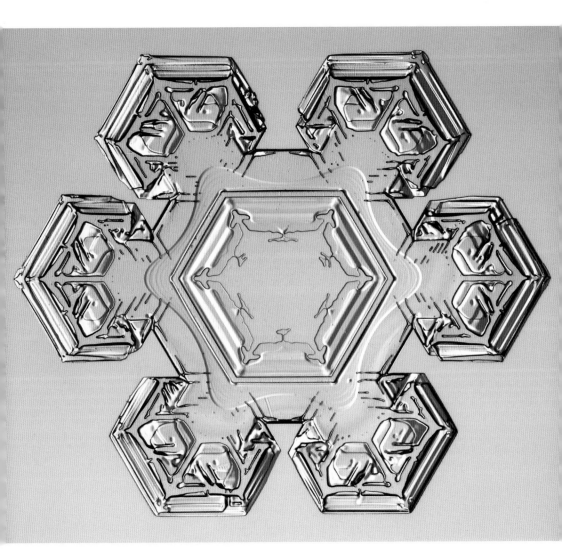

Seek Love in the pity of others' woe,
In the gentle relief of another's care,
In the darkness of night and the winter's snow,
In the naked and outcast, seek Love there!

—William Blake (1757–1827)

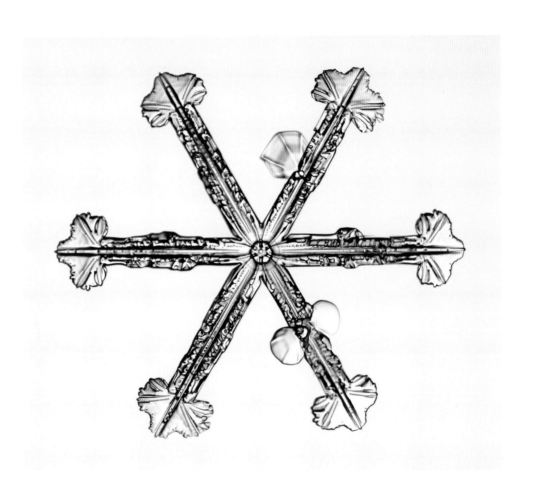

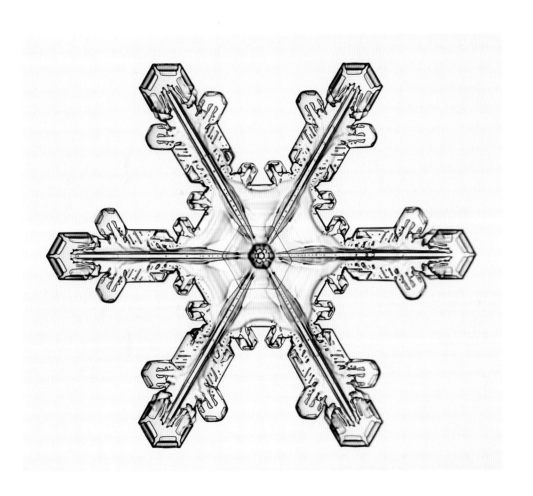

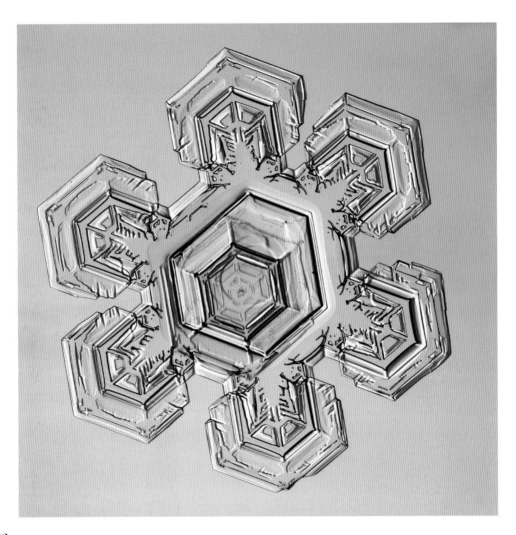

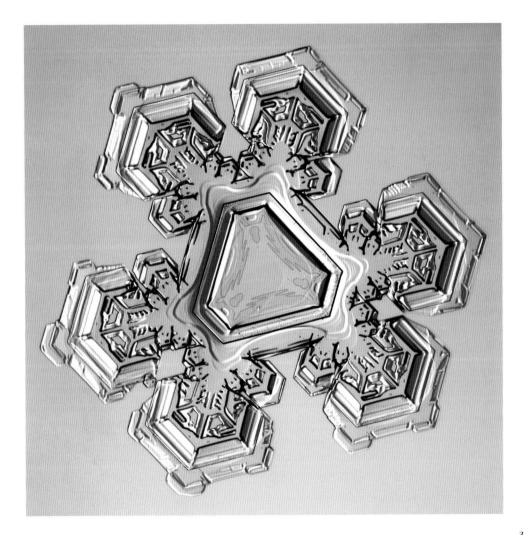

OUT OF THE BOSOM OF THE AIR,
OUT OF THE CLOUD-FOLDS OF HER GARMENTS SHAKEN,
OVER THE WOODLANDS BROWN AND BARE,
SILENT, AND SOFT, AND SLOW
DESCENDS THE SNOW.

—Henry Wadsworth Longfellow (1807–1882)

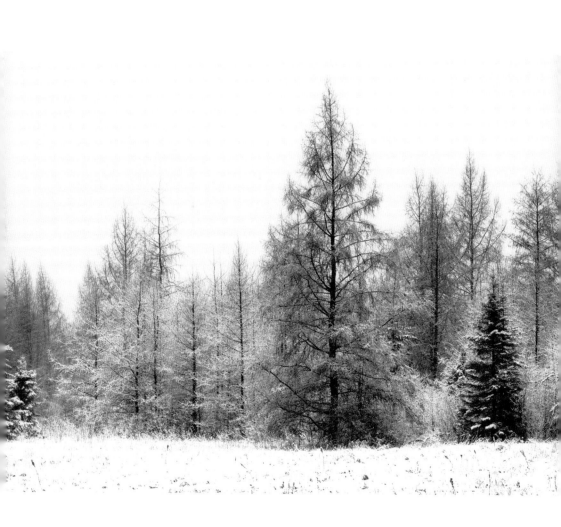

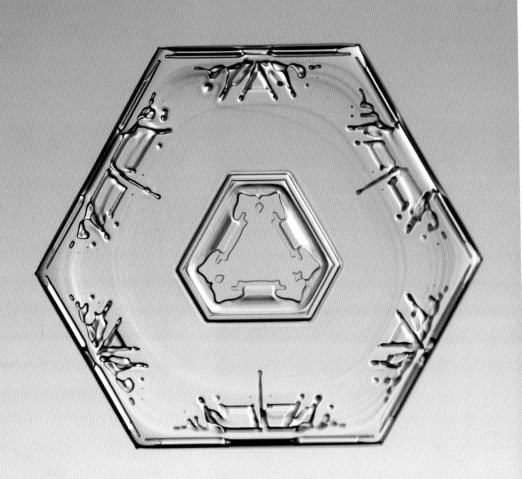

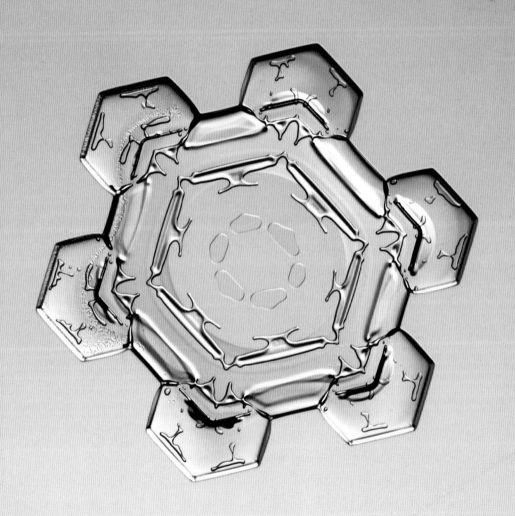

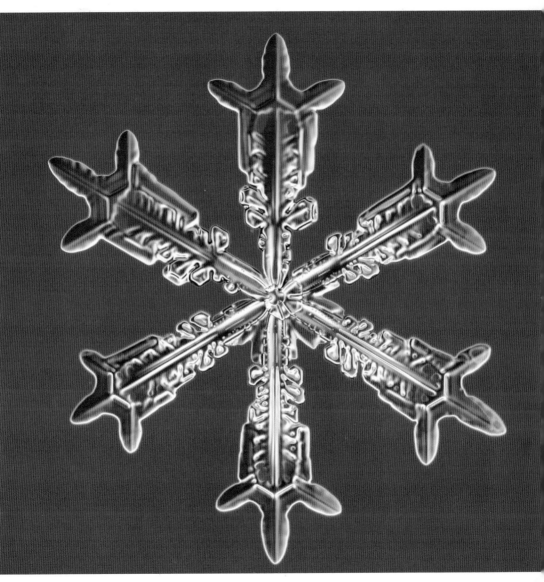

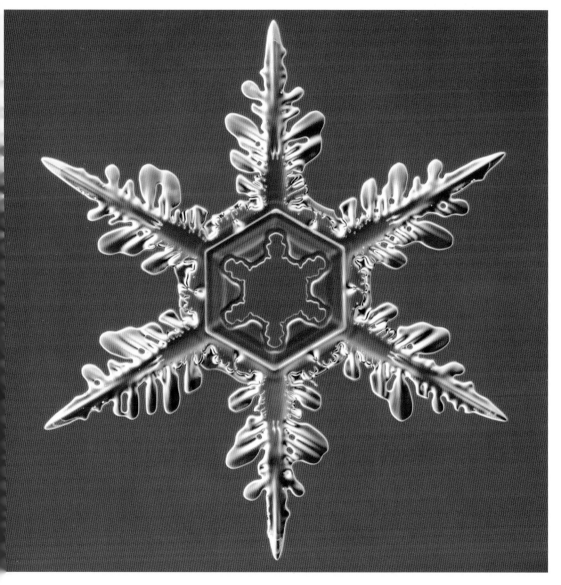

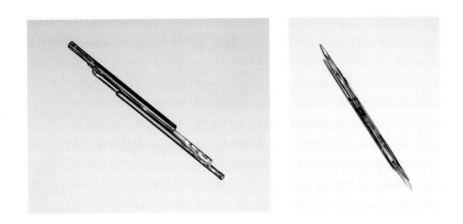

Pins and Needles. Warmer snowfalls often bring crystals shaped like slender hexagonal columns—the same basic form as wooden pencils. Often the columns have hollow ends, and some are long and thin, like tiny ice needles. These types of snow crystals are common, looking like short bits of white hair on your sleeve.

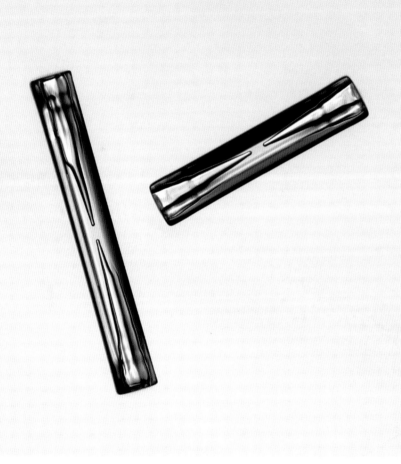

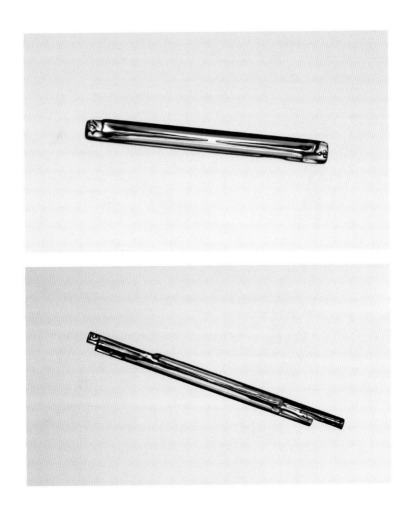

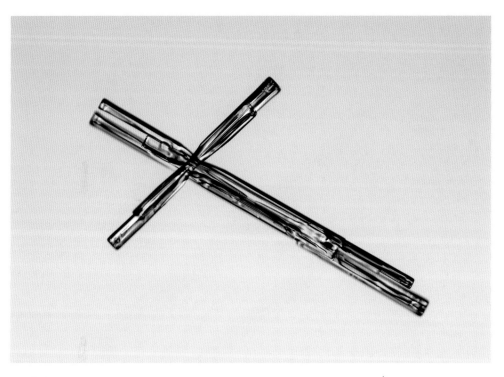

\mathcal{T}HE QUESTION IS NOT WHAT YOU LOOK AT, BUT WHAT
YOU SEE.

—Henry David Thoreau (1817–1862)

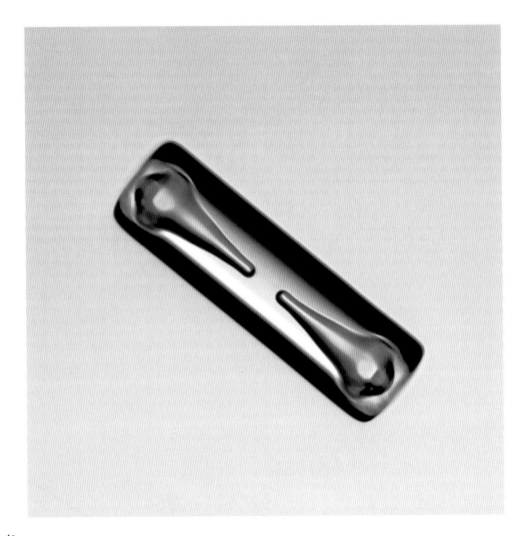

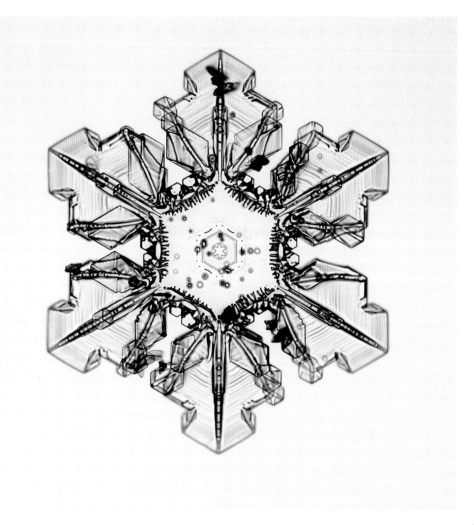

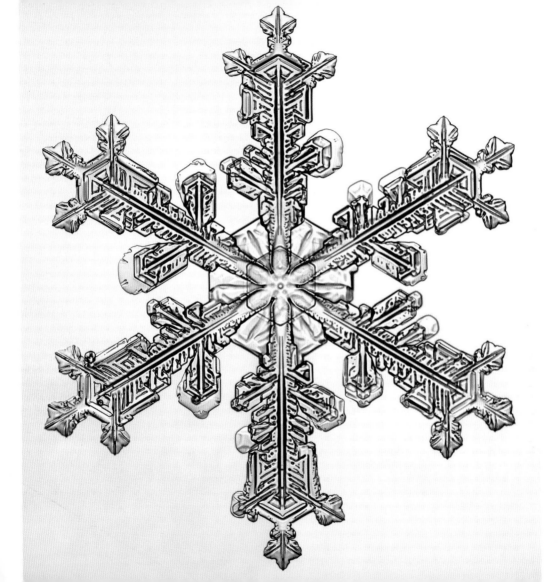

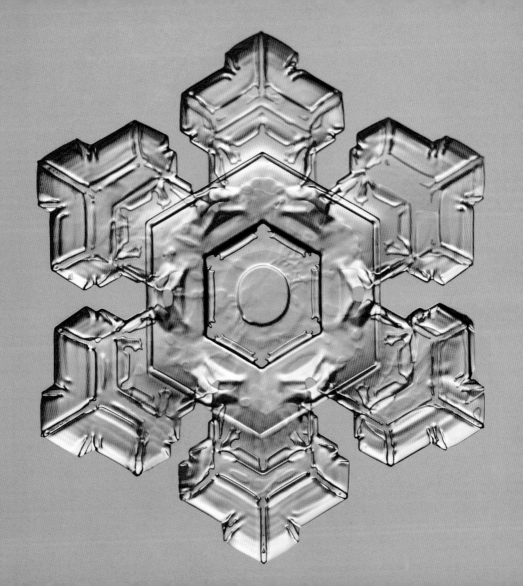

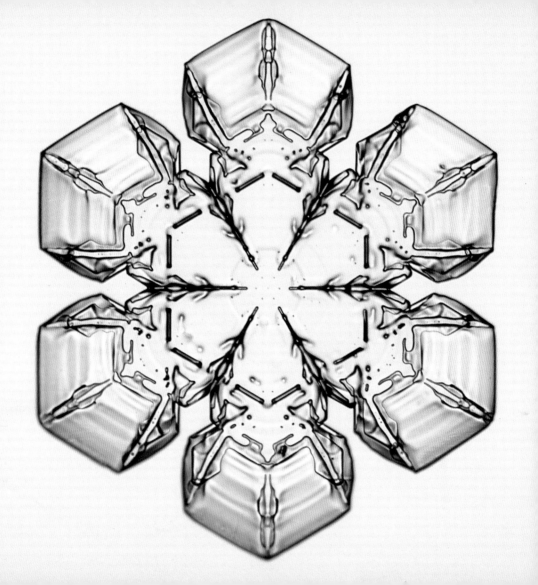

If I had influence with the good fairy who is supposed to preside over the christening of all children, I should ask that her gift to each child in the world be a sense of wonder so indestructible that it would last throughout life.

—Rachel Carson (1907–1964)

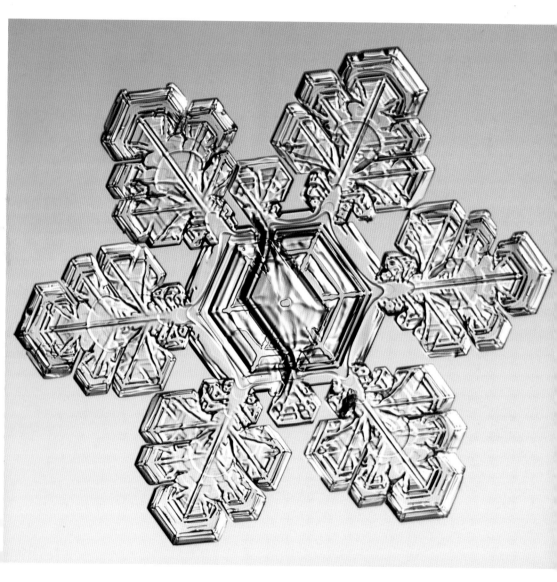

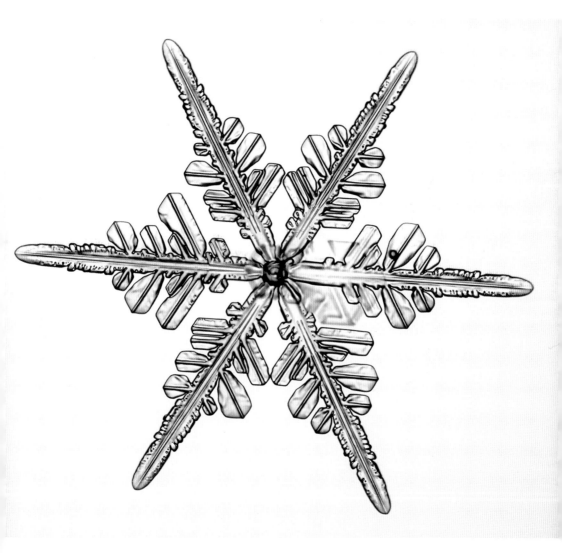

THE WORLD WILL NEVER STARVE FOR WONDER, BUT
ONLY FOR WANT OF WONDER.

—G. K. Chesterton (1874–1936)

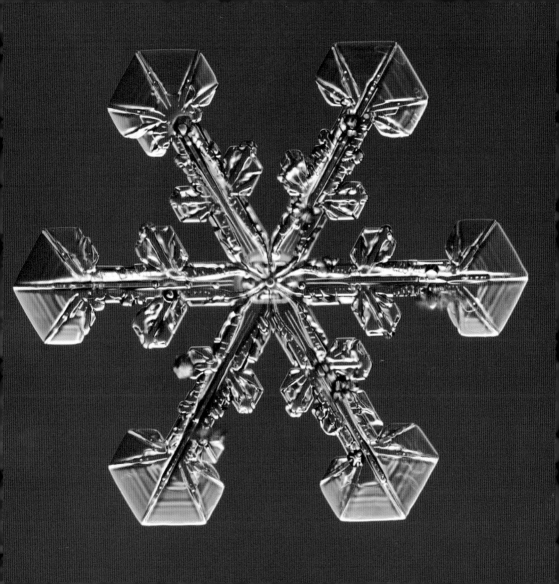

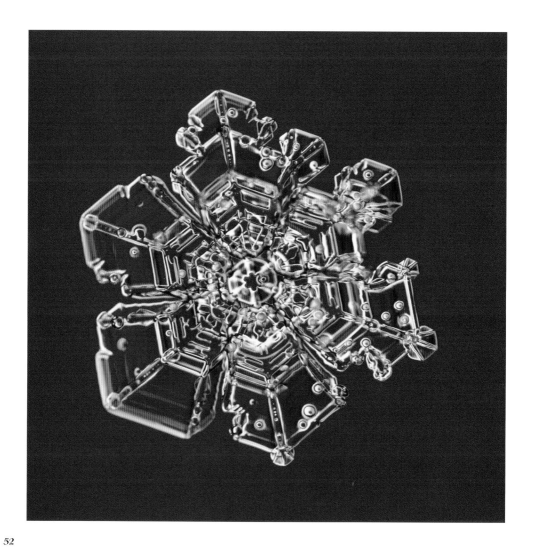

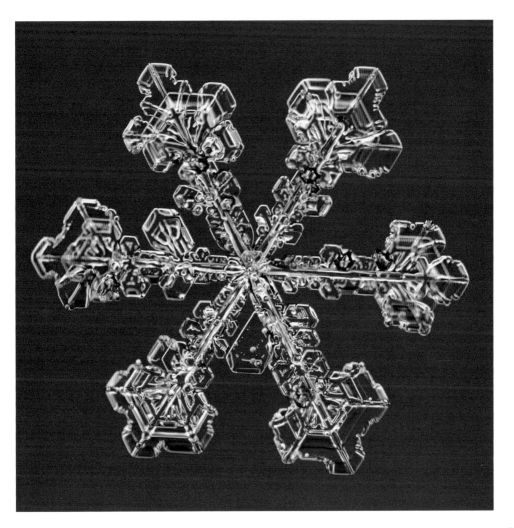

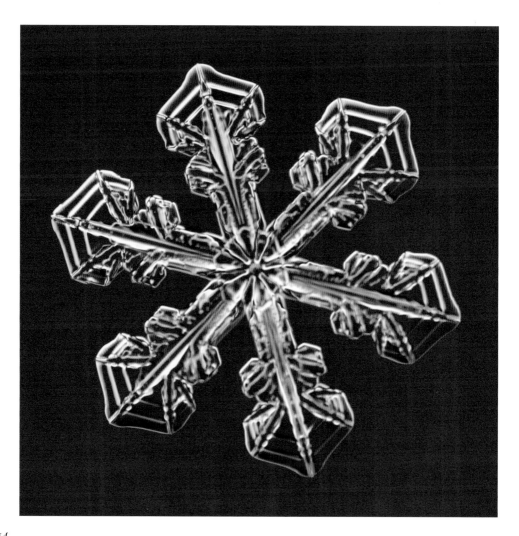

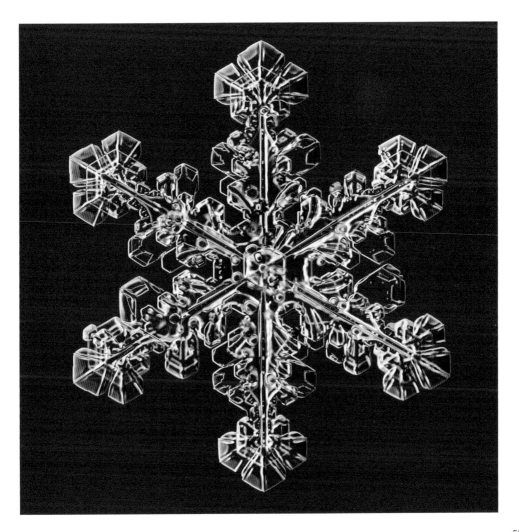

Capped Columns. A snow crystal sometimes experiences its own style of mid-life crisis, suddenly changing its growth from columnar to plate-like. The result is a column with two plates on its ends, like a stubby axle flanked by two hexagonal wheels. Capped columns are uncommon, but you can find them in the falling snow if you look for them.

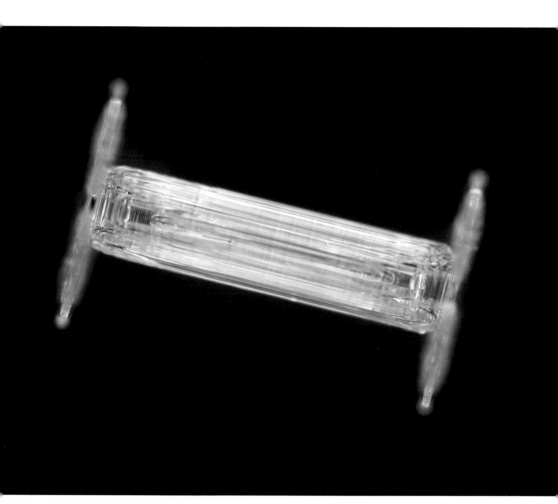

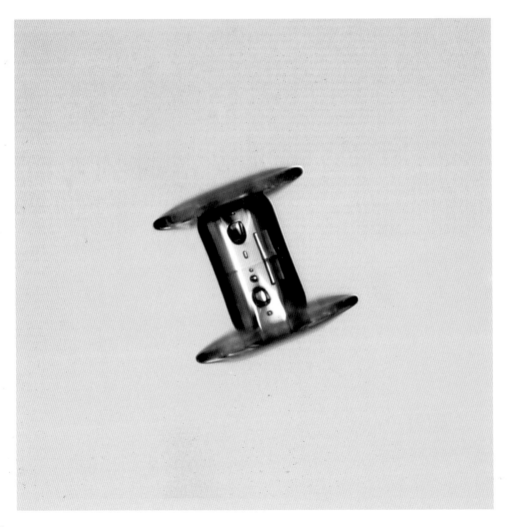

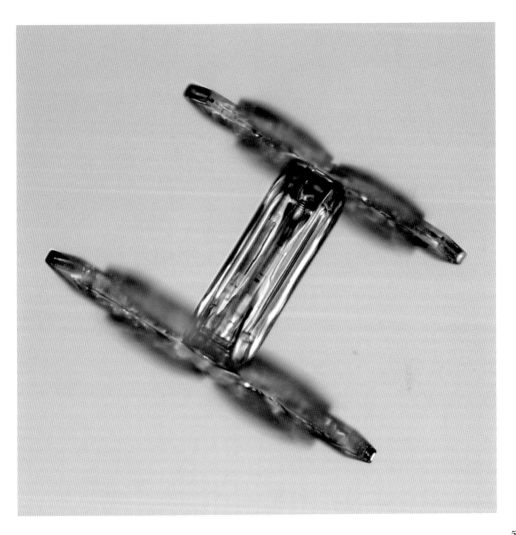

59

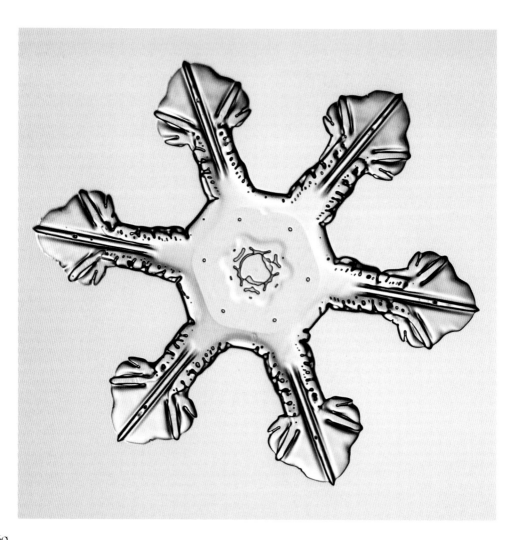

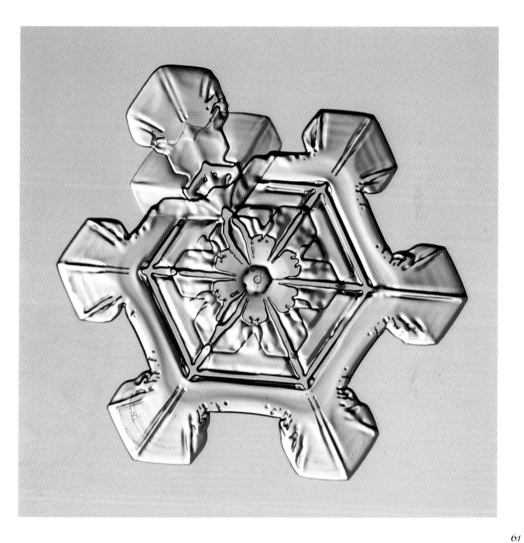

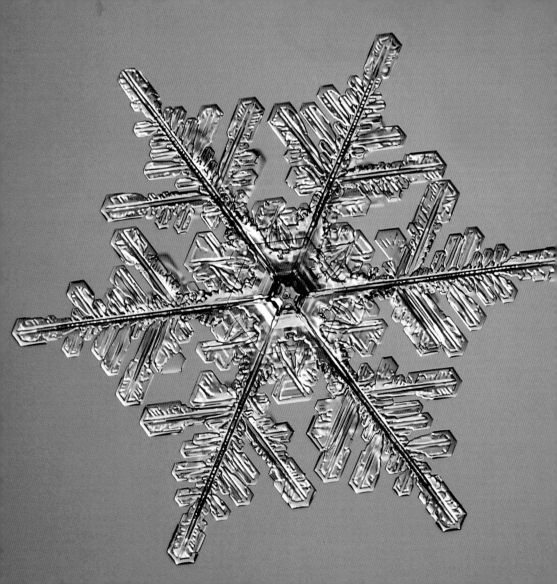

ANNOUNCED BY ALL THE TRUMPETS OF THE SKY,
ARRIVES THE SNOW, AND, DRIVING O'ER THE FIELDS,
SEEMS NOWHERE TO ALIGHT; THE WHITED AIR
HIDES HILLS AND WOODS, THE RIVER, AND THE HEAVEN,
AND VEILS THE FARM-HOUSE AT THE GARDEN'S END.

—Ralph Waldo Emerson (1803–1882)

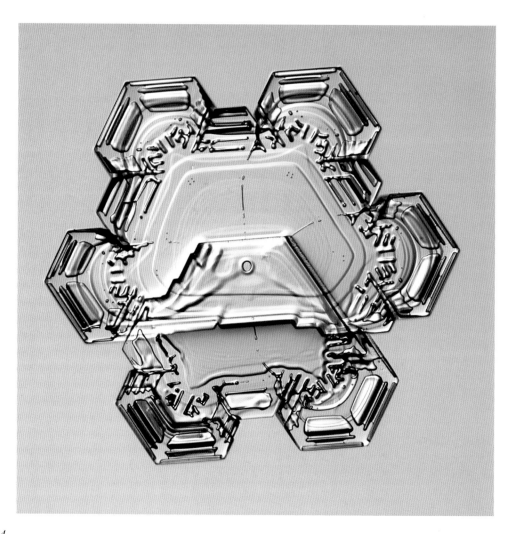

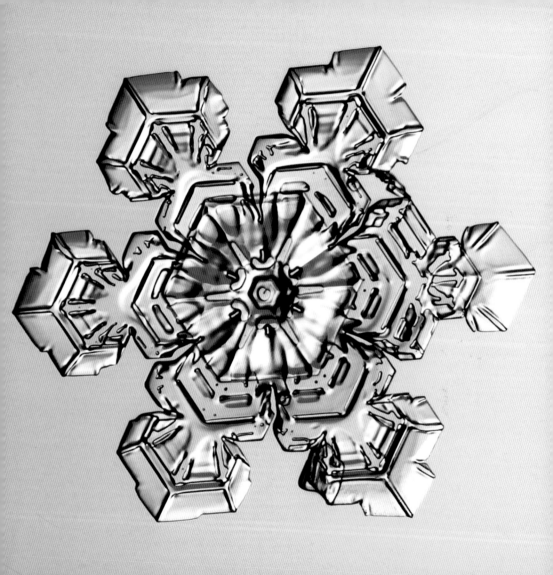

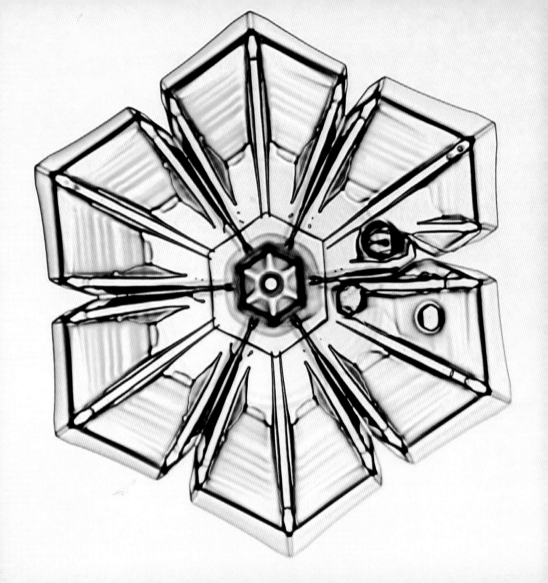

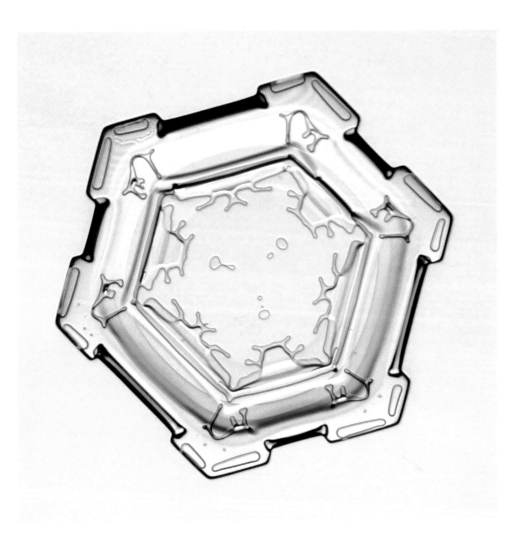

67

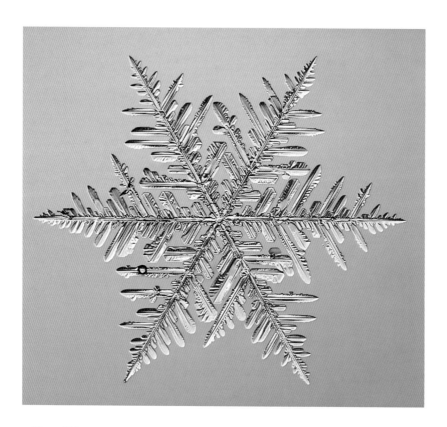

Ice Ferns. Some snowflakes grow many side branches on each of their six primary branches, making them look like tiny ice ferns.

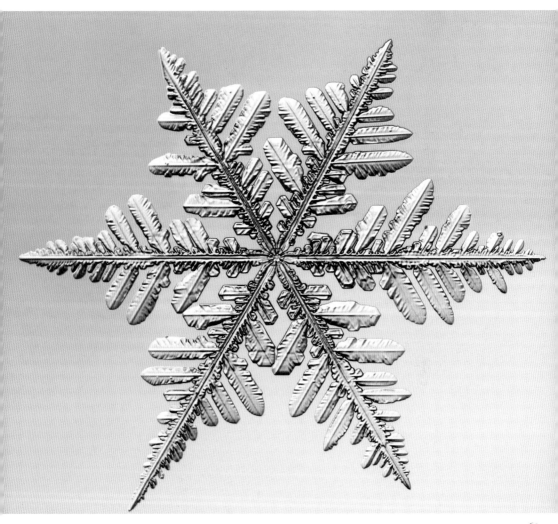

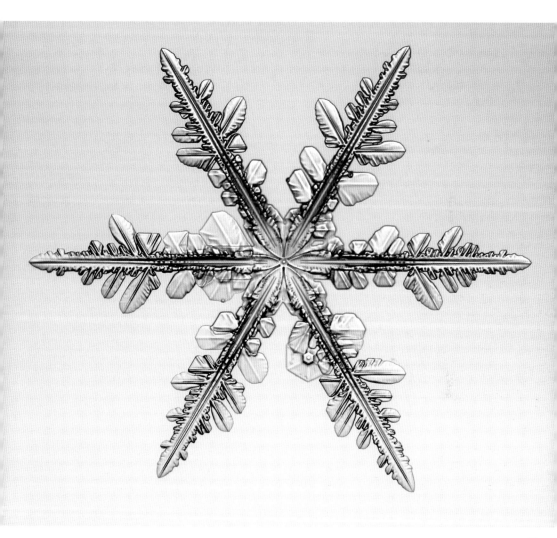

THE MOST BEAUTIFUL THING WE CAN EXPERIENCE IS THE MYSTERIOUS. IT IS THE SOURCE OF ALL TRUE ART AND SCIENCE. HE TO WHOM THIS EMOTION IS A STRANGER, WHO CAN NO LONGER PAUSE TO WONDER AND STAND RAPT IN AWE, IS AS GOOD AS DEAD: HIS EYES ARE CLOSED.

—Stanislaw Ulam (1909–1984)

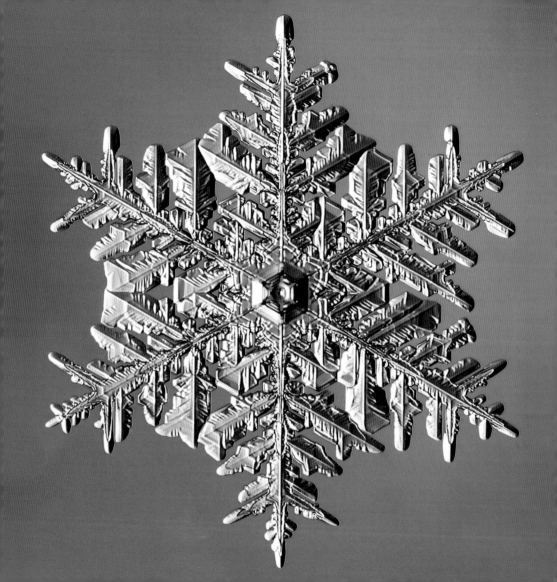

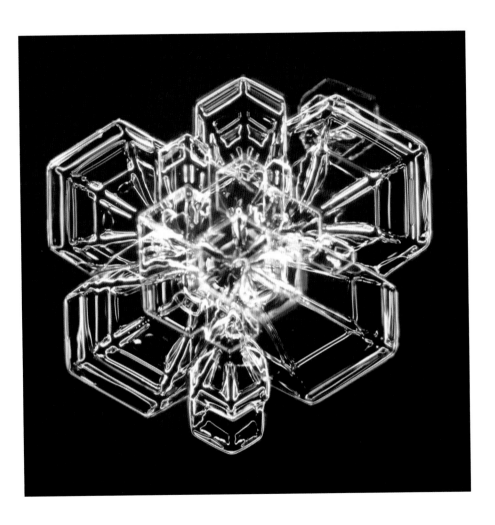

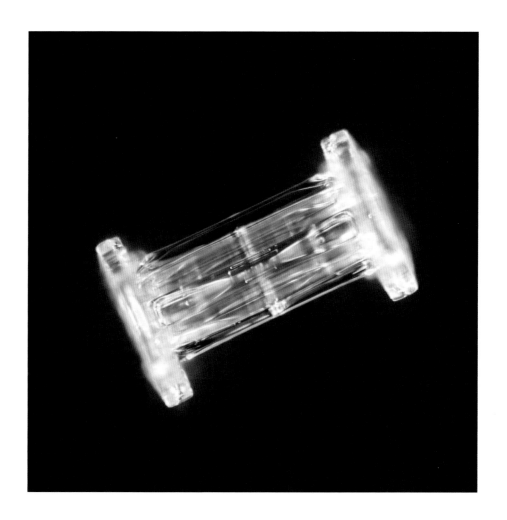

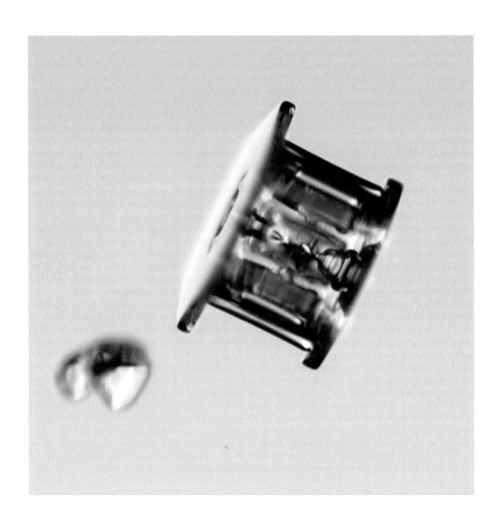

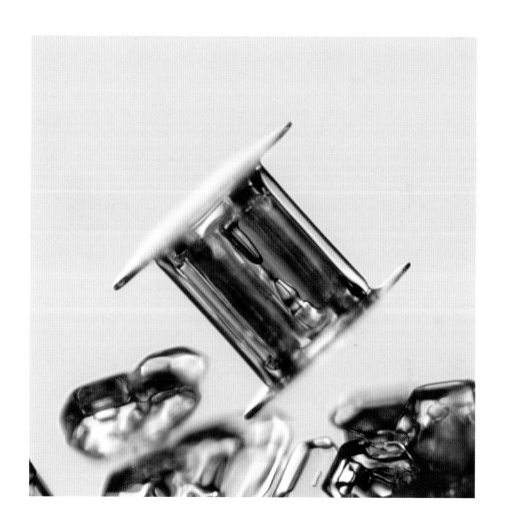

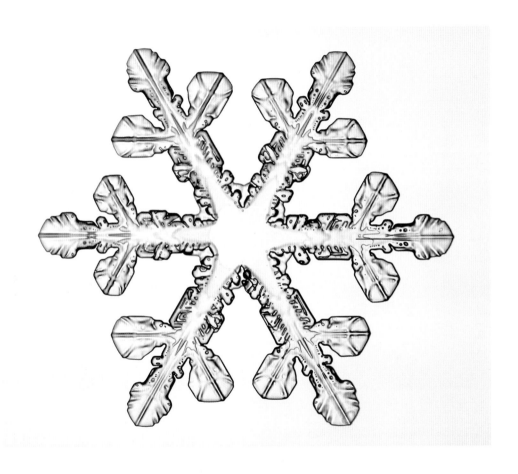

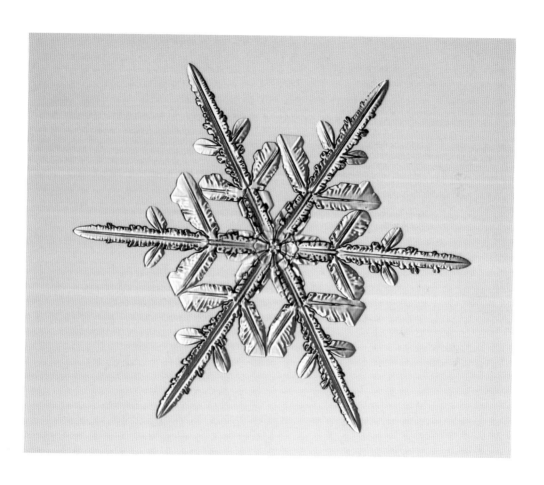

BEGIN DOING WHAT YOU WANT TO DO NOW. WE ARE NOT LIVING IN ETERNITY. WE HAVE ONLY THIS MOMENT, SPARKLING LIKE A STAR IN OUR HAND— AND MELTING LIKE A SNOWFLAKE . . .

—Sir Francis Bacon (1561–1626)

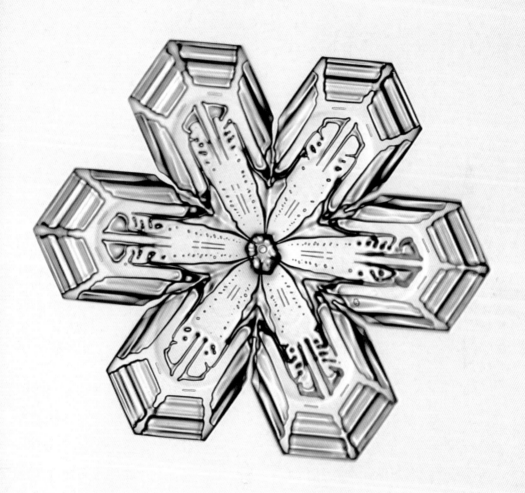

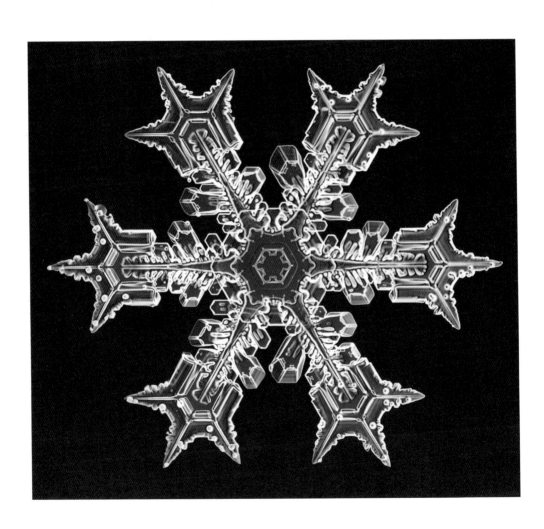

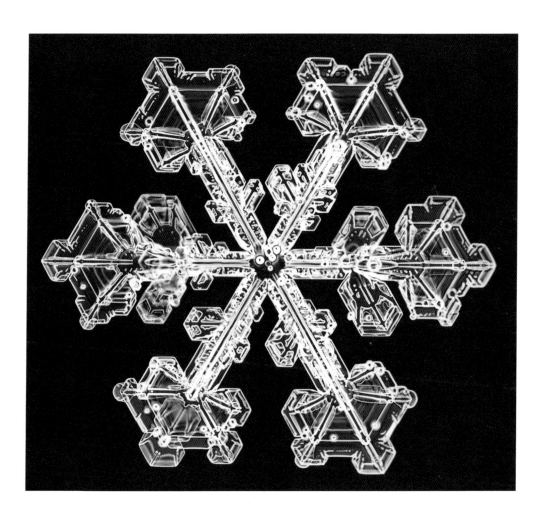

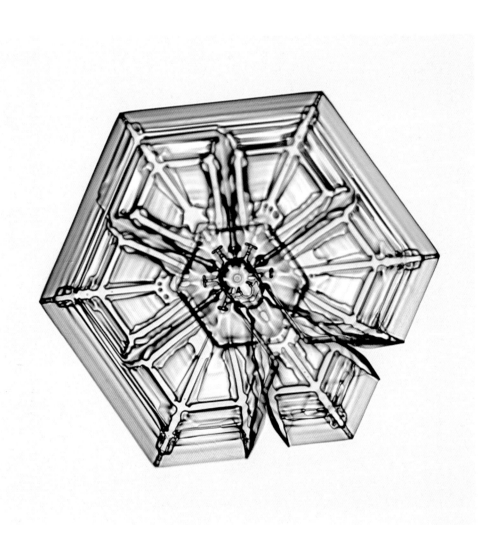

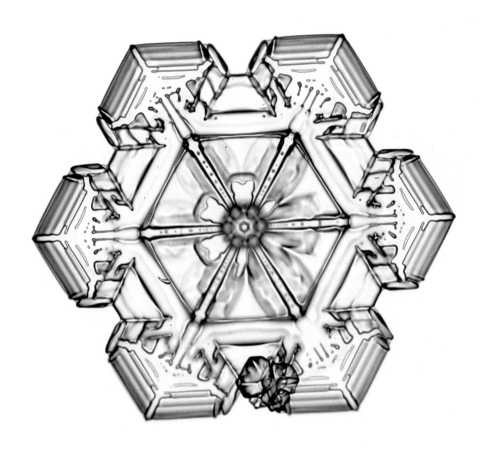

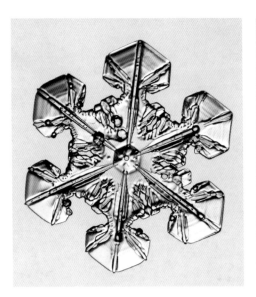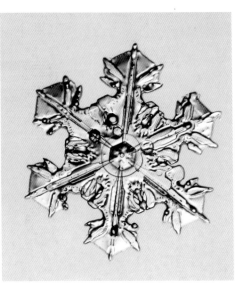

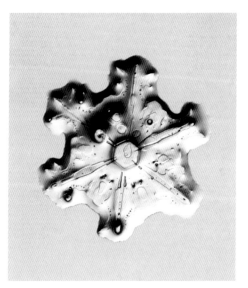
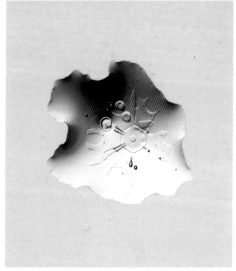

Aaarrgh . . . I'm melting! On warmer days, snow crystals can be difficult to photograph because they melt so quickly. The series of pictures on these two pages was taken in just twenty-seven seconds.

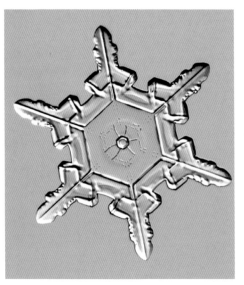
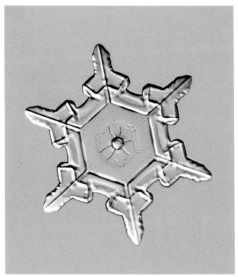

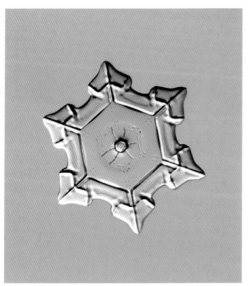
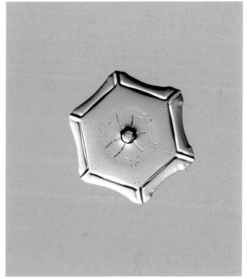

Aaarrgh . . . I'm evaporating! Even on colder days, snow crystals evaporate away under the bright lights of the microscope. The photographs on these two pages were taken over a period of two minutes.

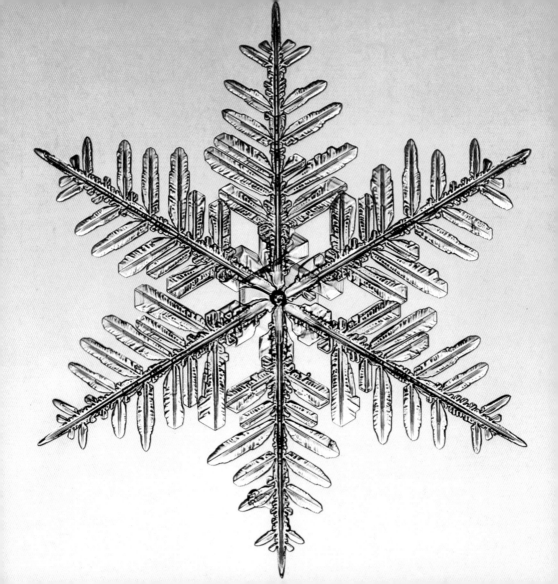

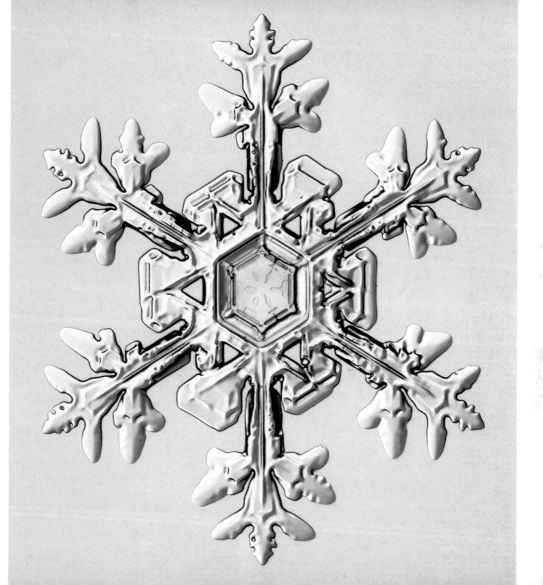

\mathcal{N}ATURE DOES NOTHING USELESSLY.

—Aristotle (394 BC–322 BC)

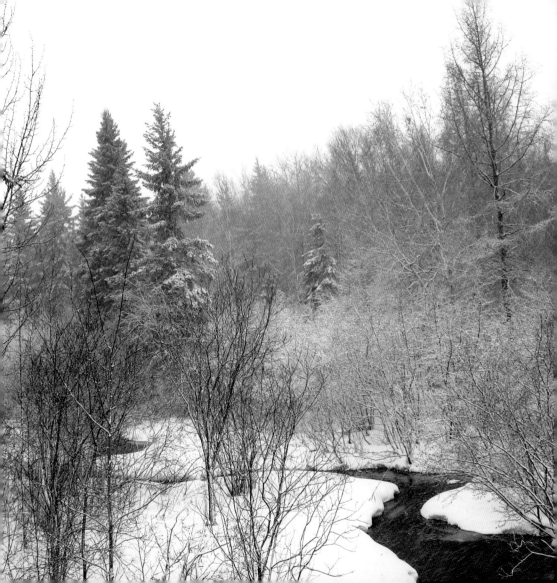

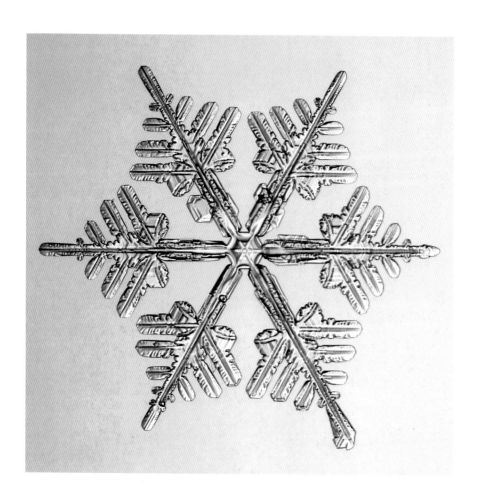

94

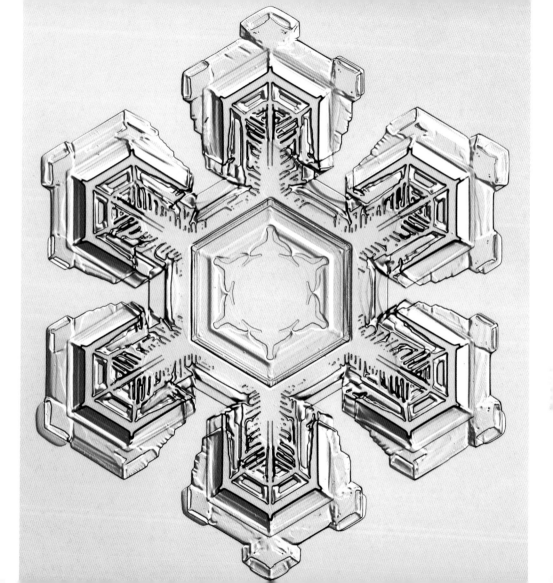

SOME OF NATURE'S MOST EXQUISITE HANDIWORK IS ON A MINIATURE SCALE, AS ANYONE KNOWS WHO HAS APPLIED A MAGNIFYING GLASS TO A SNOWFLAKE.

—Rachel Carson (1907–1964)

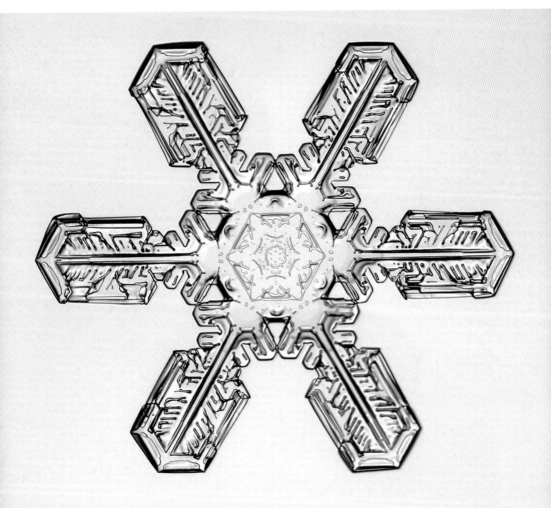

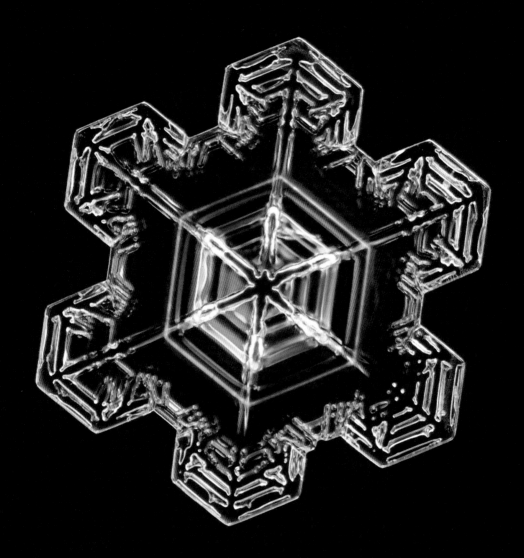

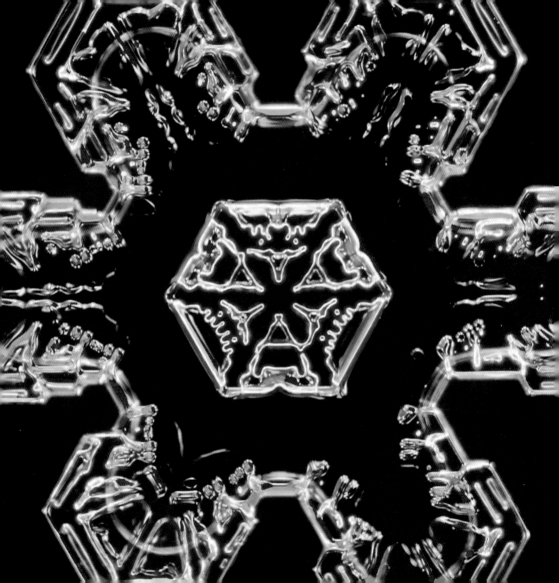

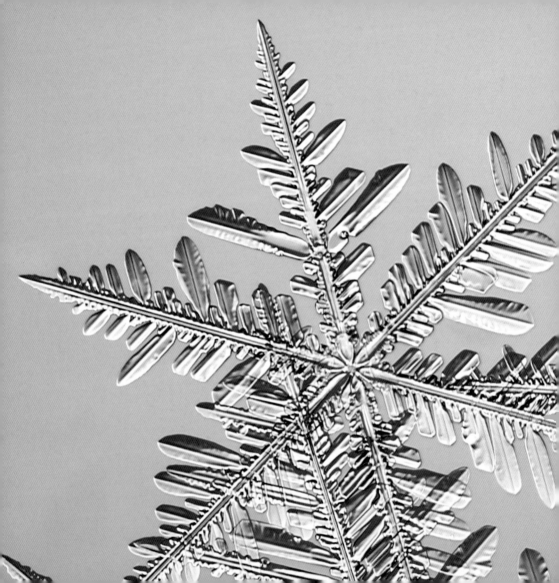

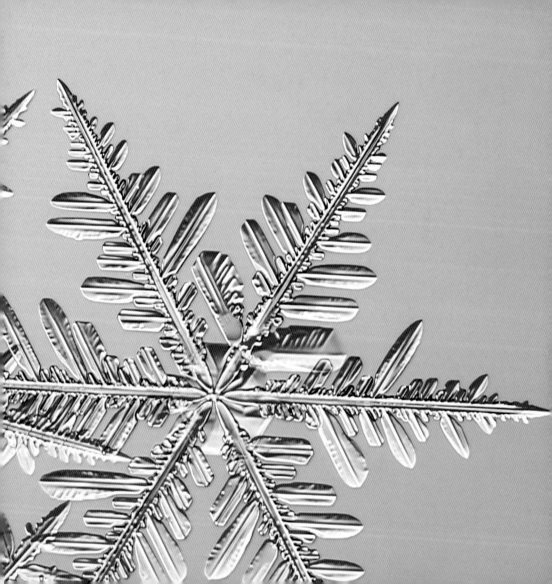

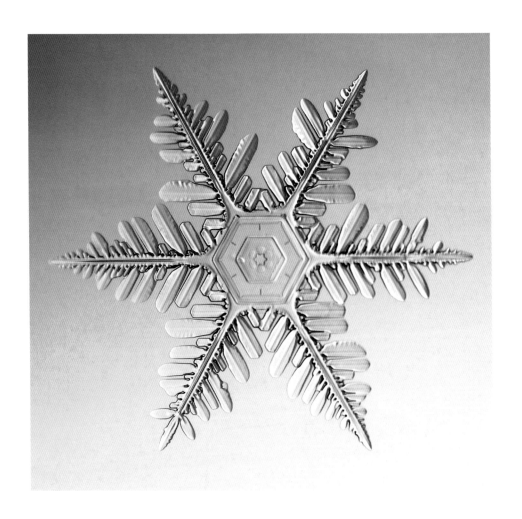

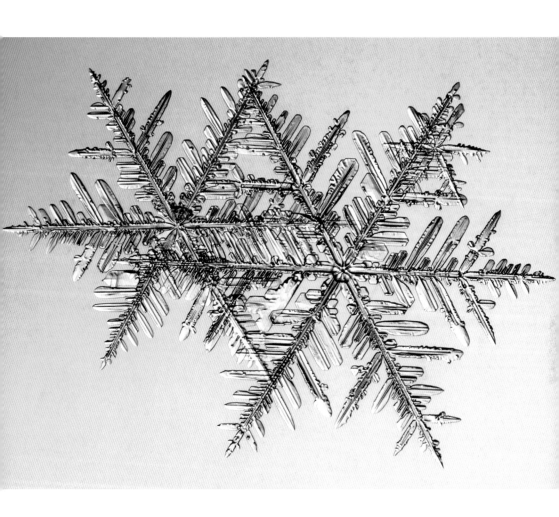

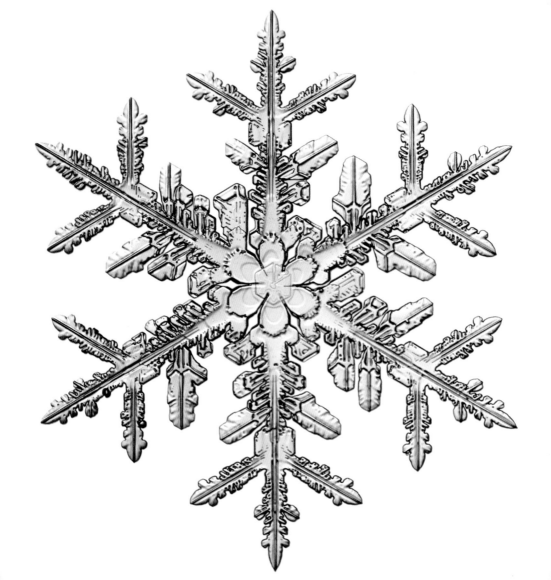

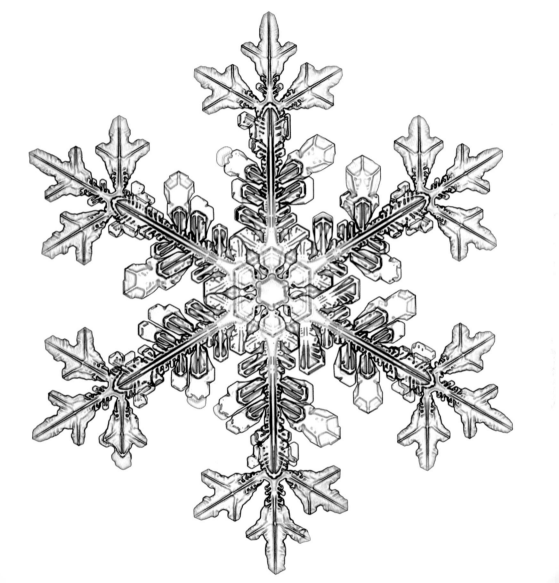

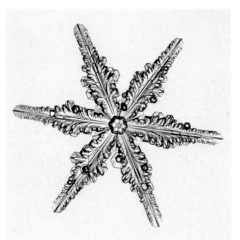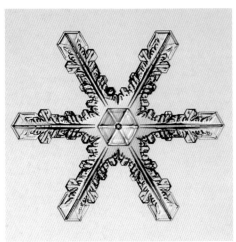

In science one tries to tell people, in such a way as to be understood by everyone, something that no one ever knew before. But in poetry, it's the exact opposite.

—Paul Dirac (1902–1984)

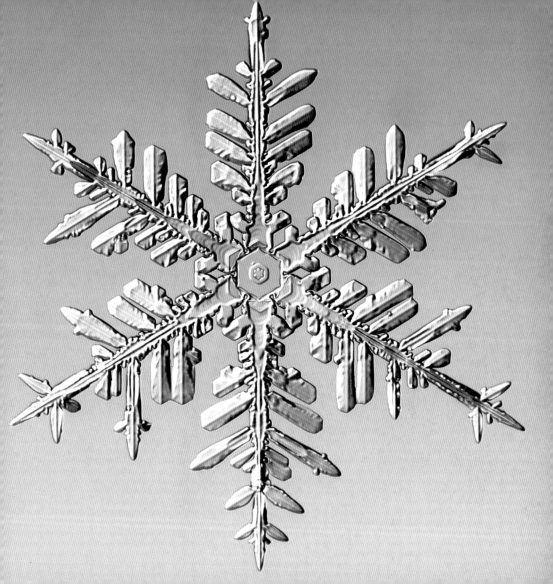

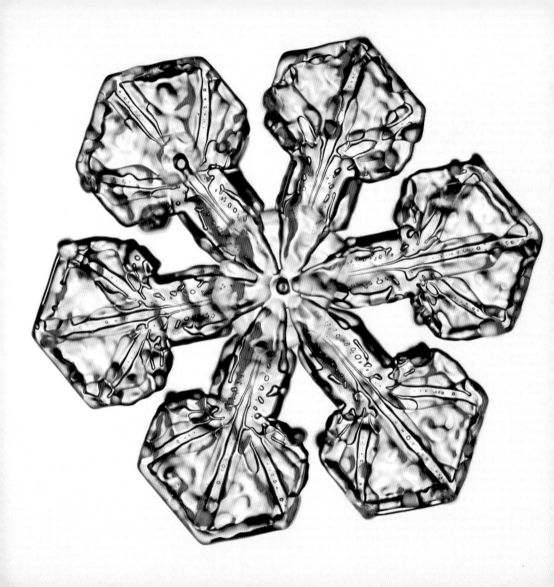

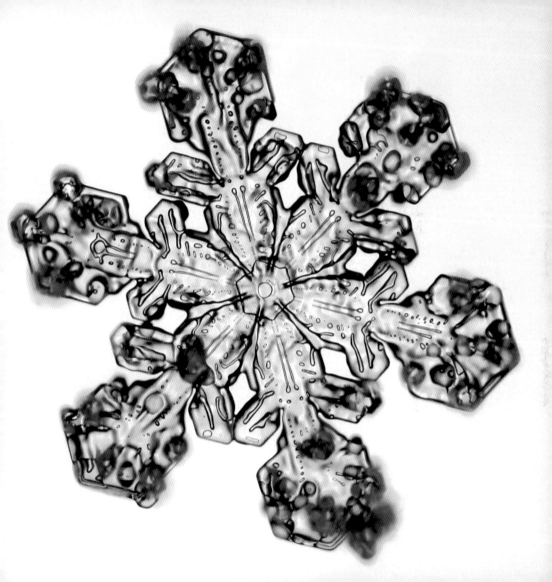

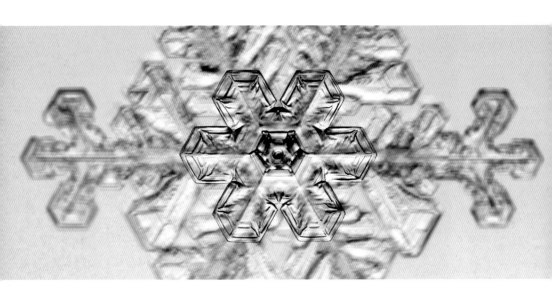

Snowflake Layers. Many stellar snowflakes are actually two crystals that grew together, connected at the center by a stubby axle. The microscope focus was adjusted in these two photographs to show the distinct layers of a single crystal.

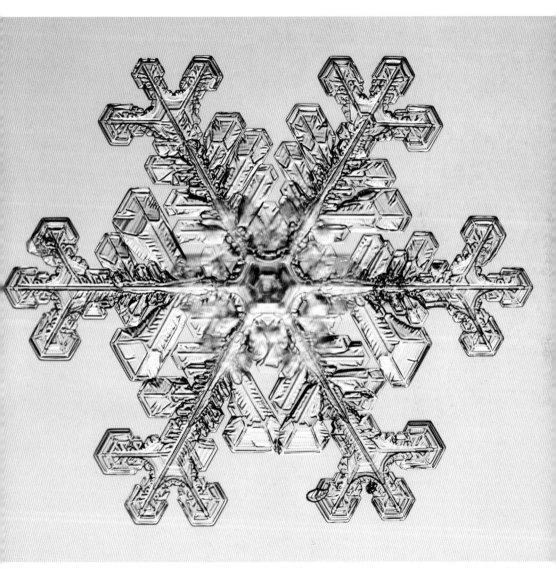

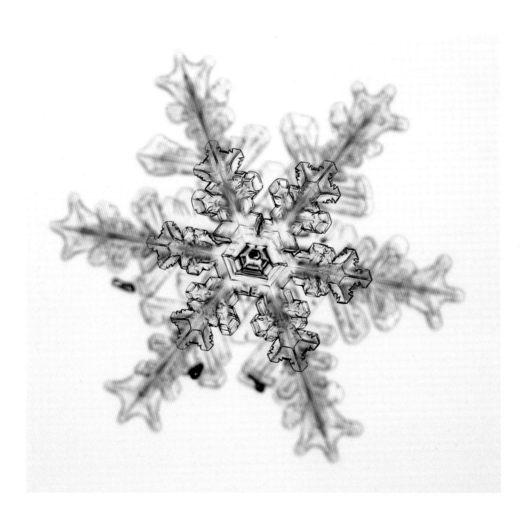

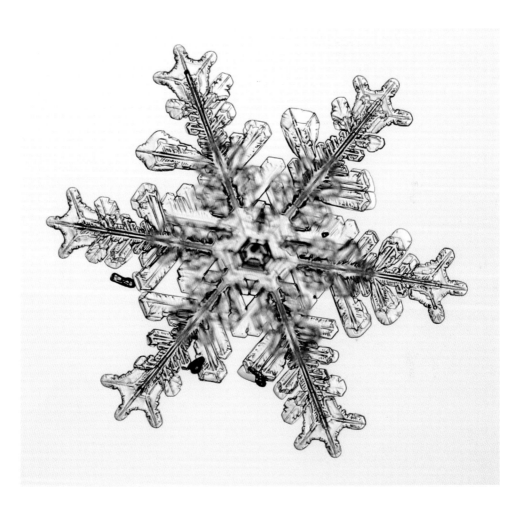

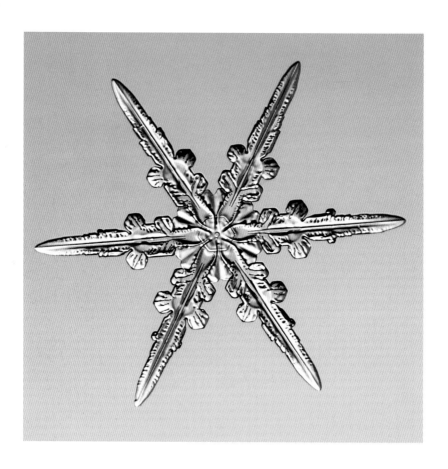

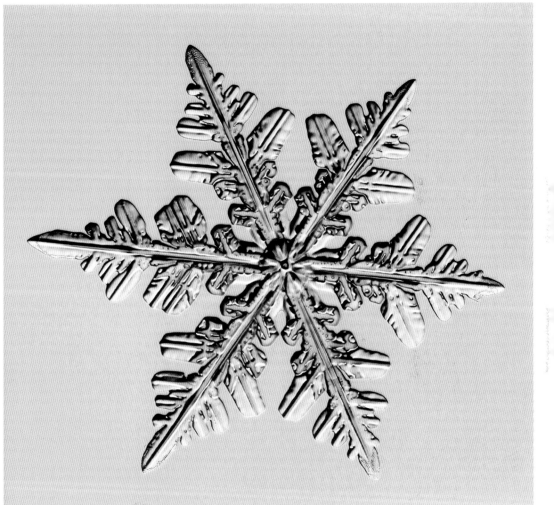

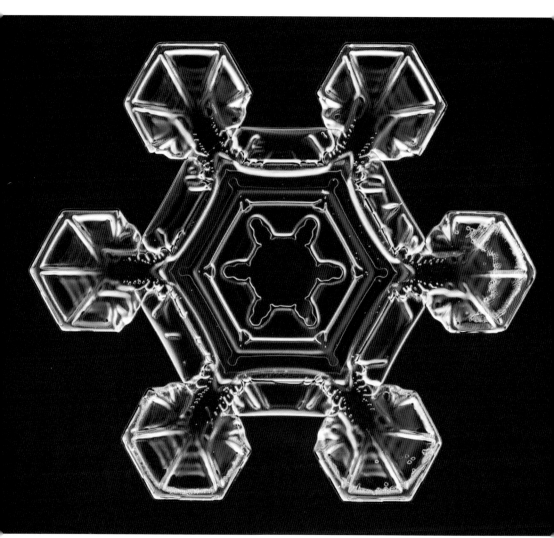

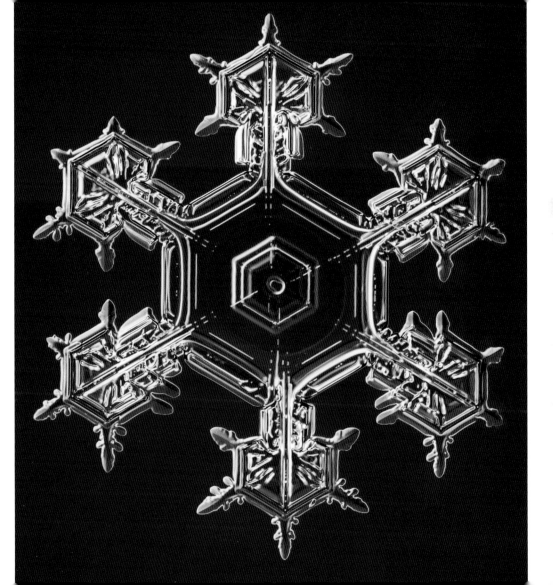

ONE CANNOT FIX ONE'S EYES ON THE COMMONEST
NATURAL PRODUCTION WITHOUT FINDING FOOD
FOR A RAMBLING FANCY.

—Jane Austen (1775–1817)

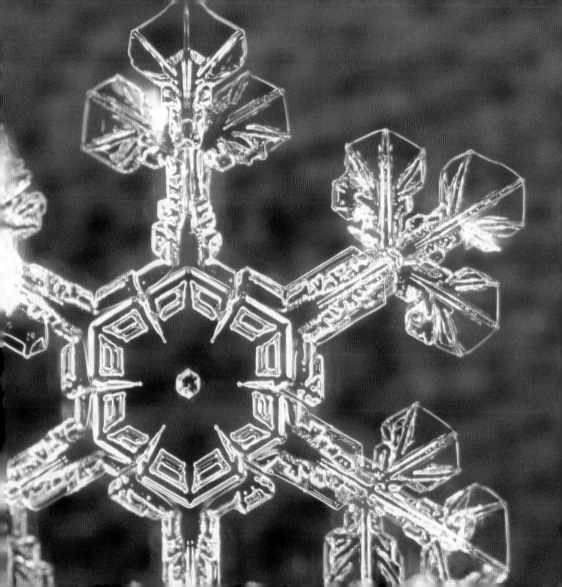

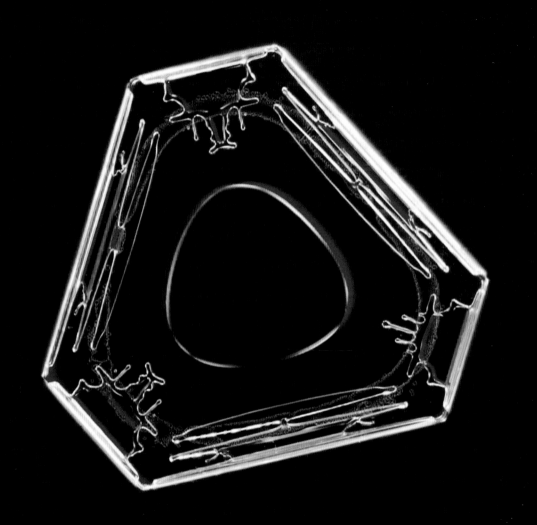

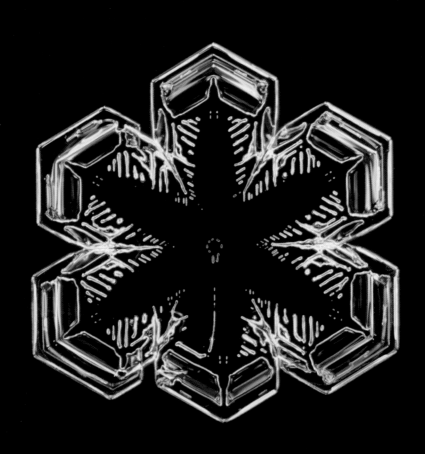

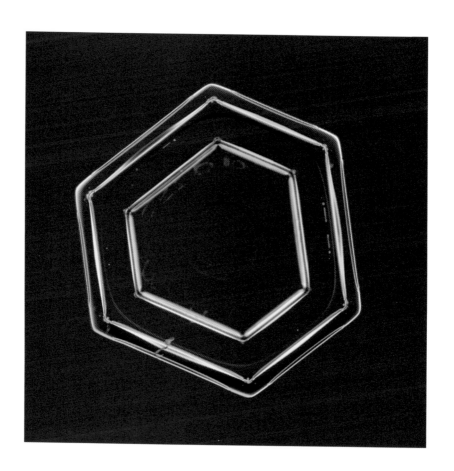

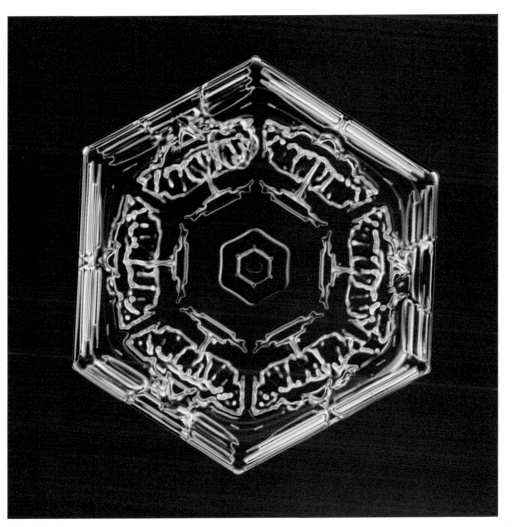

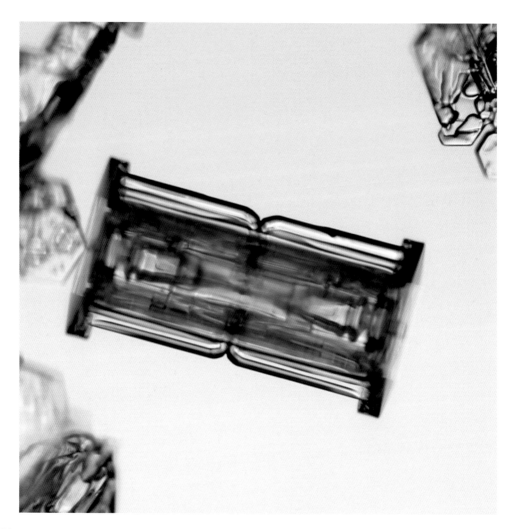

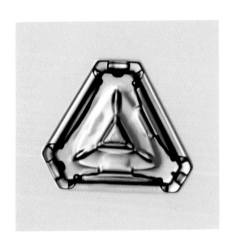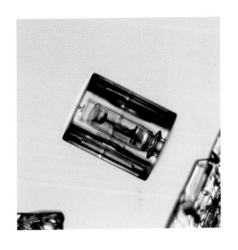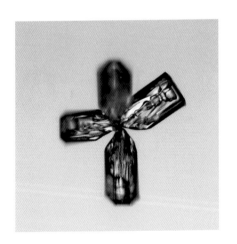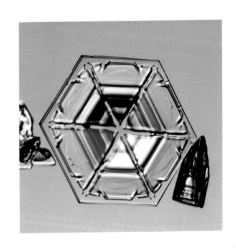

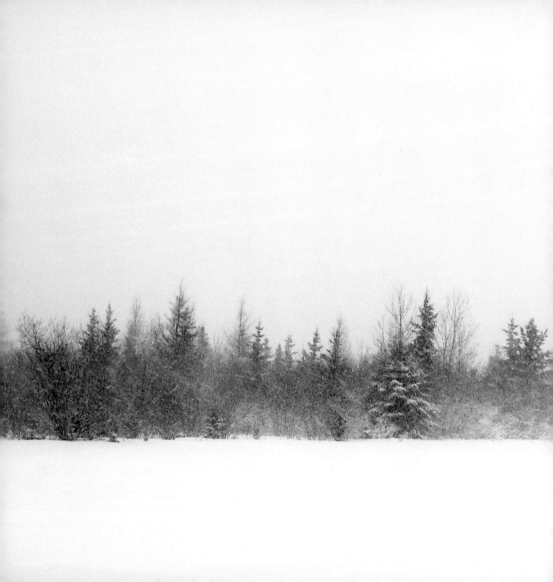

IN ALL THINGS OF NATURE THERE IS SOMETHING OF THE MARVELOUS.

—Aristotle (394 BC–322 BC)

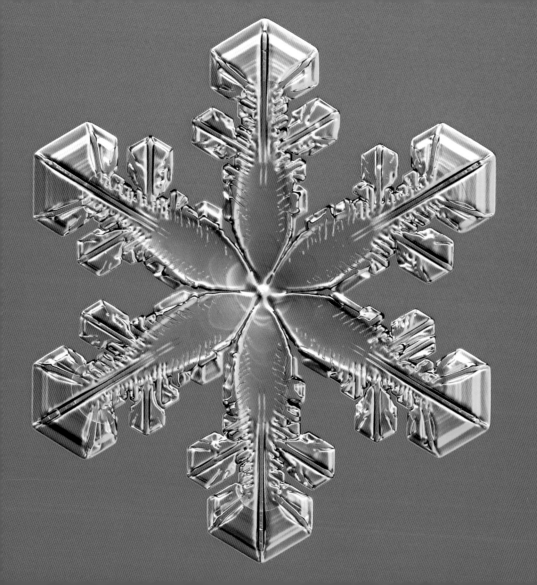

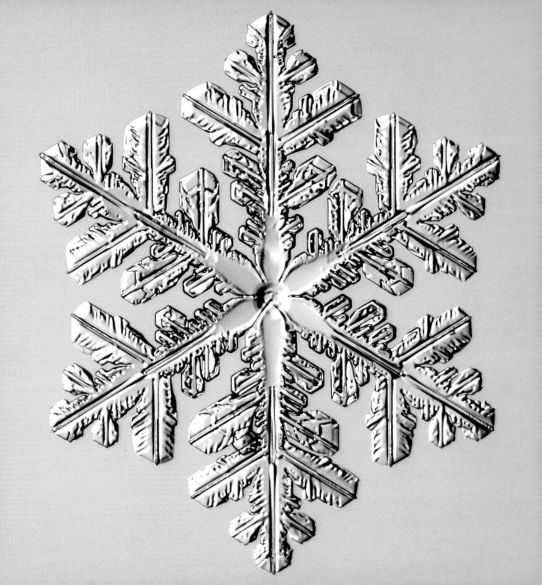

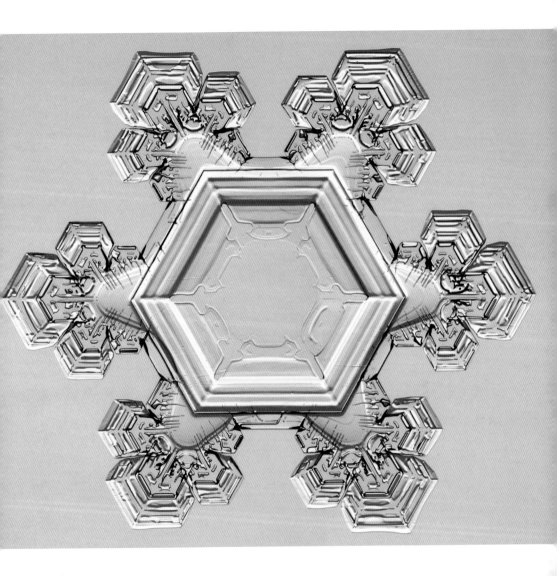

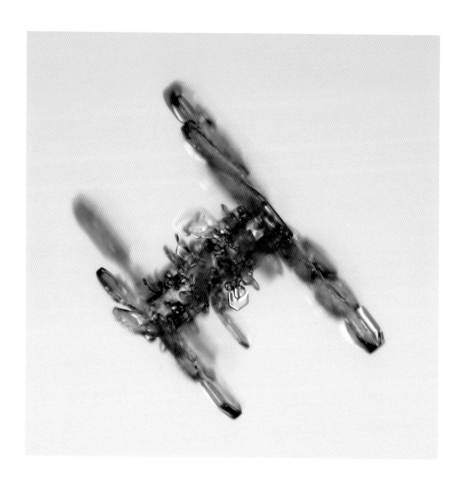

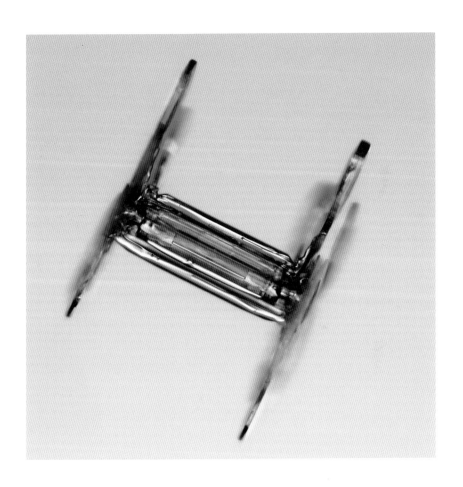

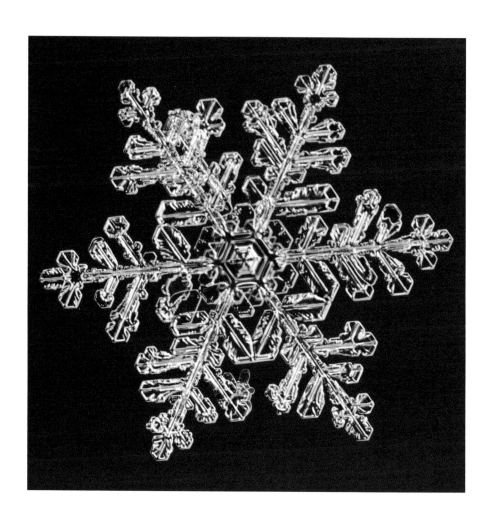

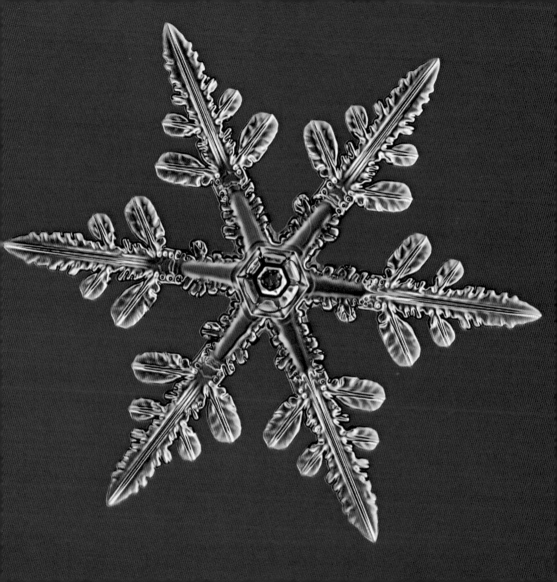

Monster Snowflakes. The picture at right shows perhaps the largest single snow crystal ever photographed, measuring 10.2 mm (0.4 inches) from tip to tip, about as large as a dime. I captured it in northern Ontario on December 30, 2003, during a light snowfall in which countless numbers of these enormous ice flowers drifted slowly to earth.

Individual snow crystals often collide in midair and stick together to form flimsy puffballs. When there is little wind and the snow is especially sticky, these puffball snowflakes can grow to the size of your hand—or even larger.

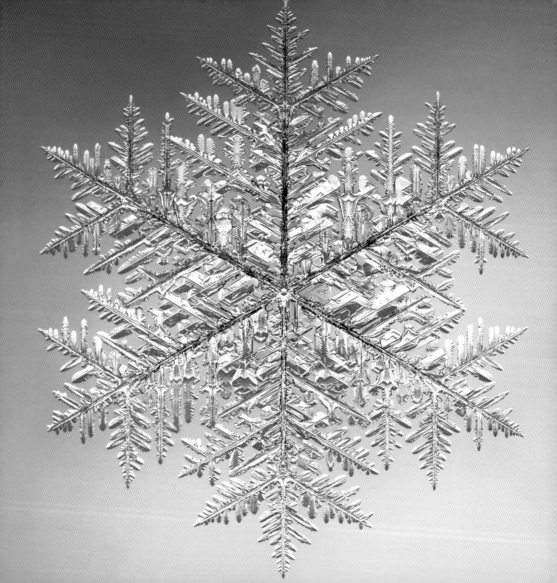

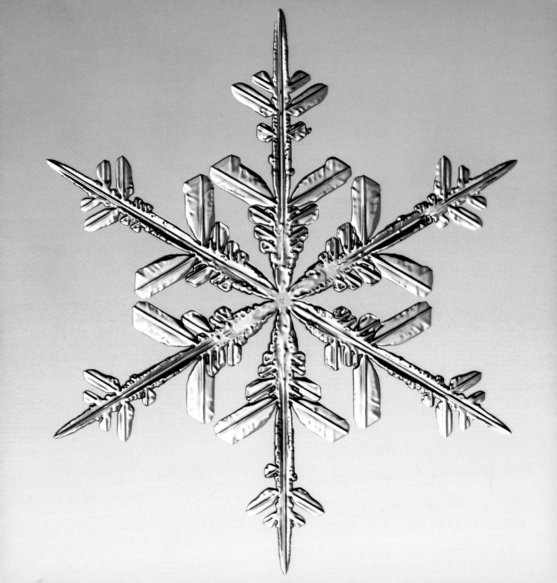

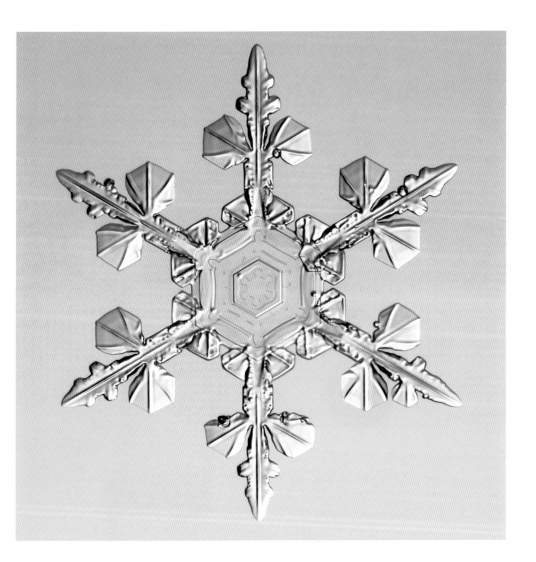

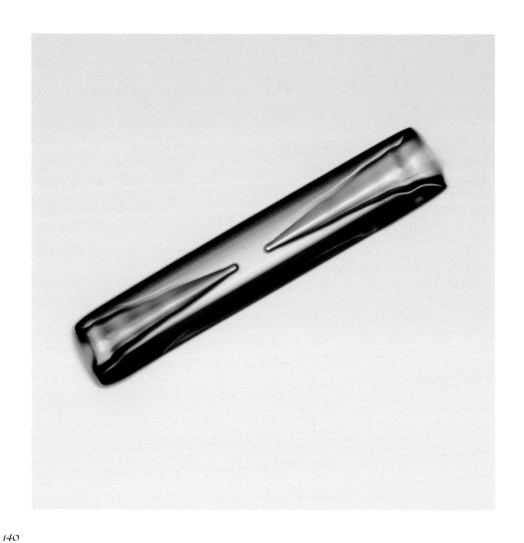

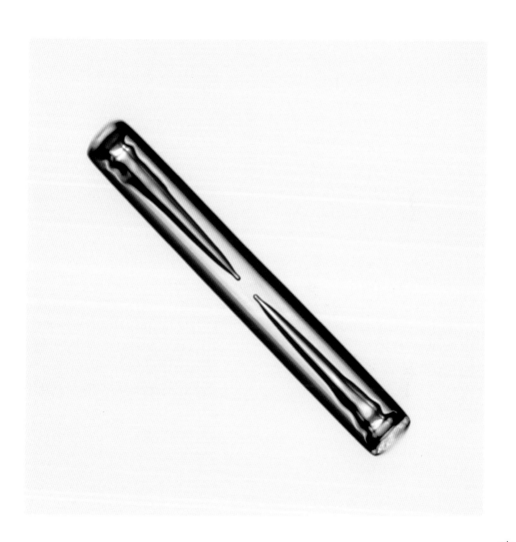

THE THIN SNOW NOW DRIVING FROM THE NORTH AND LODGING ON MY COAT CONSISTS OF THOSE BEAUTIFUL STAR CRYSTALS, NOT COTTONY AND CHUBBY SPOKES, AS ON THE 13TH DECEMBER, BUT THIN AND PARTLY TRANSPARENT CRYSTALS. THEY ARE ABOUT A TENTH OF AN INCH IN DIAMETER, PERFECT LITTLE WHEELS WITH SIX SPOKES WITHOUT A TIRE, OR RATHER WITH SIX PERFECT LITTLE LEAFLETS, FERN-LIKE, WITH A DISTINCT STRAIGHT AND SLENDER MIDRIB, RAYING FROM THE CENTRE. ON EACH SIDE OF EACH MIDRIB THERE IS A TRANSPARENT THIN BLADE WITH A CRENATE EDGE. . . . HOW FULL OF THE CREATIVE GENIUS IS THE AIR IN WHICH THESE ARE GENERATED! I SHOULD HARDLY ADMIRE MORE IF REAL STARS FELL AND LODGED ON MY COAT. NATURE IS FULL OF GENIUS, FULL OF THE DIVINITY; SO THAT NOT A SNOWFLAKE ESCAPES ITS FASHIONING HAND. NOTHING IS CHEAP AND COARSE, NEITHER DEWDROPS NOR SNOWFLAKES.

— Henry David Thoreau (1817–1862)

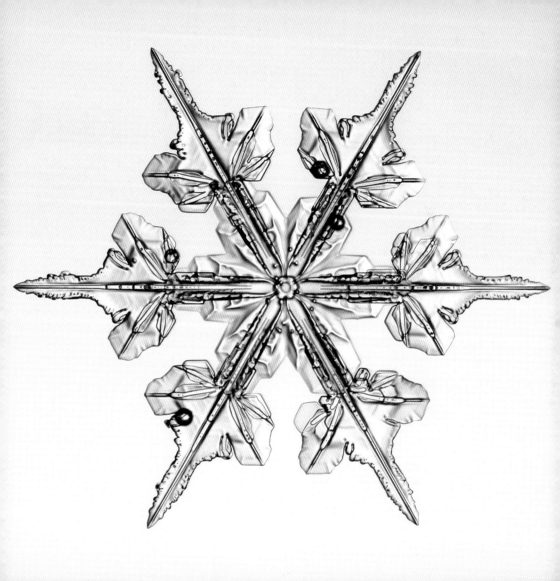

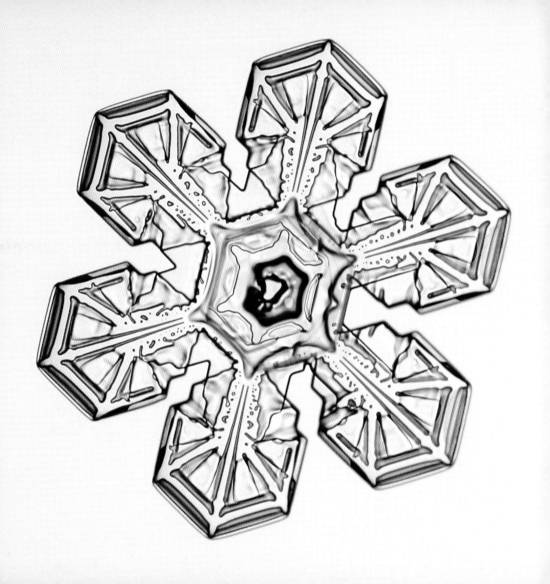

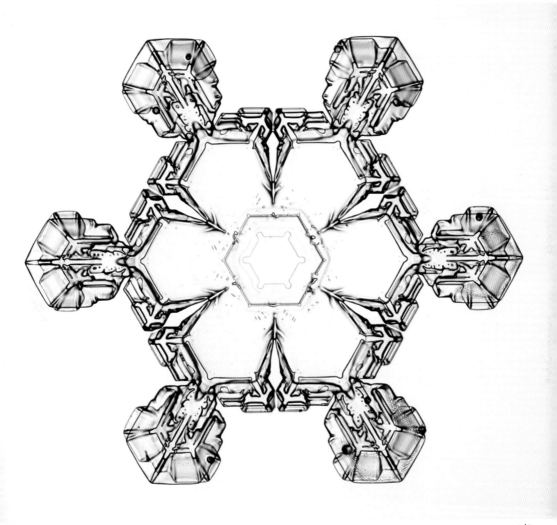

SOON THE STORM INCREASES—IT WAS ALREADY VERY SEVERE TO FACE—AND THE SNOW COMES FINER, MORE WHITE AND POWDERY. WHO KNOWS BUT THIS IS THE ORIGINAL FORM OF ALL SNOWFLAKES, BUT THAT WHEN I OBSERVE THESE CRYSTAL STARS FALLING AROUND ME THEY ARE BUT JUST GENERATED IN THE LOW MIST NEXT THE EARTH? I AM NEARER TO THE SOURCE OF THE SNOW, ITS PRIMAL, AURORAL, AND GOLDEN HOUR OR INFANCY.

— Henry David Thoreau (1817–1862)

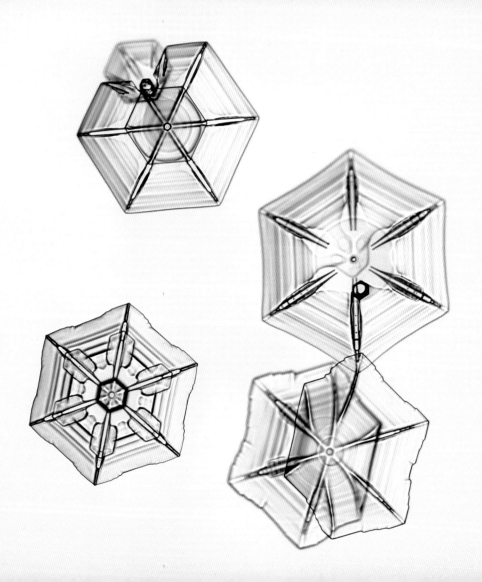

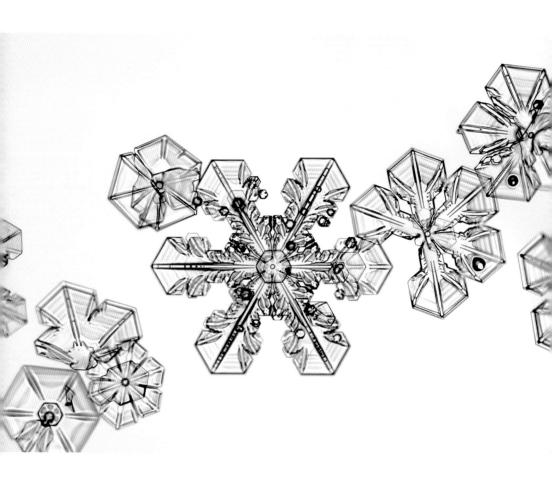

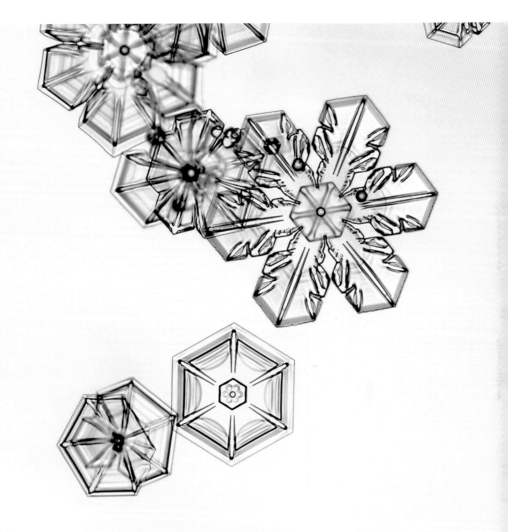

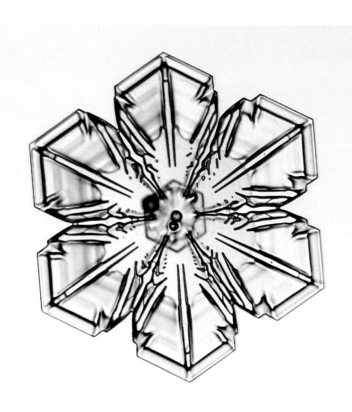

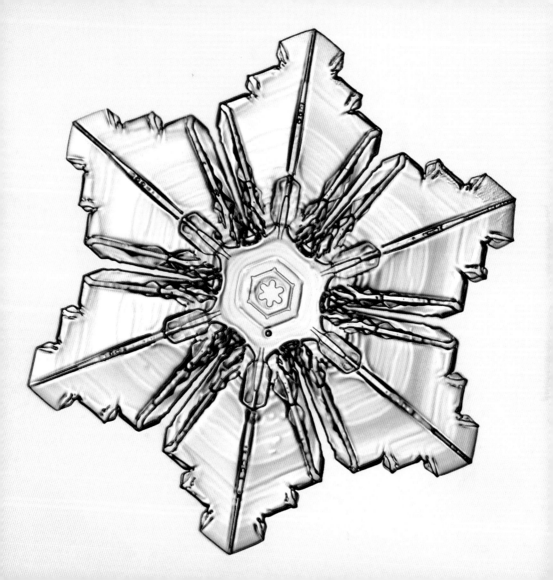

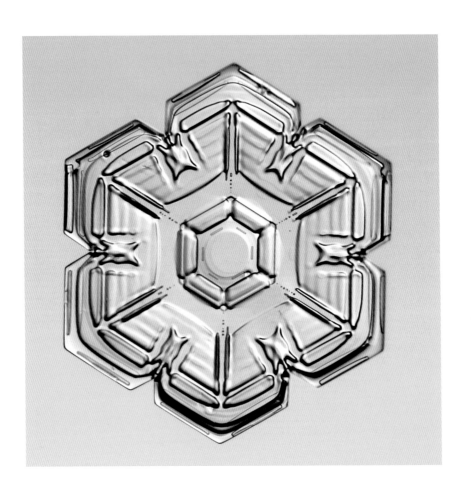

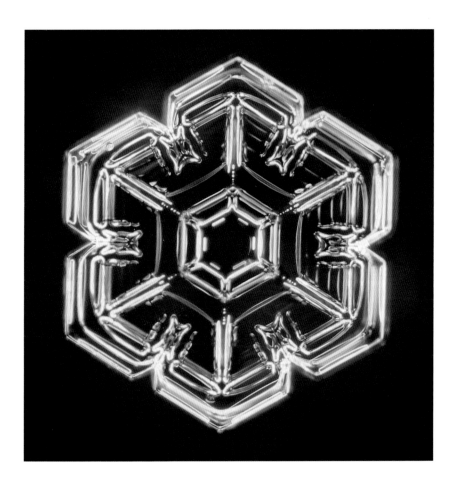

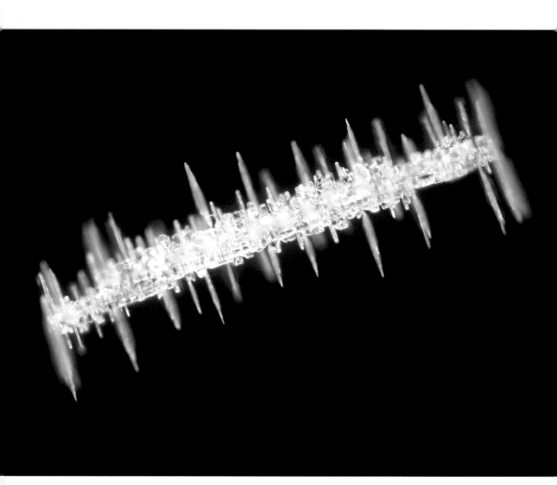

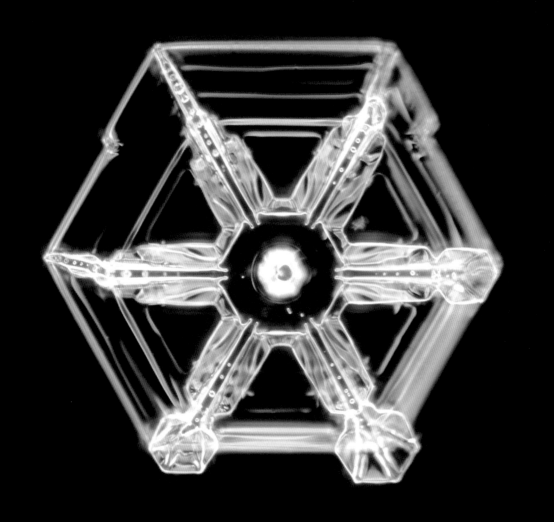

To see a World in a grain of Sand,
And a Heaven in a Wild Flower.
Hold Infinity in the palm of your hand,
And Eternity in an hour.

—William Blake (1757–1827)

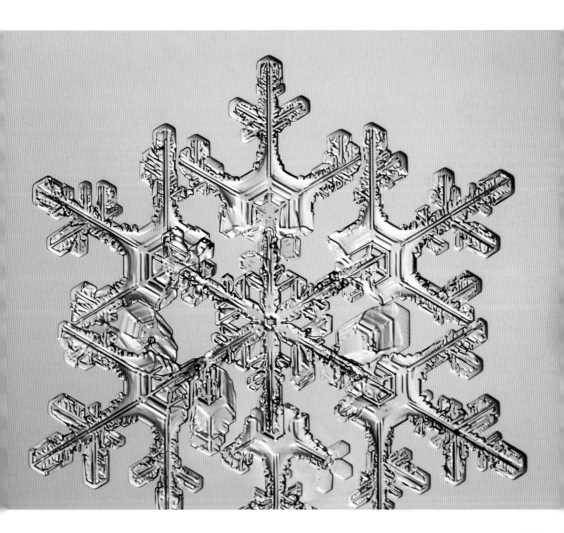

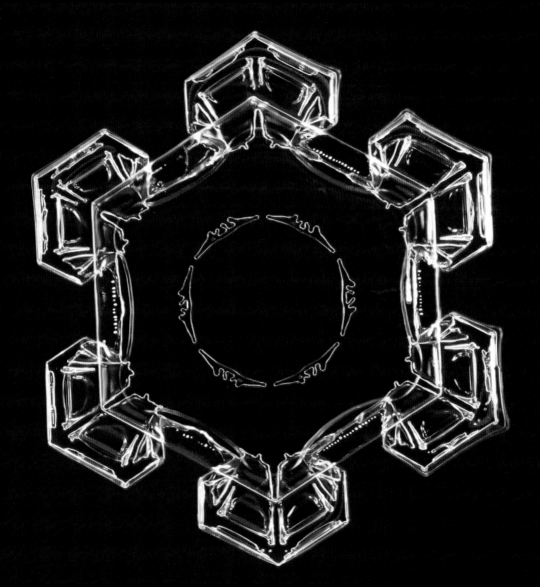

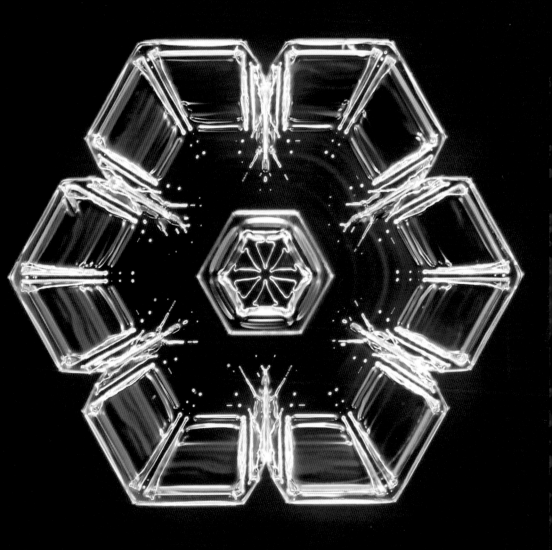

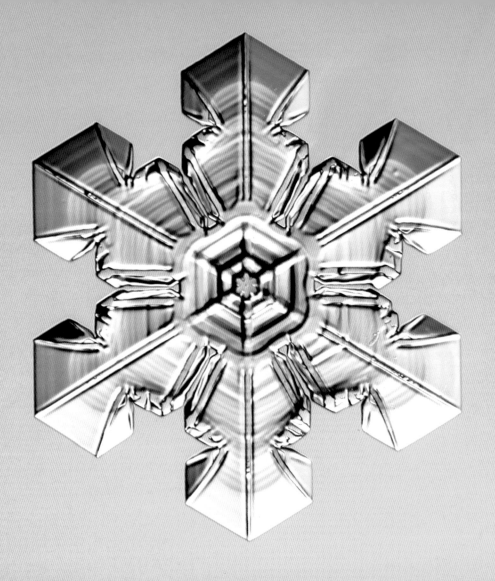

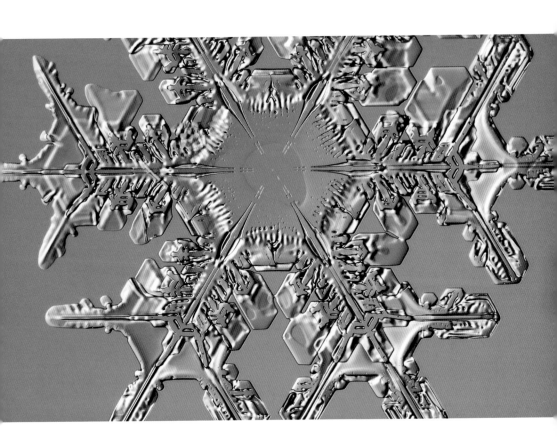

\mathscr{N}EW BEAUTY MEETS US AT EVERY STEP IN ALL OUR WANDERINGS.

—John Muir (1838–1914)

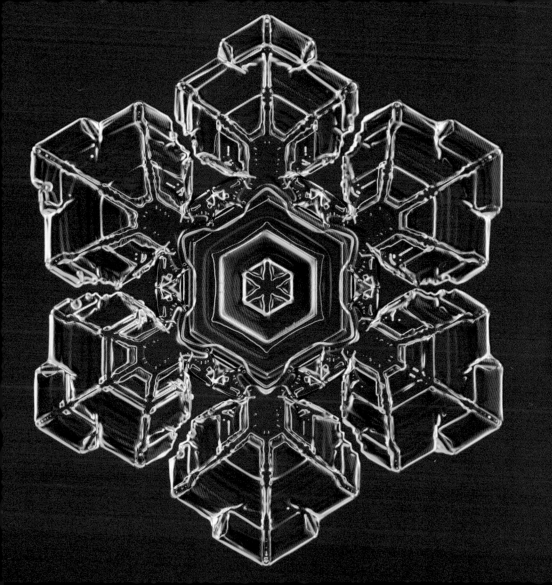

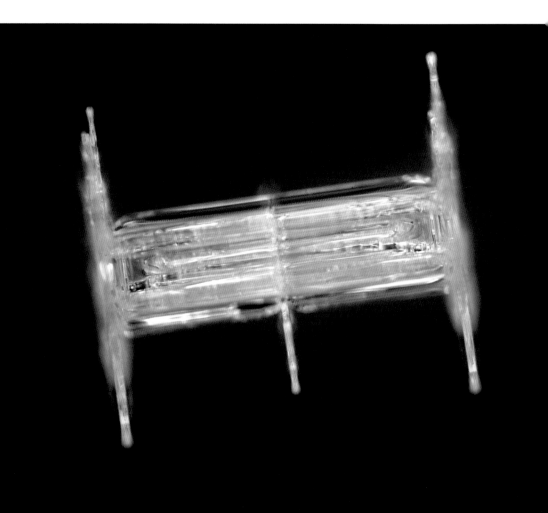

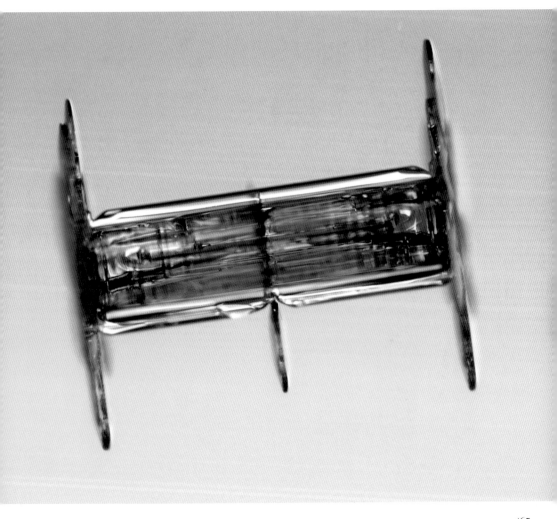

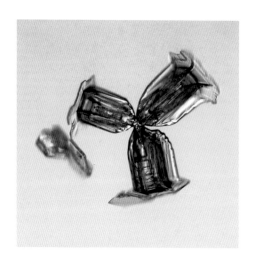
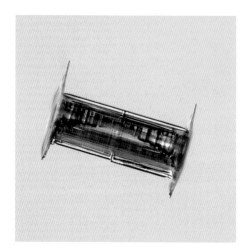
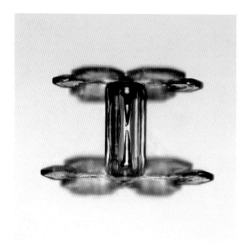
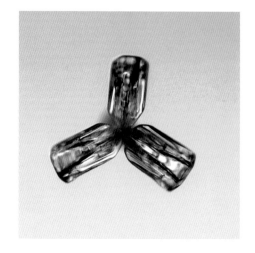

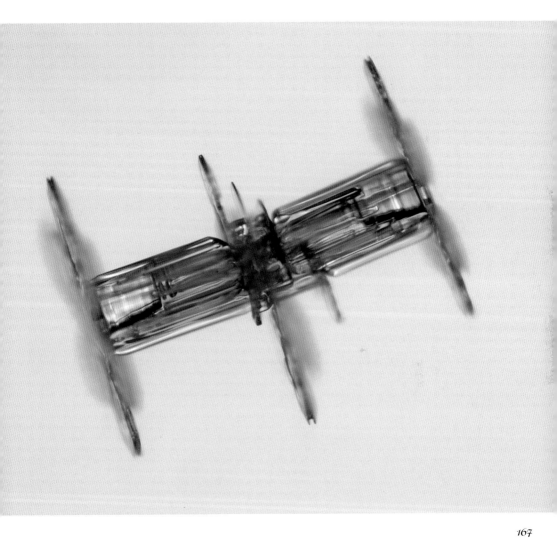

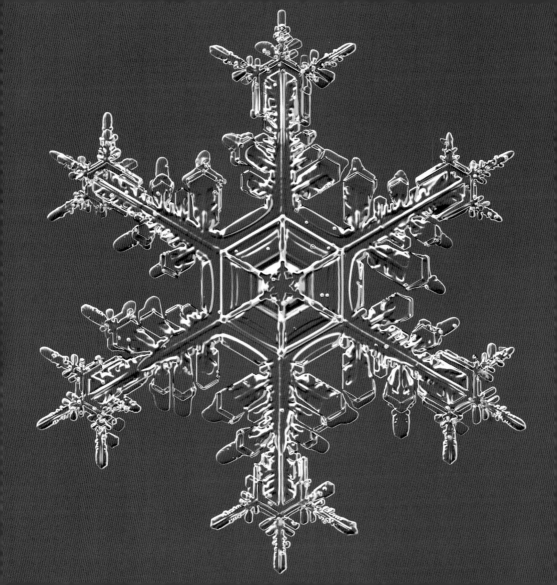

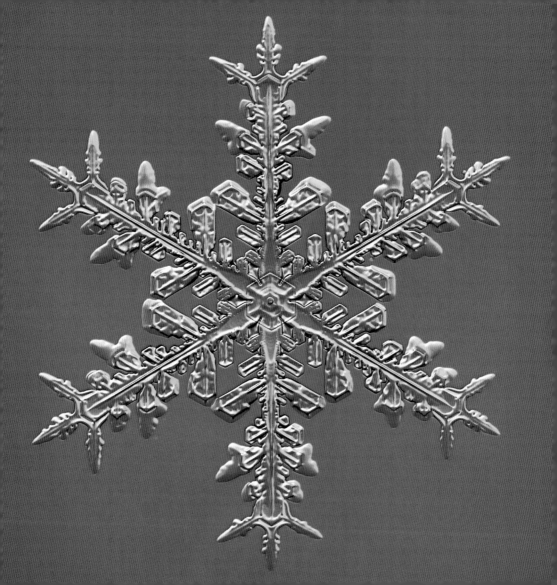

FORESTS, LAKES, AND RIVERS, CLOUDS AND WINDS, STARS AND FLOWERS, STUPENDOUS GLACIERS AND CRYSTAL SNOWFLAKES — EVERY FORM OF ANIMATE OR INANIMATE EXISTENCE, LEAVES ITS IMPRESS UPON THE SOUL OF MAN.

—Orison Swett Marden (1850–1924)

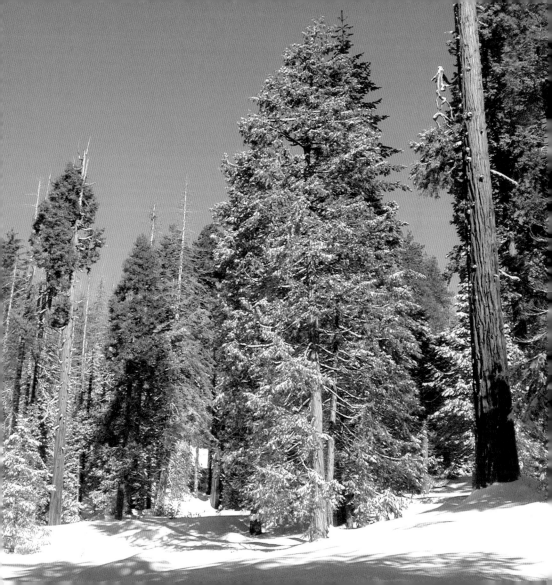

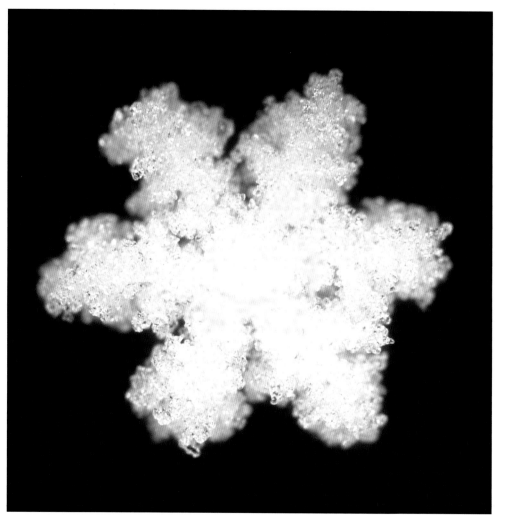

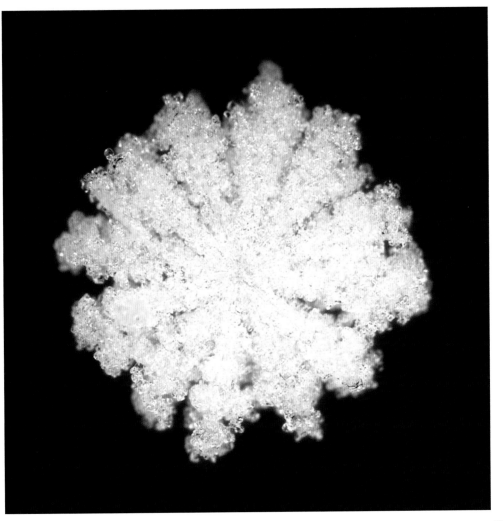

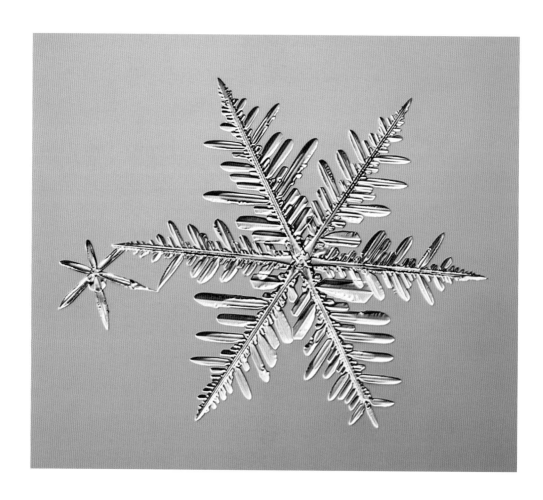

174

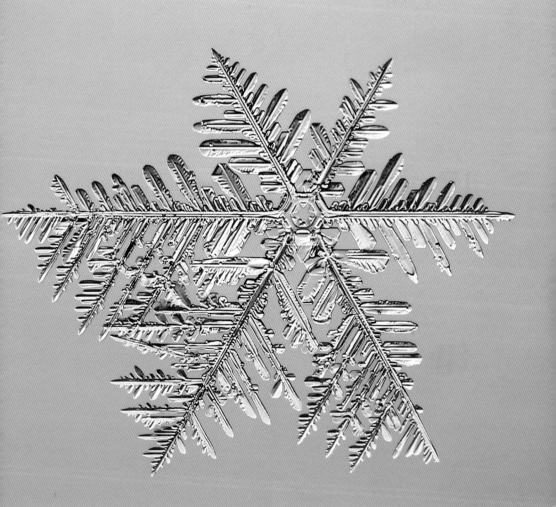

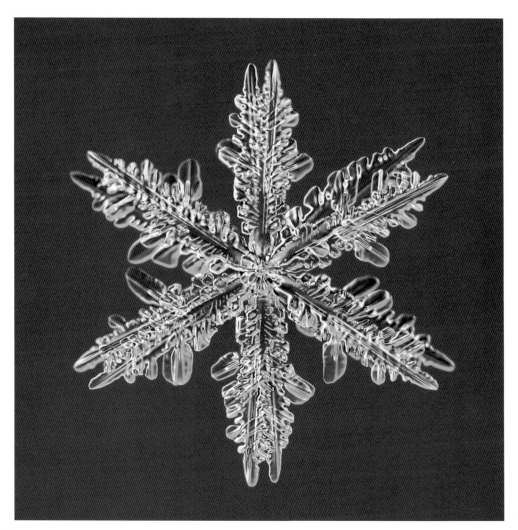

176

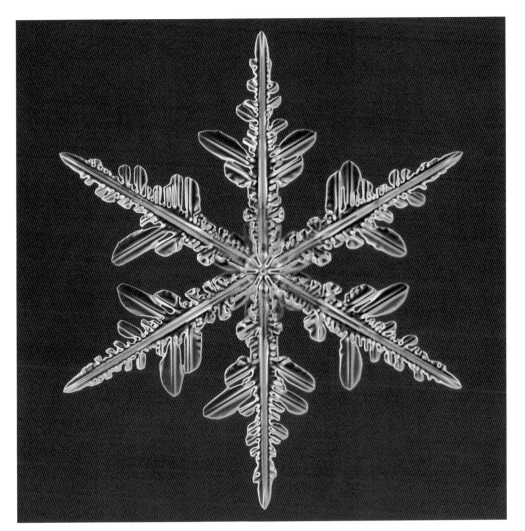

THE PURSUIT OF TRUTH AND BEAUTY IS A SPHERE OF ACTIVITY IN WHICH WE ARE PERMITTED TO REMAIN CHILDREN ALL OUR LIVES.

—Albert Einstein (1879–1955)

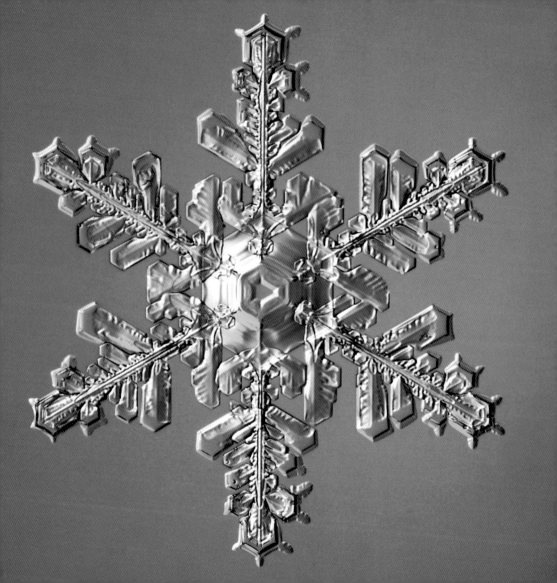

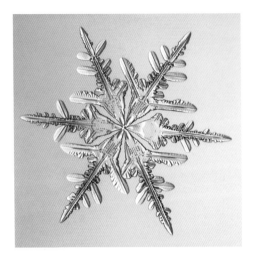
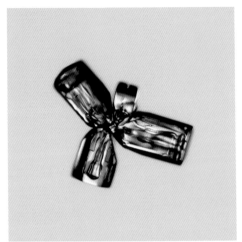
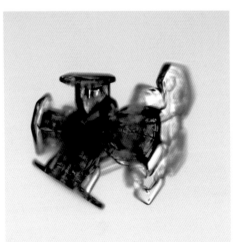
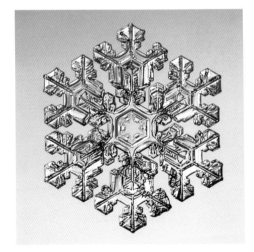

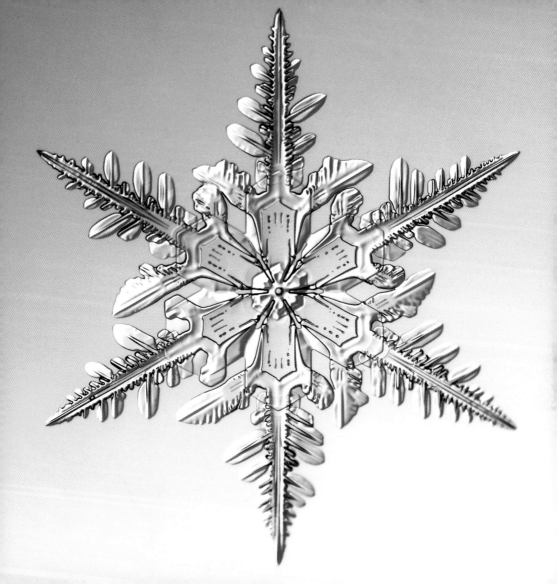

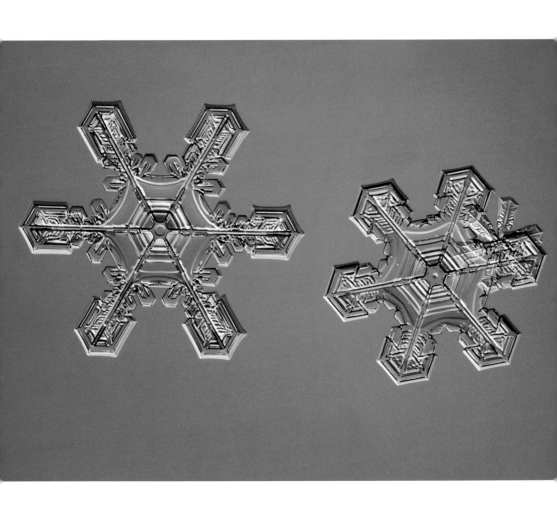

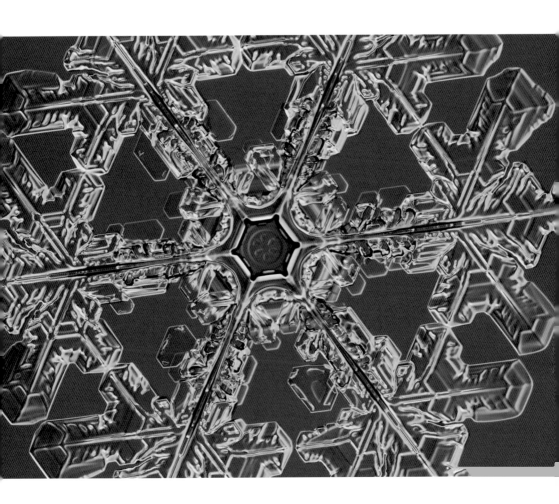

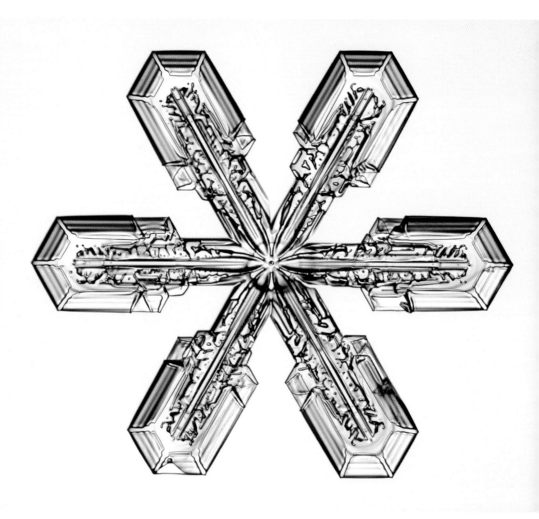

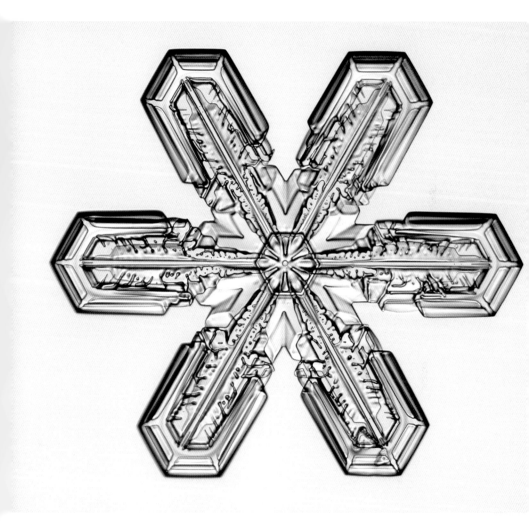

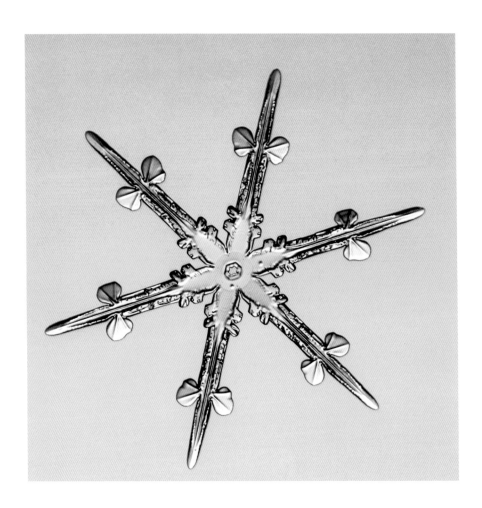

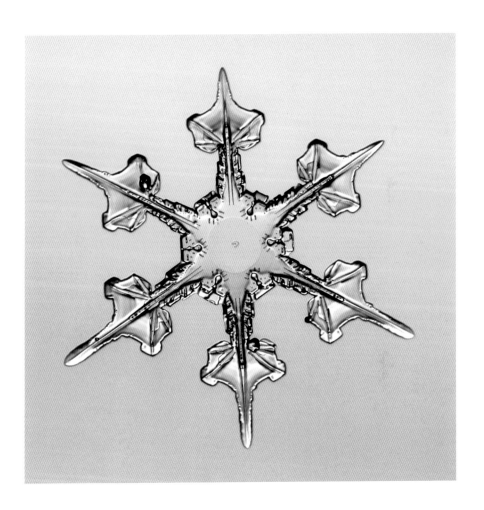

THEY SAY THAT EVERY SNOWFLAKE IS DIFFERENT.
IF THAT WERE TRUE, HOW COULD THE WORLD GO ON?
HOW COULD WE EVER GET UP OFF OUR KNEES?
HOW COULD WE EVER RECOVER FROM THE WONDER
OF IT?

—Jeanette Winterson (1959–)

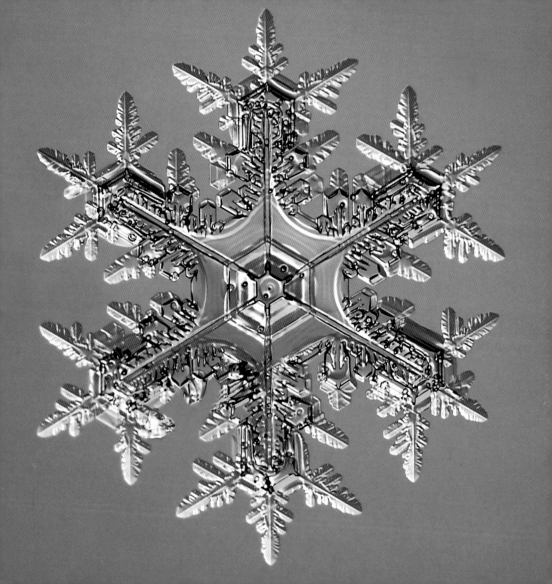

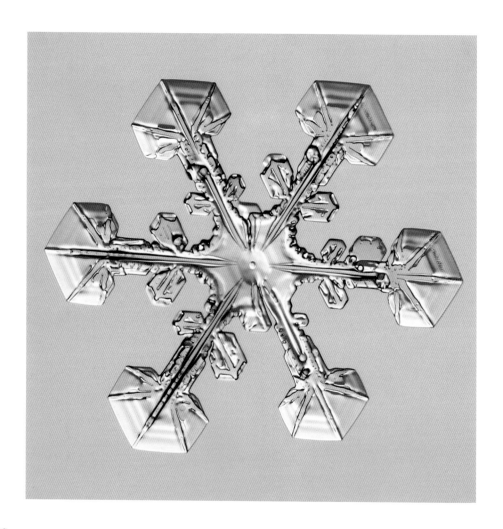

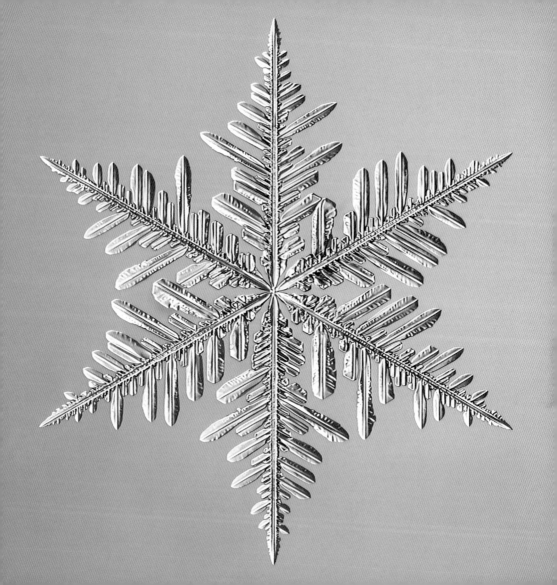

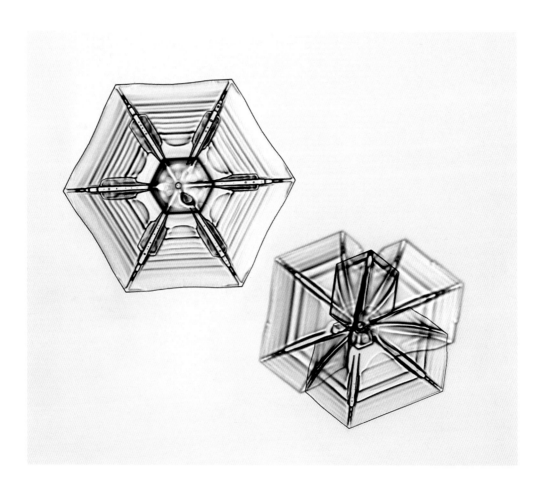

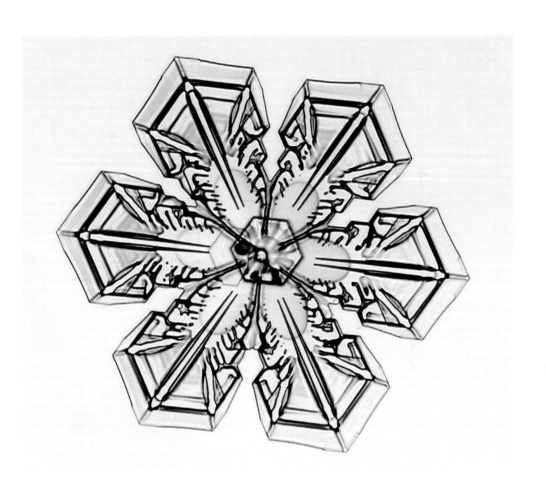

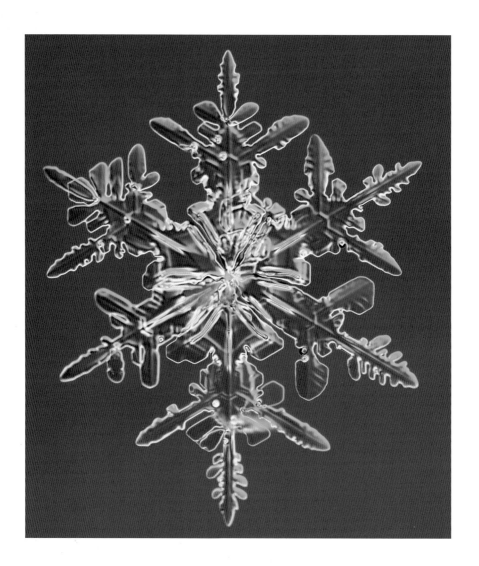

194

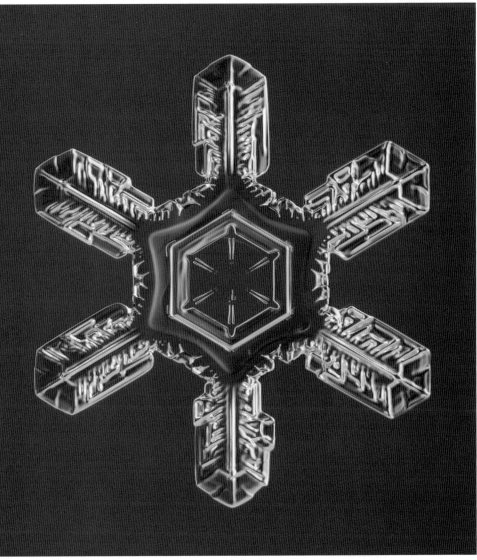

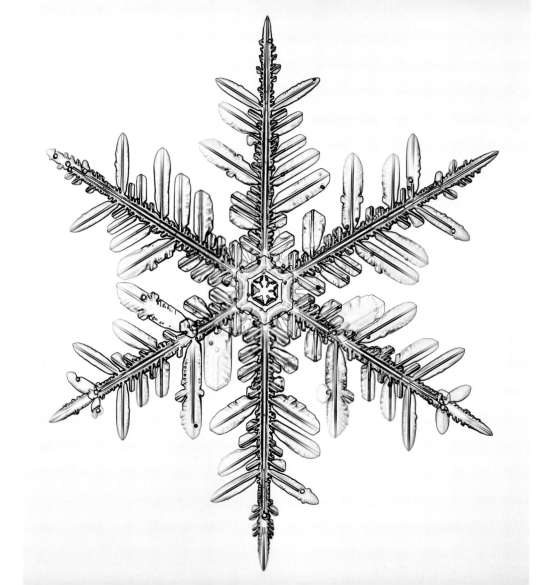

ABANDON THE URGE TO SIMPLIFY EVERYTHING, TO LOOK FOR FORMULAS AND EASY ANSWERS, AND BEGIN TO THINK MULTIDIMENSIONALLY, TO GLORY IN THE MYSTERY AND PARADOXES OF LIFE, NOT TO BE DISMAYED BY THE MULTITUDE OF CAUSES AND CONSEQUENCES THAT ARE INHERENT IN EACH EXPERIENCE— TO APPRECIATE THE FACT THAT LIFE IS COMPLEX.

—M. Scott Peck (1936–2005)

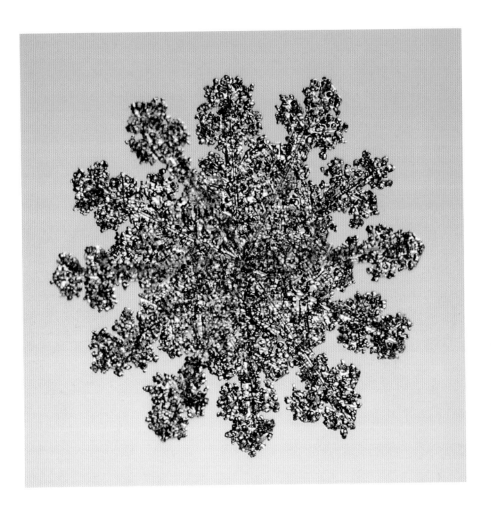

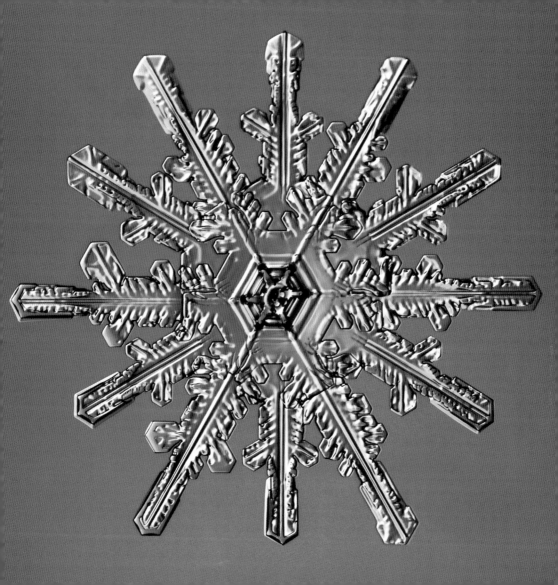

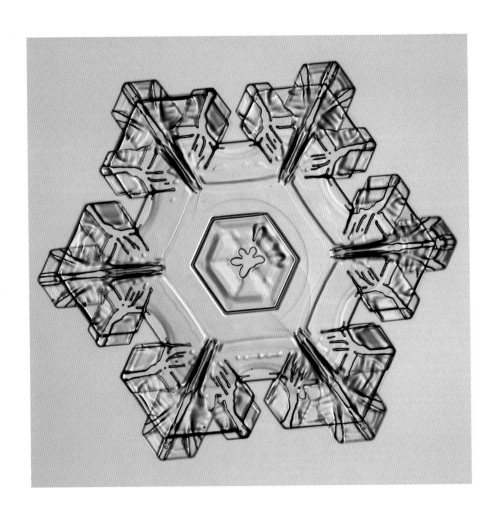

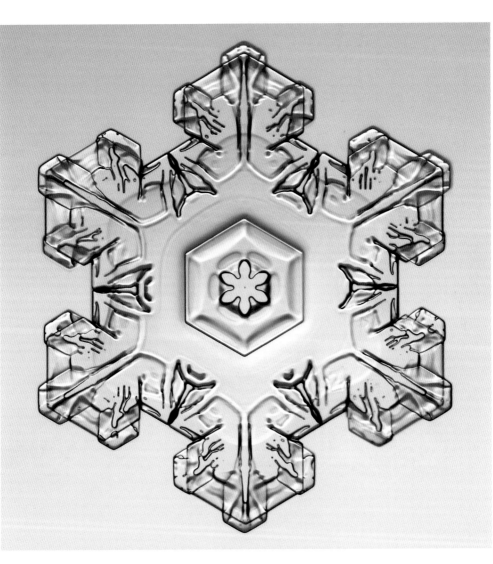

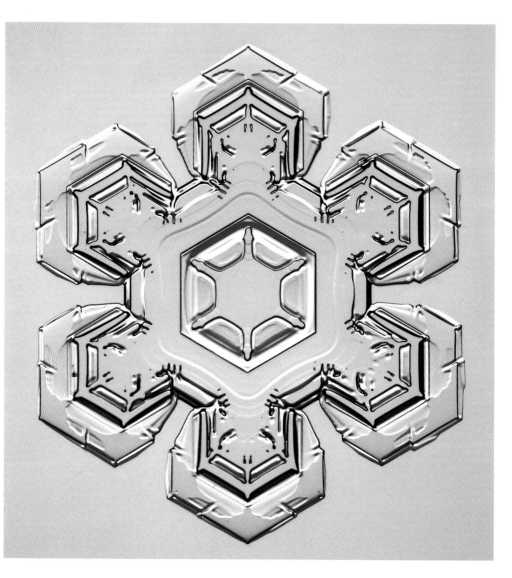

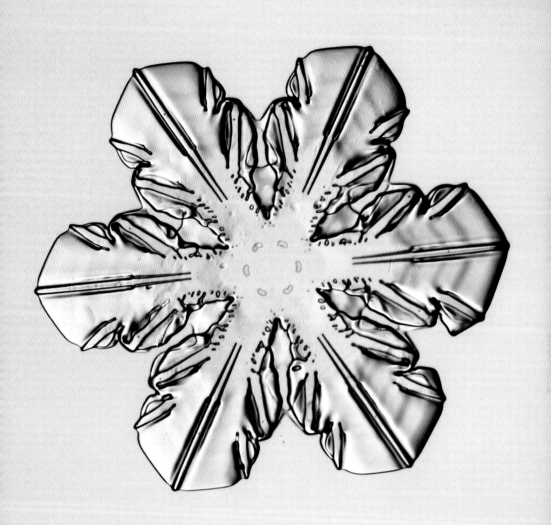

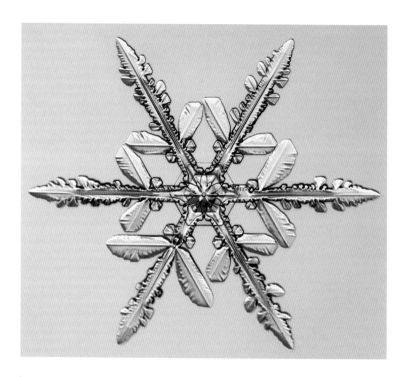

THOSE WHO DWELL AMONG THE BEAUTIES
AND MYSTERIES OF THE EARTH ARE NEVER
ALONE OR WEARY OF LIFE.

—Rachel Carson (1907–1964)

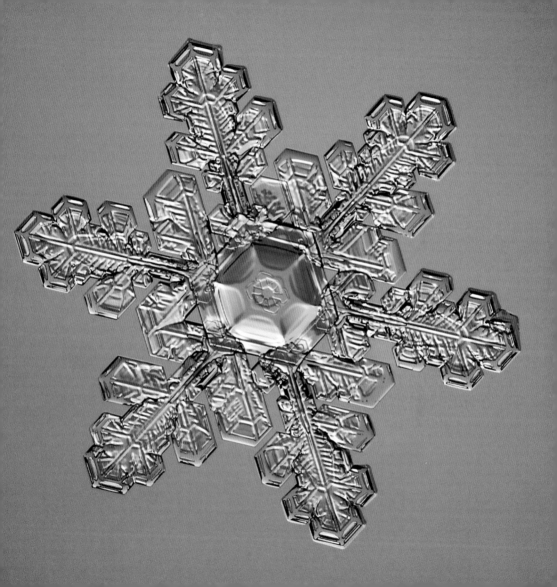

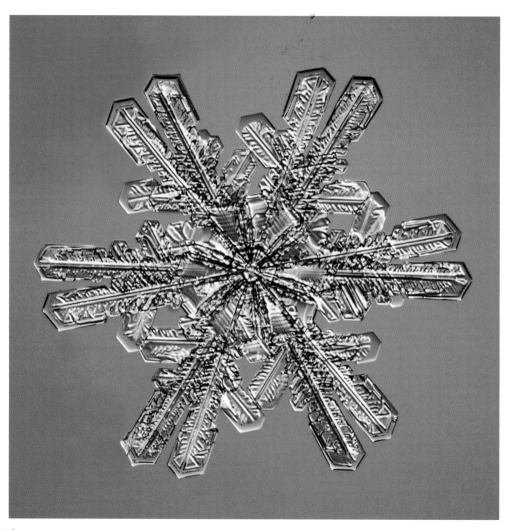

206

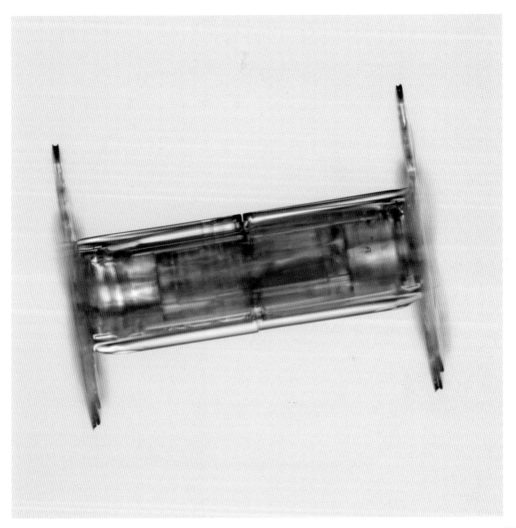

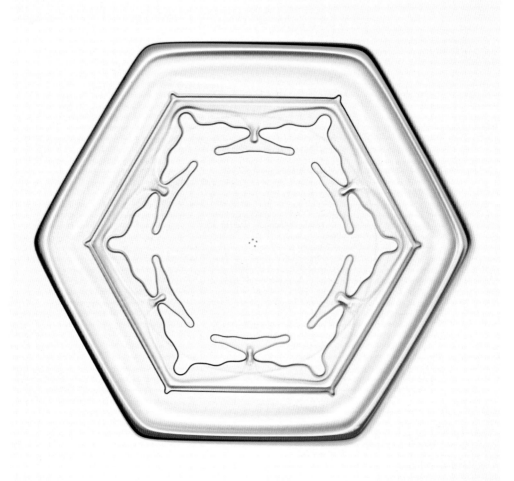

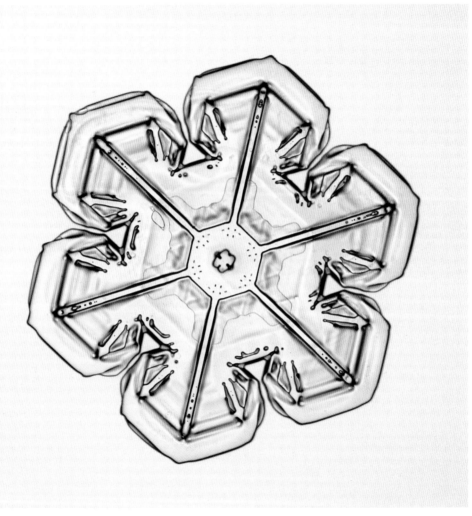

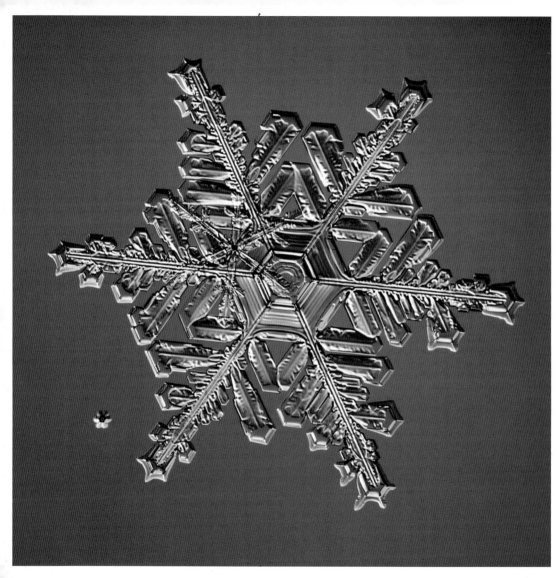

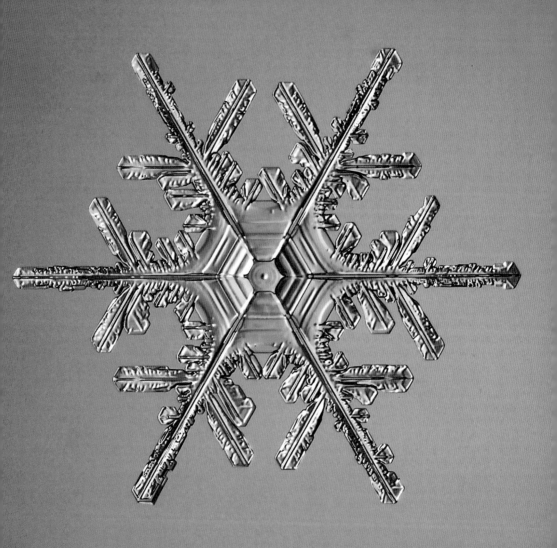

THERE IS NOTHING IN THE WORLD MORE BEAUTIFUL THAN THE FOREST CLOTHED TO ITS VERY HOLLOWS IN SNOW. IT IS THE STILL ECSTASY OF NATURE, WHEREIN EVERY SPRAY, EVERY BLADE OF GRASS, EVERY SPIRE OF REED, EVERY INTRICACY OF TWIG, IS CLAD WITH RADIANCE.

—Fiona MacLeod (1855–1905)

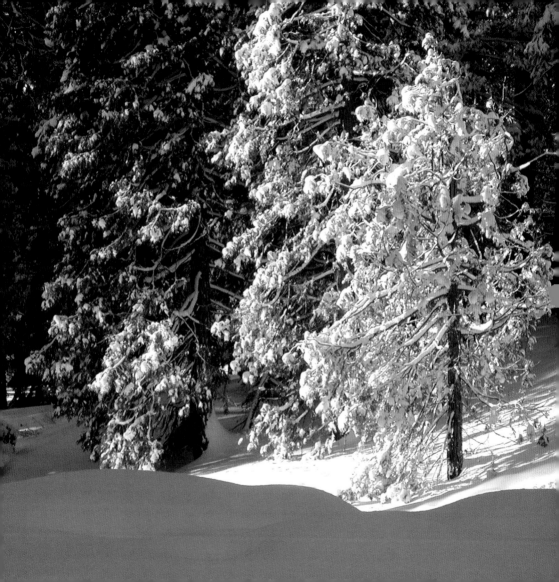

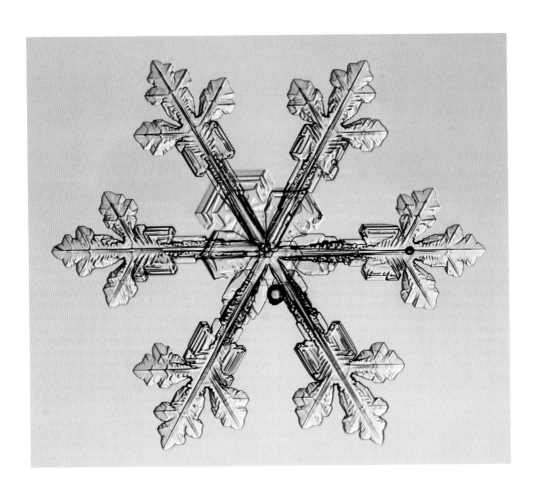

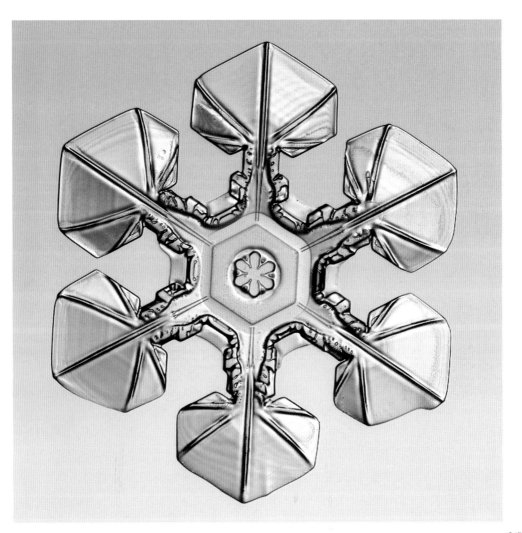

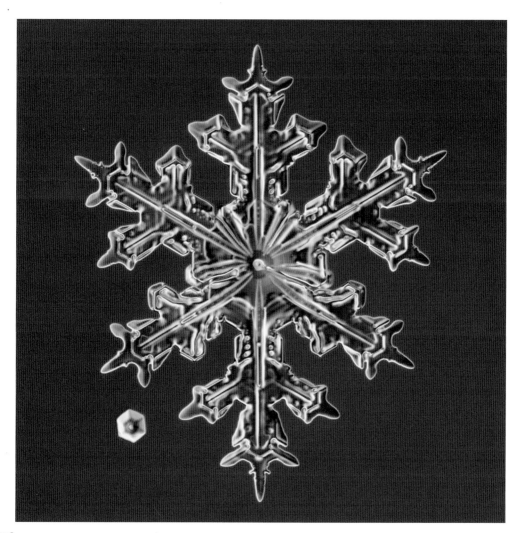

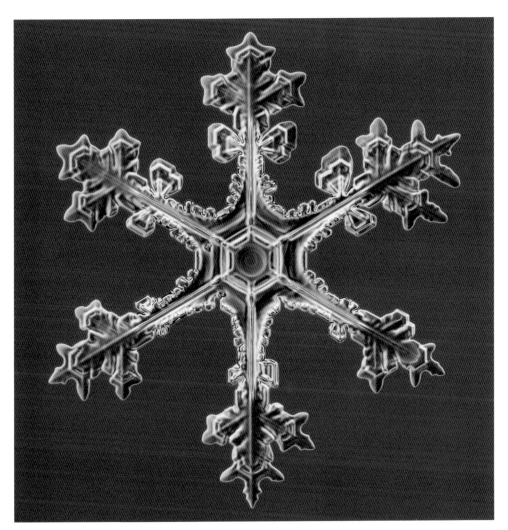

This grand show is eternal. It is always sunrise somewhere; the dew is never all dried at once; a shower is forever falling; vapor ever rising. Eternal sunrise, eternal sunset, eternal dawn and gloaming. On seas and continents and islands, each in its turn, as the round earth rolls.

—John Muir (1838–1914)

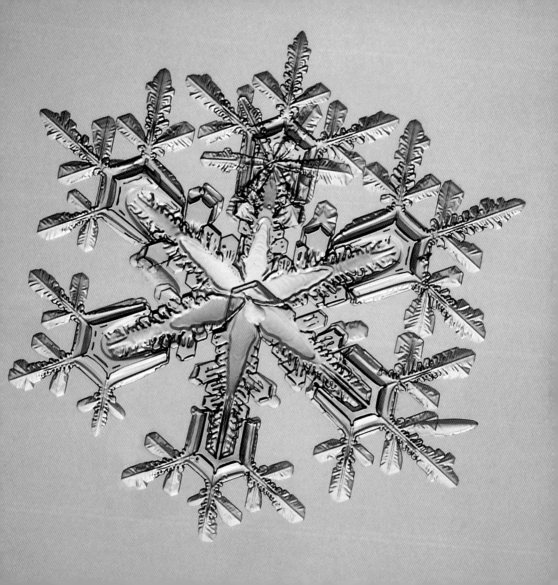

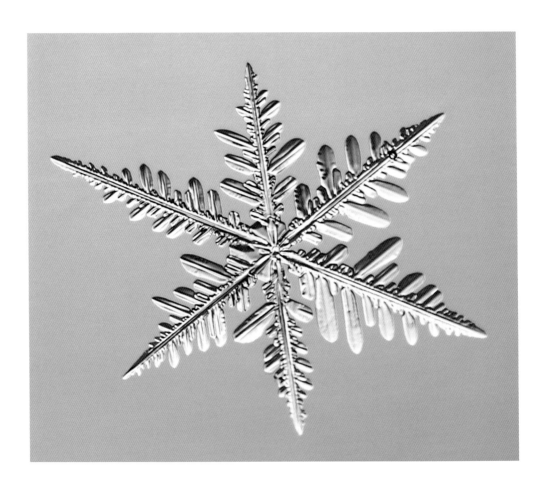

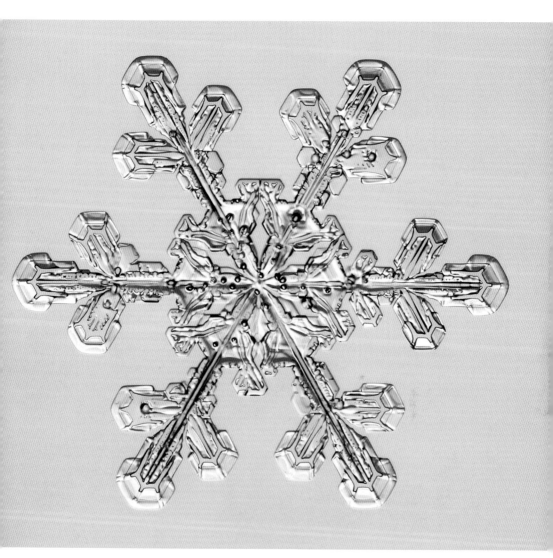

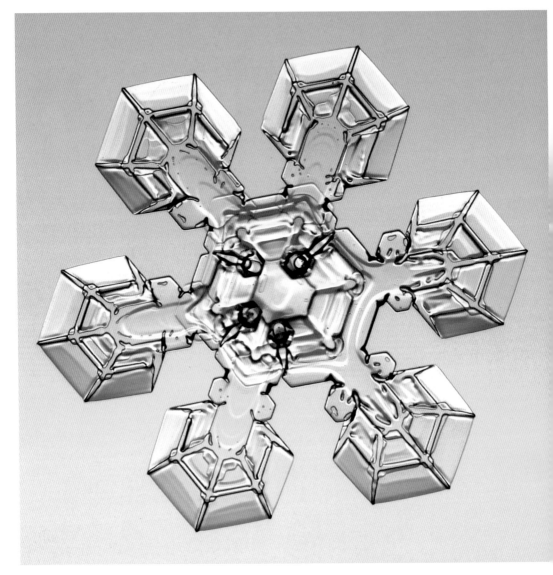

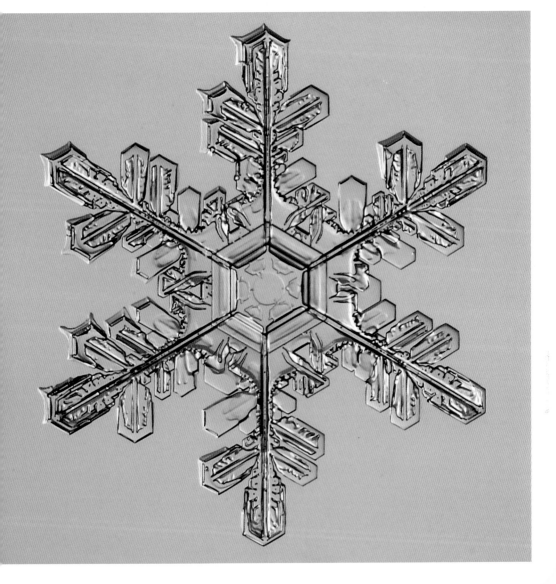

THE SUBTLETY OF NATURE IS GREATER MANY TIMES OVER
THAN THE SUBTLETY OF THE SENSES AND UNDERSTANDING.

—Sir Francis Bacon (1561–1626)

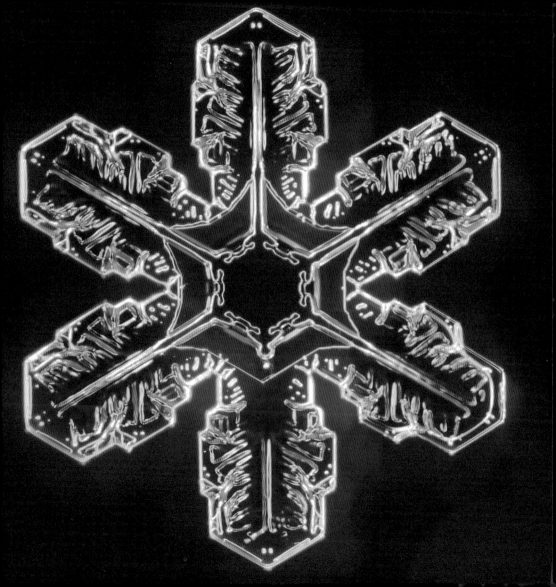

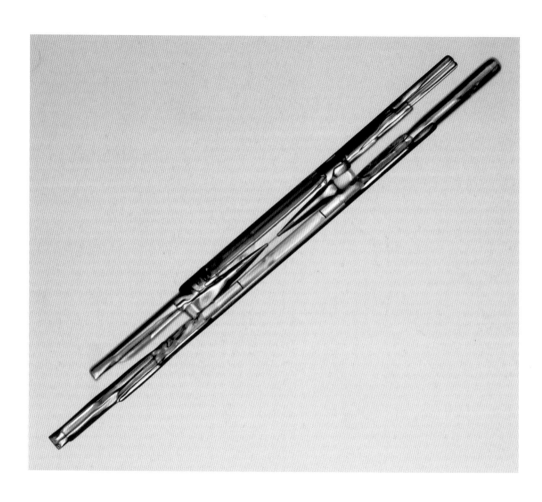

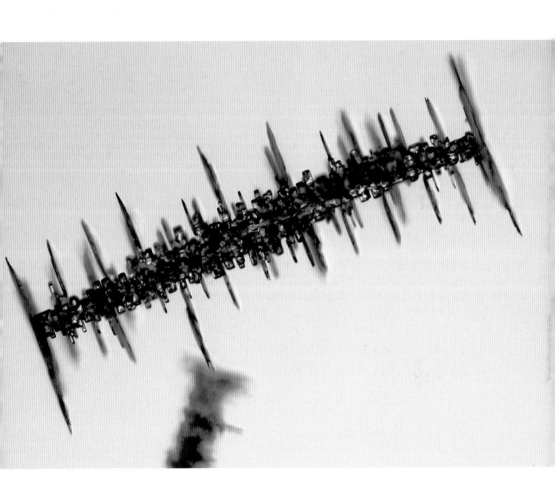

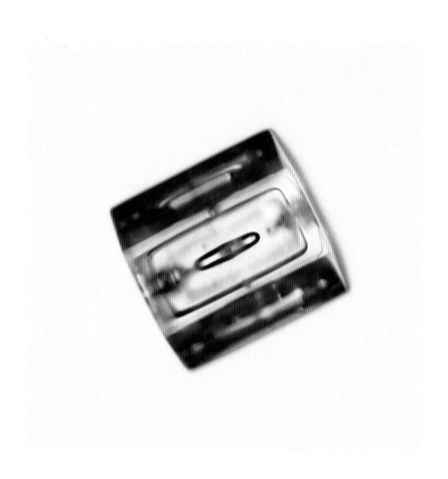

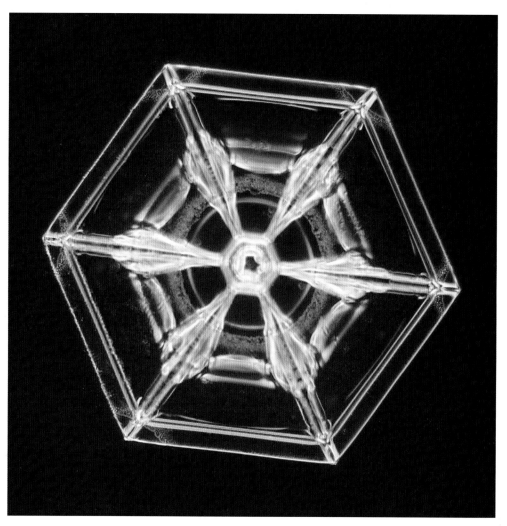

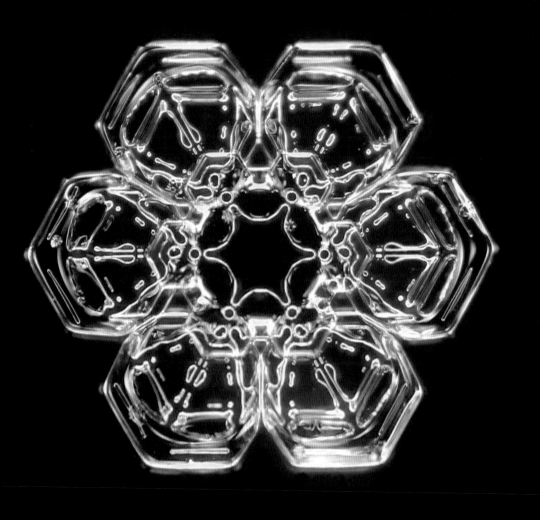

NATURE NEVER HURRIES: ATOM BY ATOM, LITTLE BY LITTLE, SHE ACHIEVES HER WORK.

—Ralph Waldo Emerson (1803–1882)

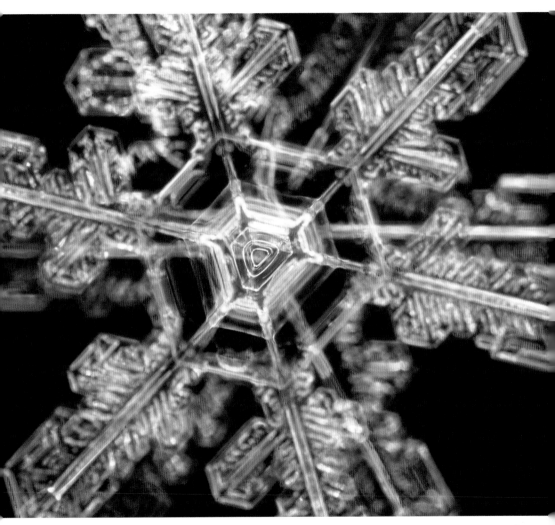

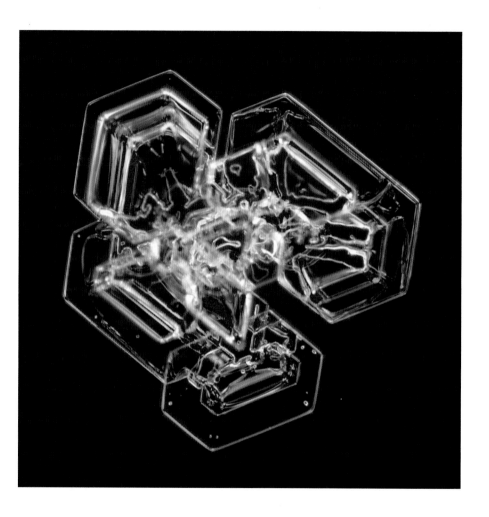

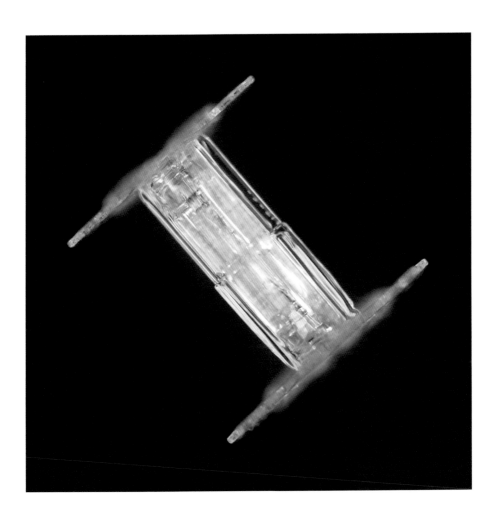

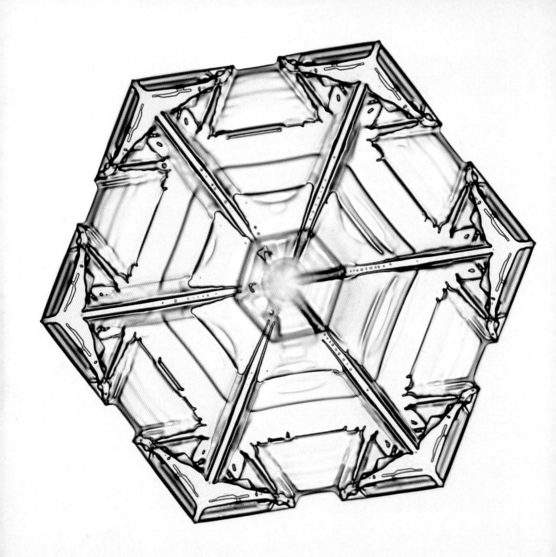

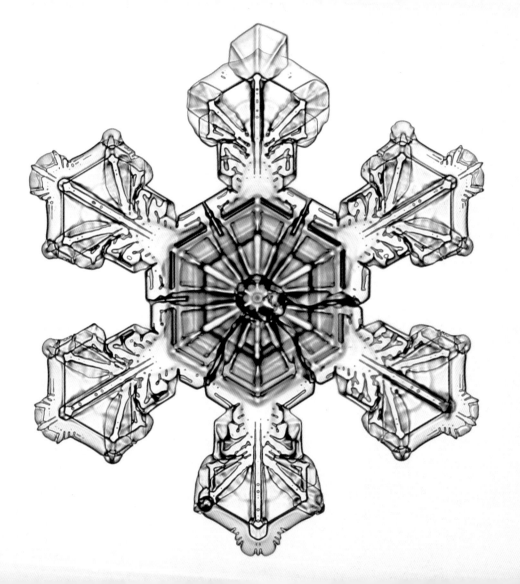

BESIDES COMBINING HER GREATEST SKILL AND ARTISTRY IN THE PRODUCTION OF SNOWFLAKES, NATURE GENEROUSLY FASHIONS THE MOST BEAUTIFUL SPECIMENS ON A VERY THIN PLANE SO THAT THEY ARE SPECIALLY ADAPTED FOR PHOTO-MICROGRAPHICAL STUDY.

—Wilson Bentley (1865–1931)

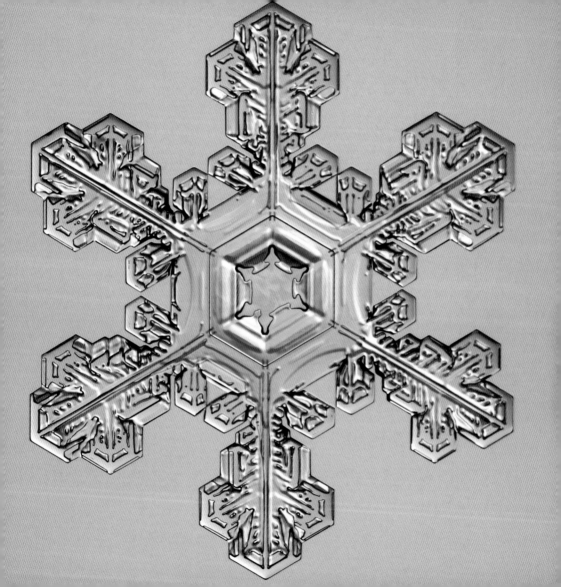

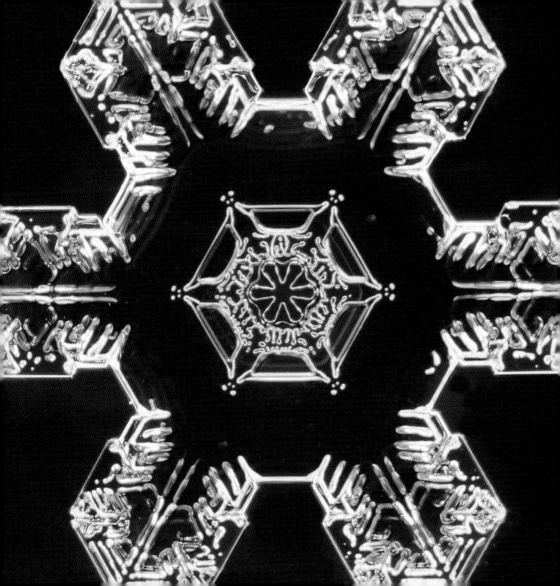

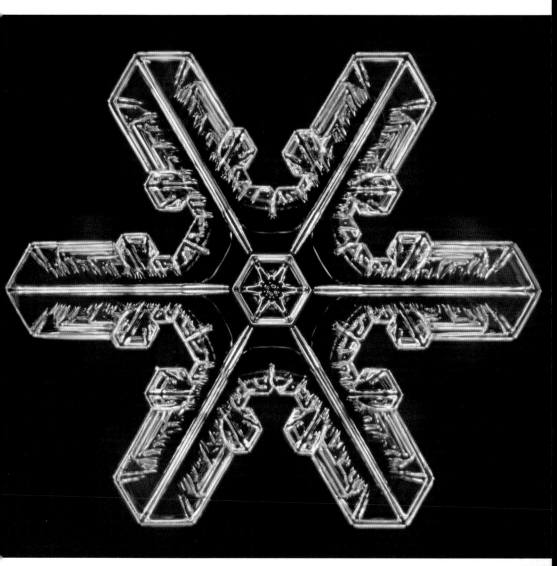

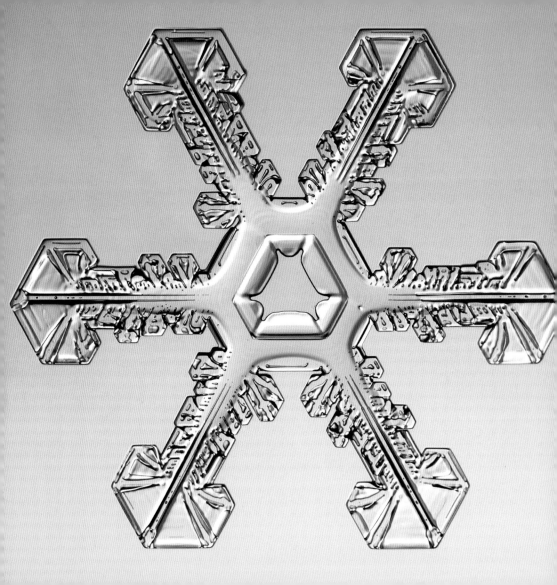

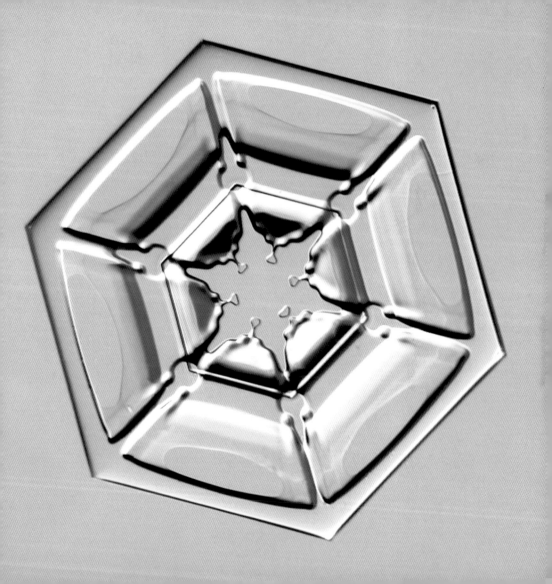

THERE IS NOT A "FRAGMENT" IN ALL NATURE, FOR EVERY RELATIVE FRAGMENT OF ONE THING IS A FULL HARMONIOUS UNIT IN ITSELF.

—John Muir (1838–1914)

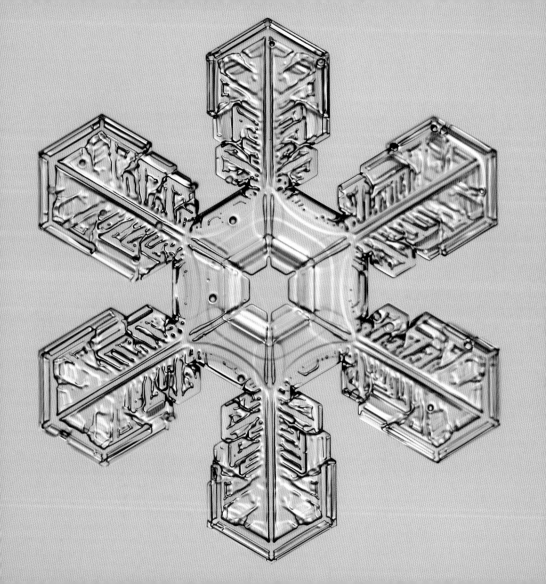

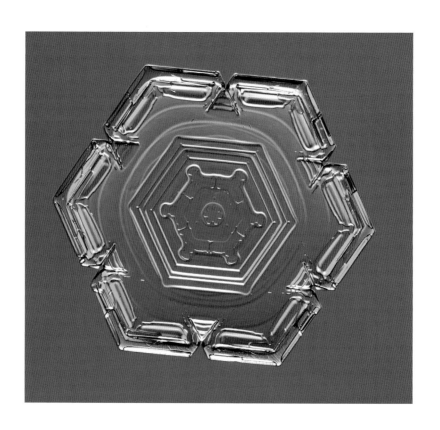

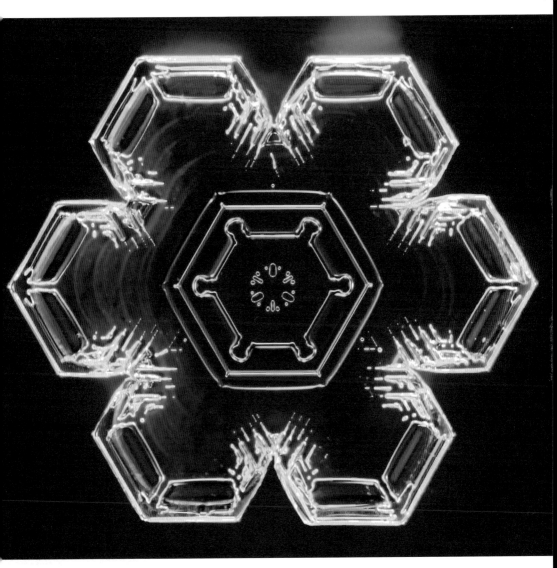

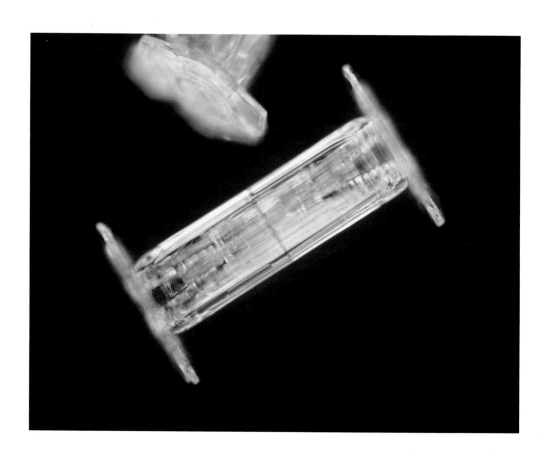

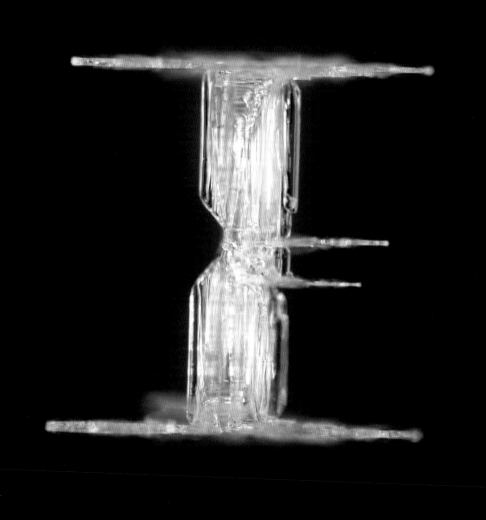

THERE IS A PLEASURE IN THE PATHLESS WOODS,
THERE IS A RAPTURE ON THE LONELY SHORE,
THERE IS A SOCIETY WHERE NONE INTRUDES,
BY THE DEEP SEA AND MUSIC IN ITS ROAR:
I LOVE NOT MAN THE LESS, BUT NATURE MORE.

—Lord Byron (1788–1824)

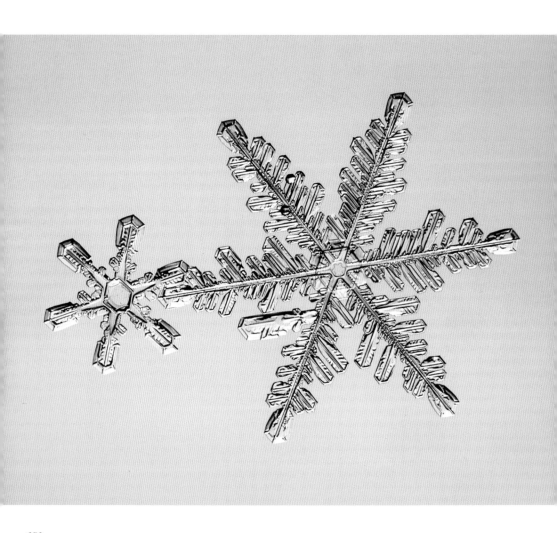

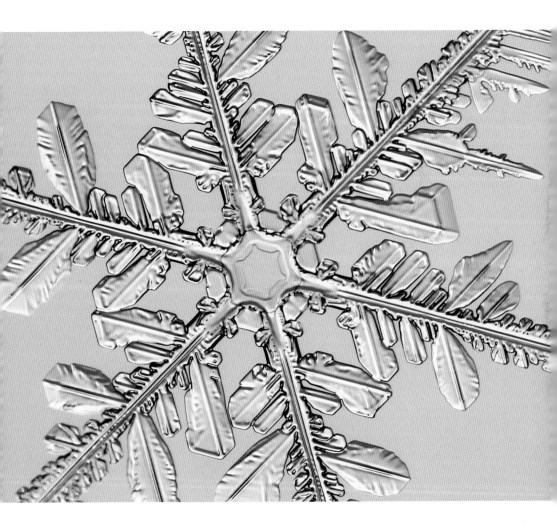

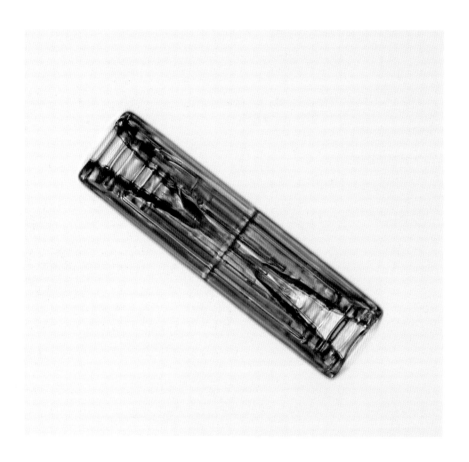

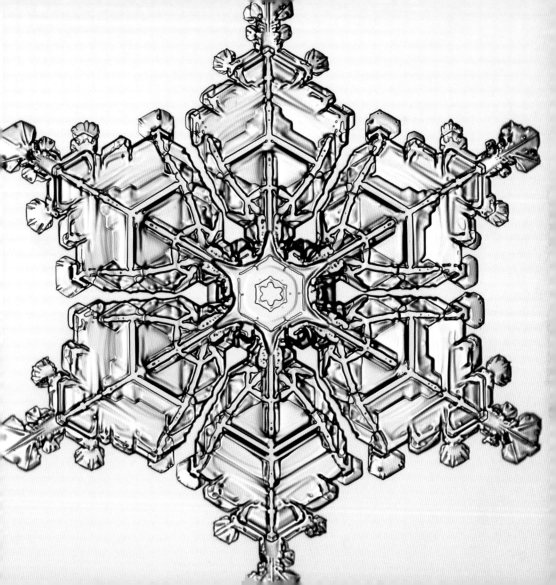

\mathcal{N}O SNOWFLAKE EVER FALLS IN THE WRONG PLACE.

—Zen Proverb

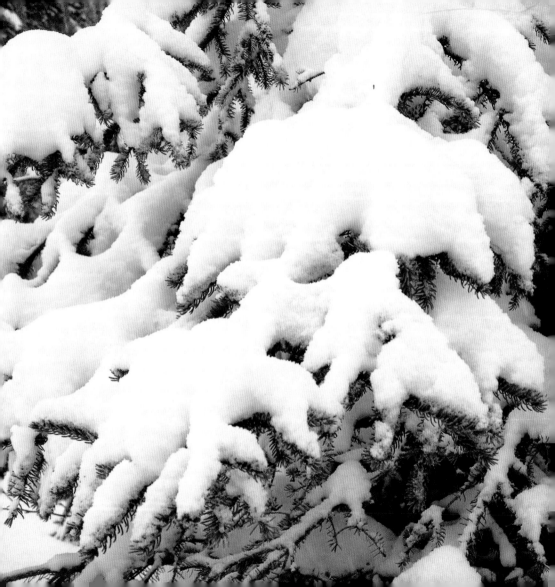

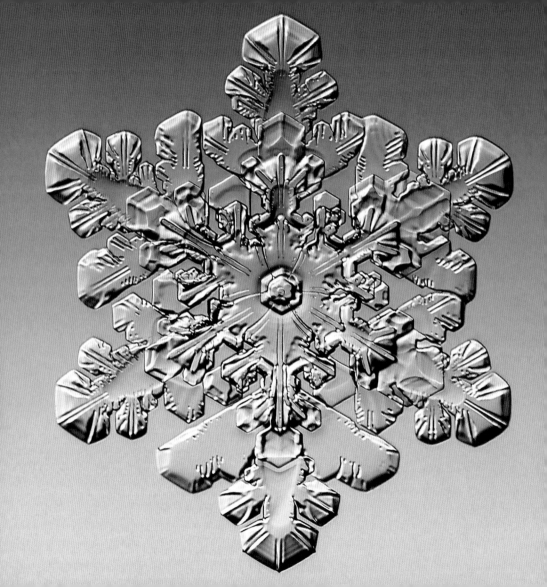

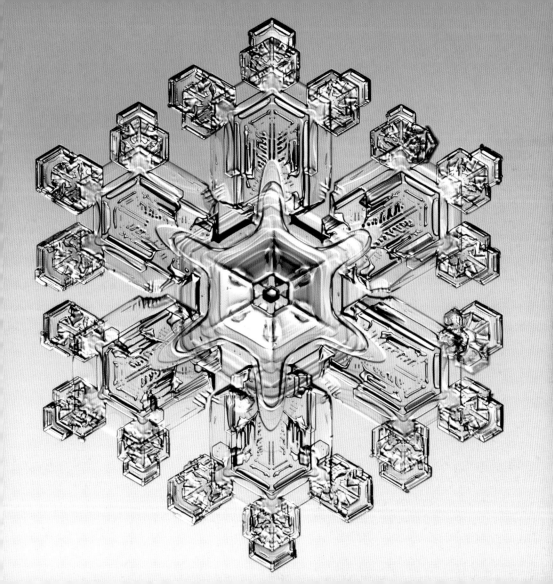

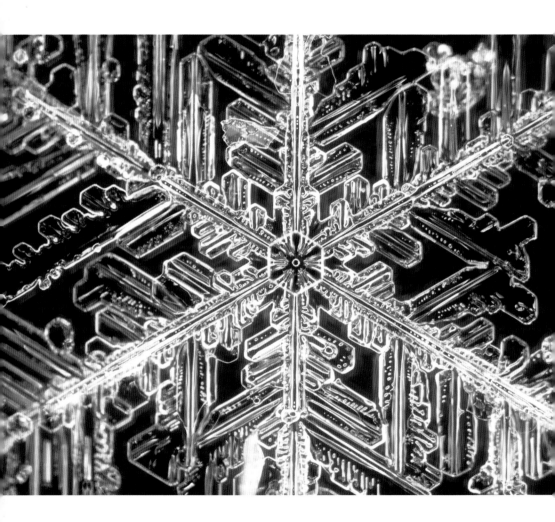

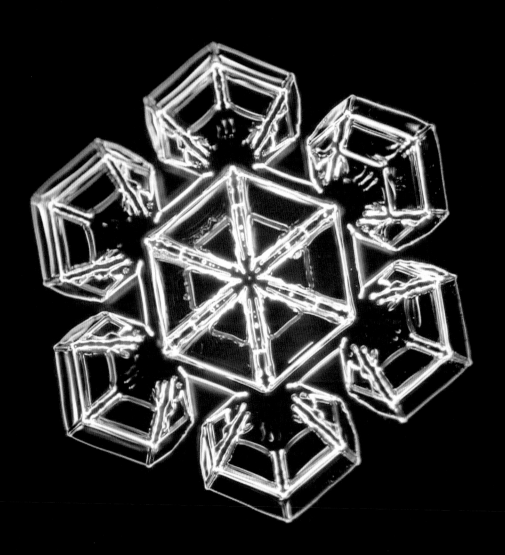

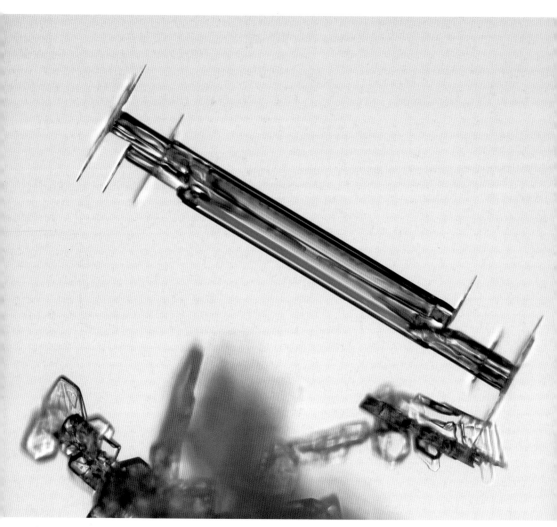

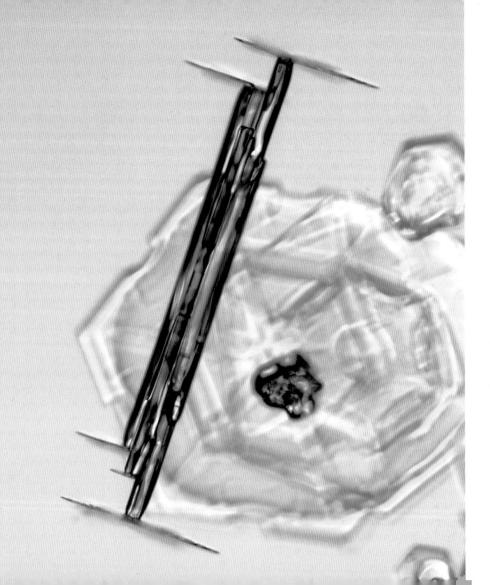

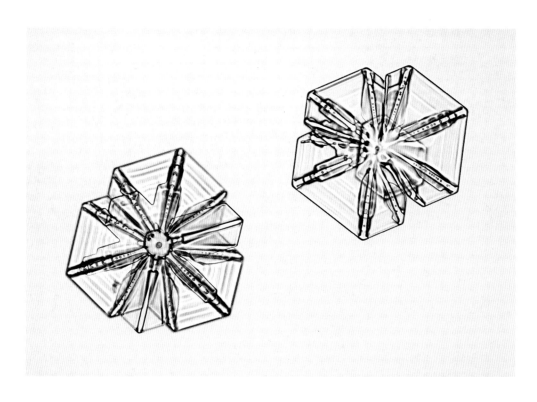

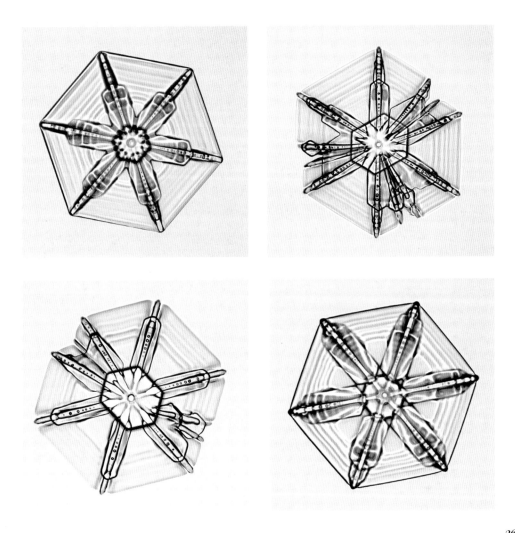

\mathcal{L}IKE SNOWFLAKES, THE HUMAN PATTERN IS NEVER CAST TWICE. WE ARE UNCOMMONLY AND MARVELOUSLY INTRICATE IN THOUGHT AND ACTION, OUR PROBLEMS ARE MOST COMPLEX AND, TOO OFTEN, SILENTLY BORNE.

—Alice Childress (1920–1994)

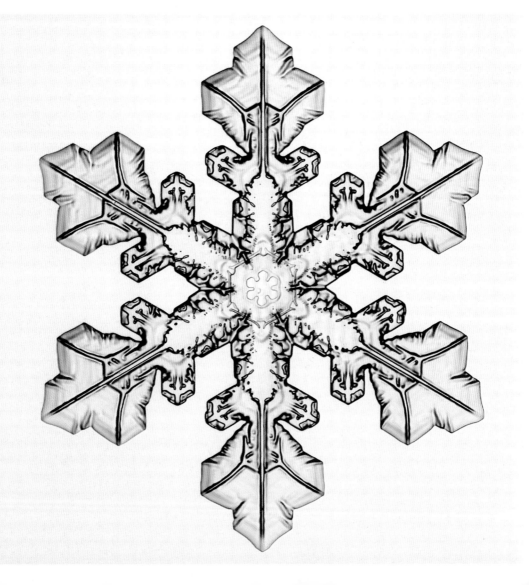

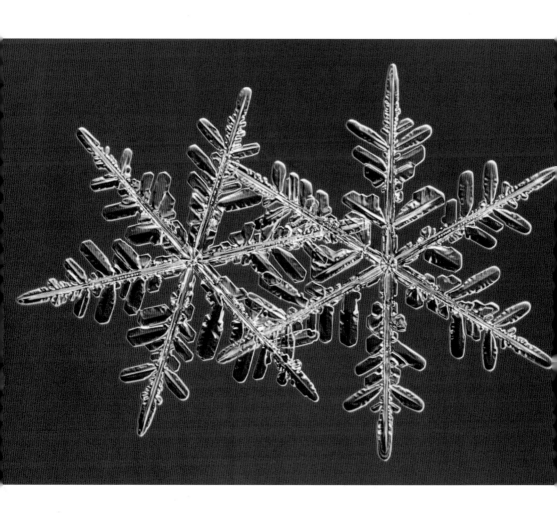

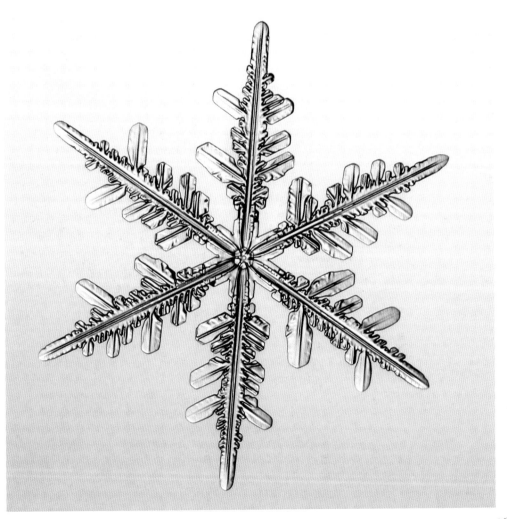

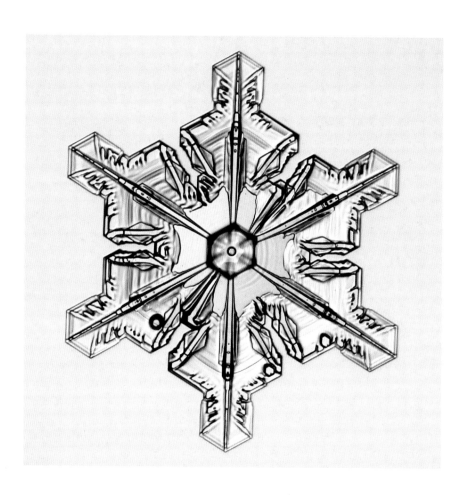

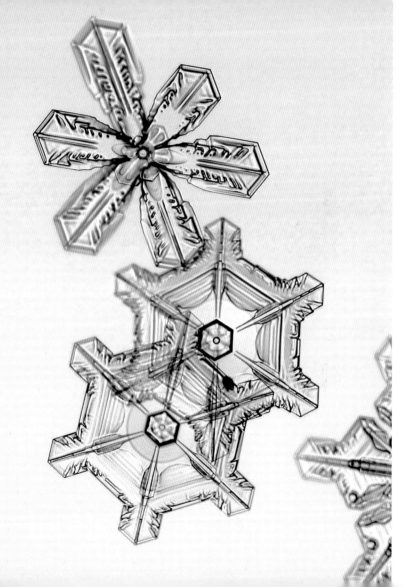

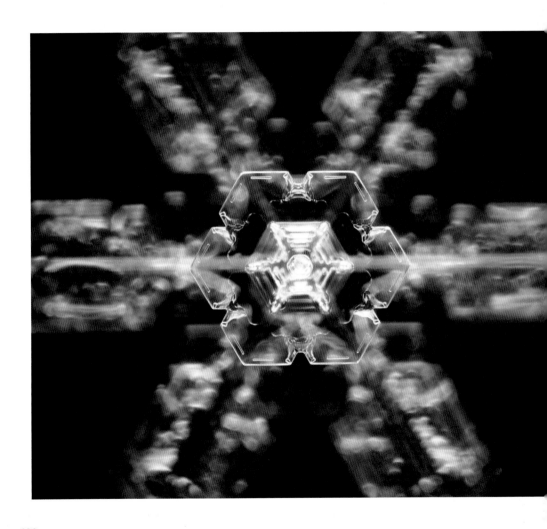

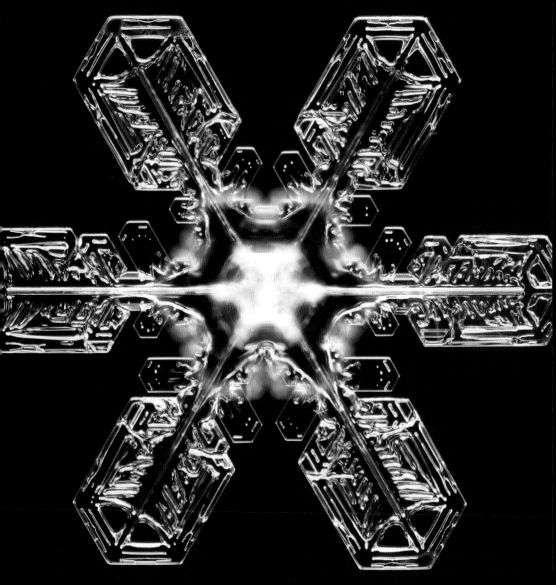

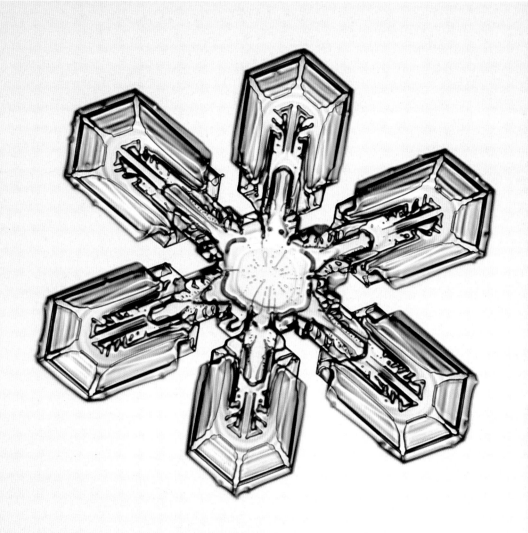

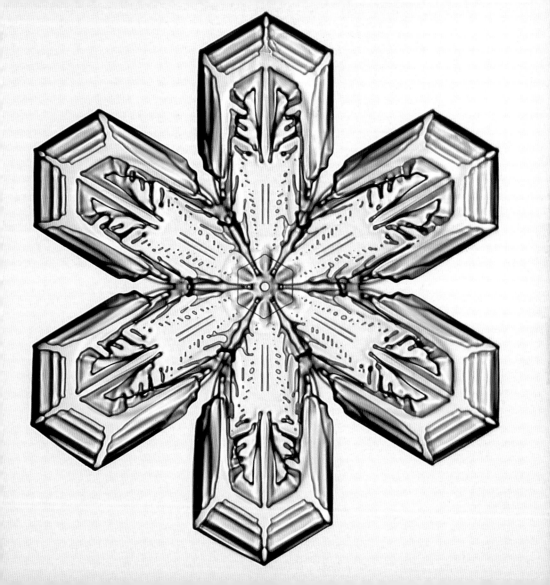

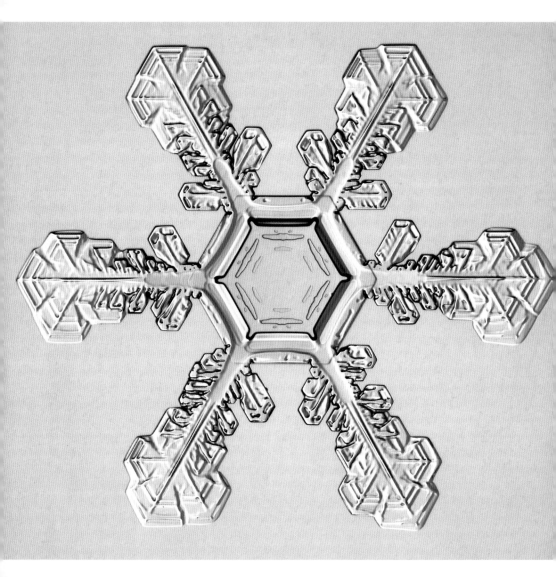

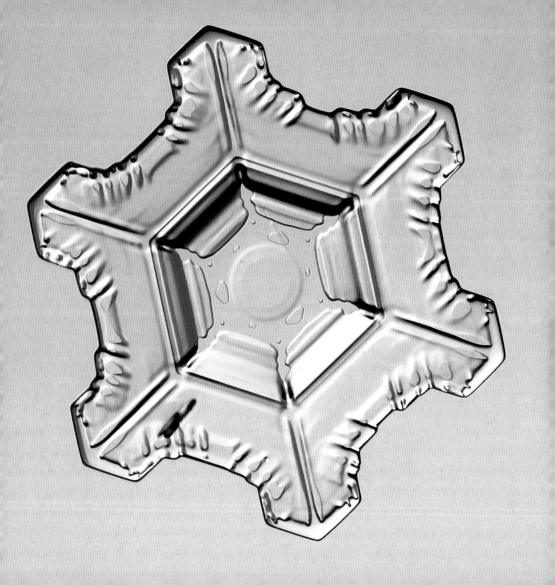

Nature is ever at work building and pulling down, creating and destroying, keeping everything whirling and flowing, allowing no rest but in rhythmical motion, chasing everything in endless song out of one beautiful form into another.

—John Muir (1838–1914)

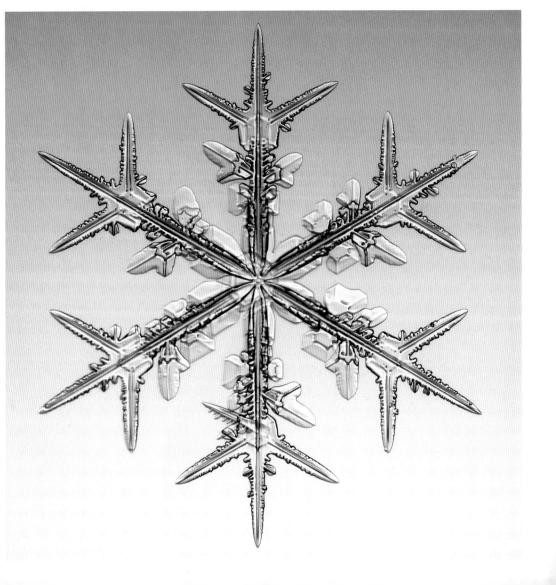

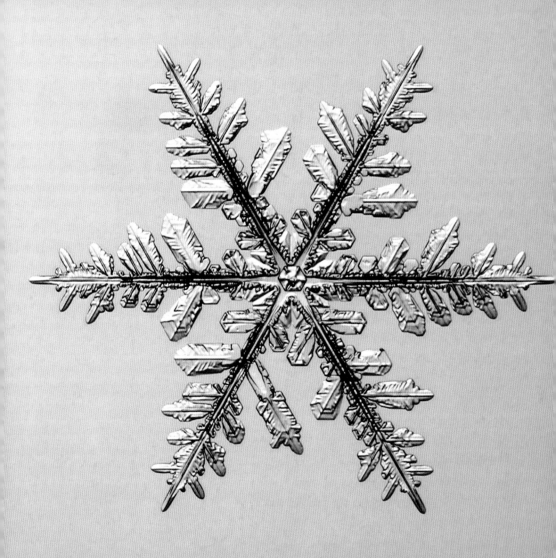

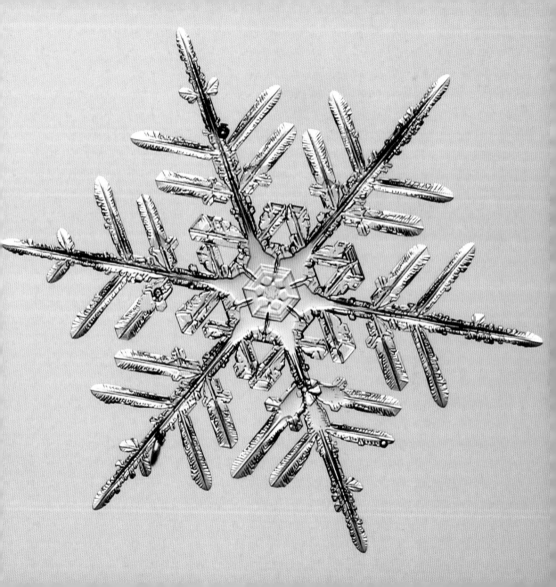

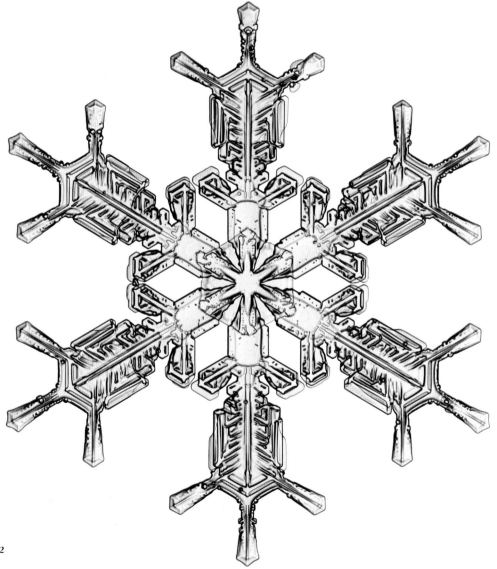

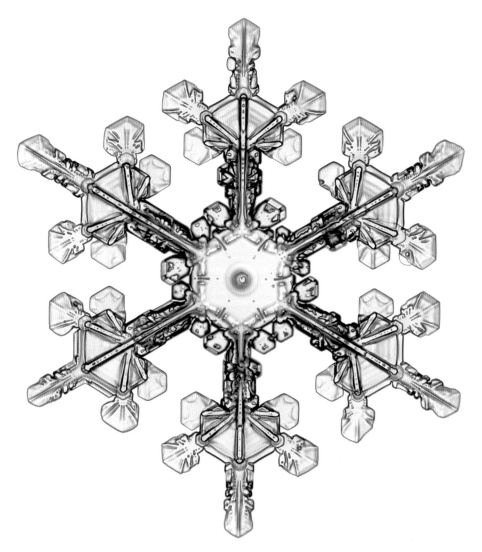

283

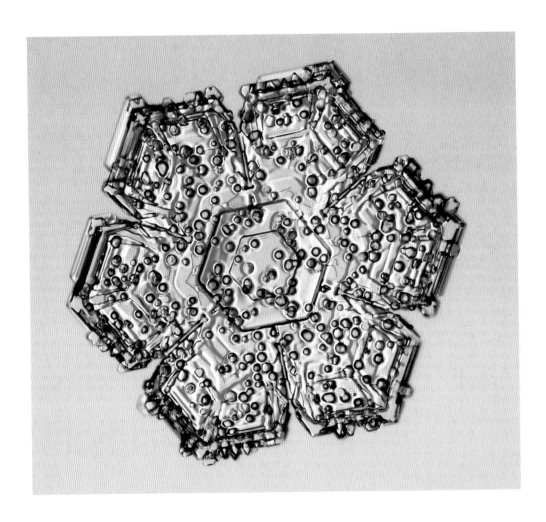

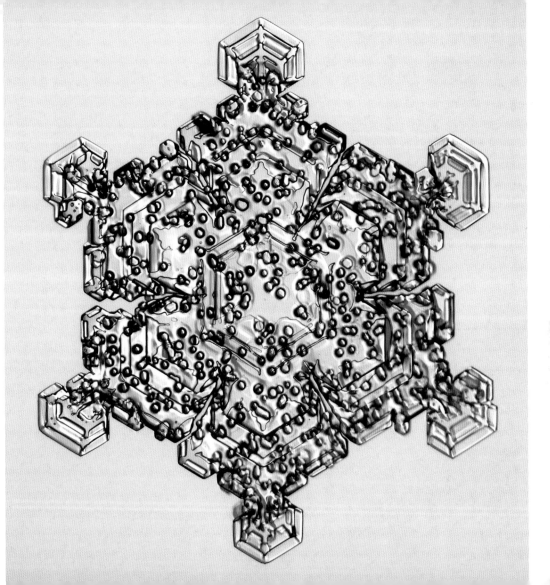

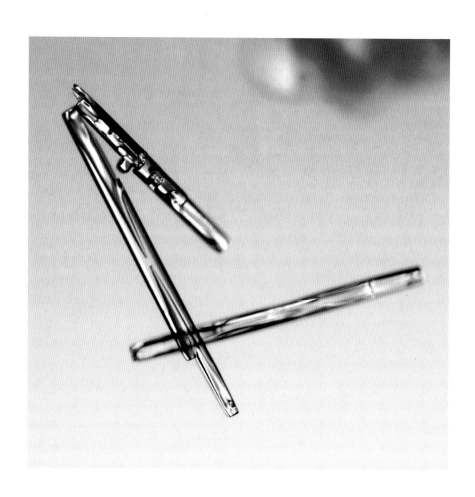

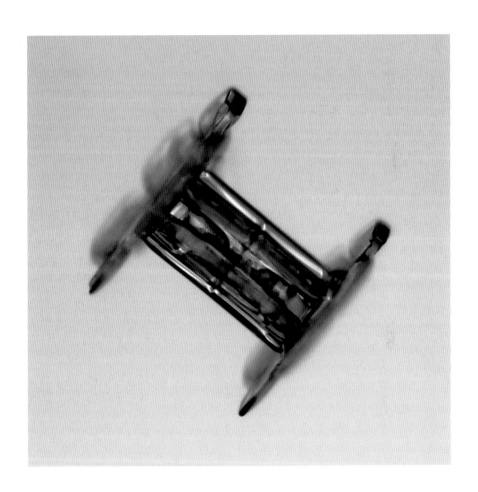

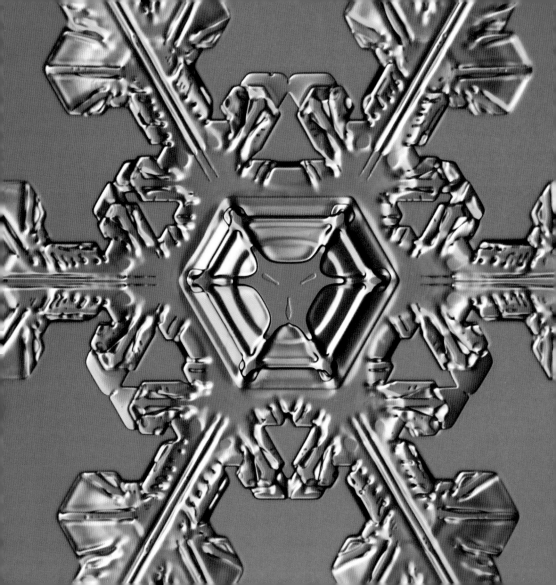

THE BEAUTY OF A SNOW-CRYSTAL DEPENDS ON ITS MATH-EMATICAL REGULARITY AND SYMMETRY; BUT SOMEHOW THE ASSOCIATION OF MANY VARIANTS OF A SINGLE TYPE, ALL RELATED BUT NO TWO THE SAME, VASTLY INCREASES OUR PLEASURE AND ADMIRATION . . . THE SNOW-CRYSTAL IS FURTHER COMPLICATED, AND ITS BEAUTY IS NOTABLY ENHANCED, BY MINUTE OCCLUDED BUBBLES OF AIR OR DROPS OF WATER, WHOSE SYMMETRICAL FORM AND ARRANGEMENT ARE VERY CURIOUS AND NOT ALWAYS EASY TO EXPLAIN. LASTLY WE ARE APT TO SEE OUR SNOW CRYSTALS AFTER A SLIGHT THAW HAS ROUNDED THEIR EDGES, AND HAS HEIGHTENED THEIR BEAUTY BY SOFTENING THEIR CONTOURS.

—D'Arcy Wentworth Thompson (1860–1948)

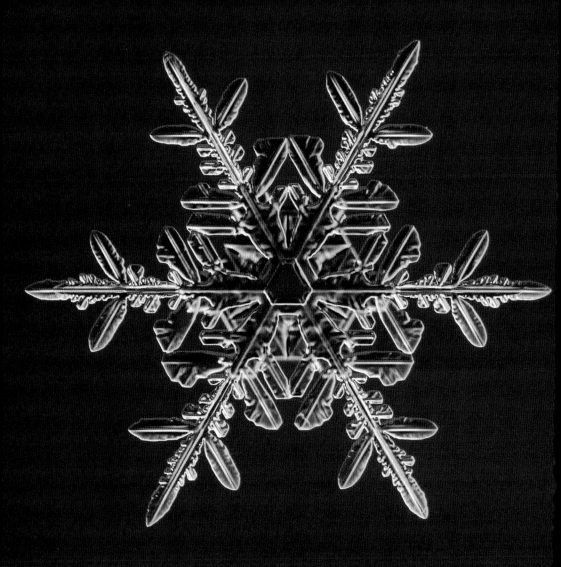

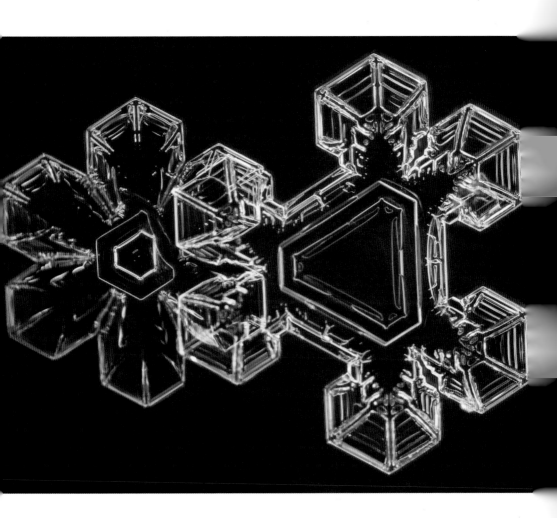

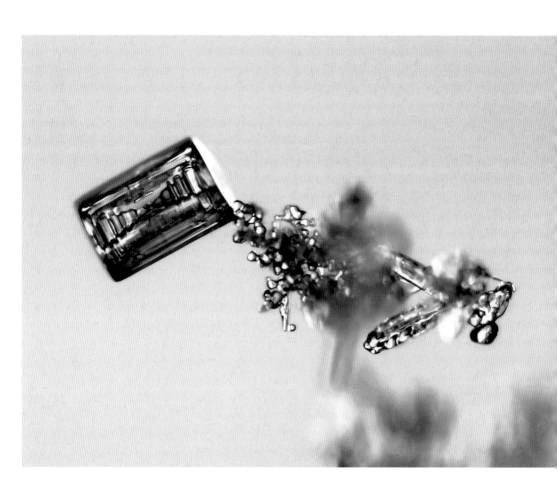

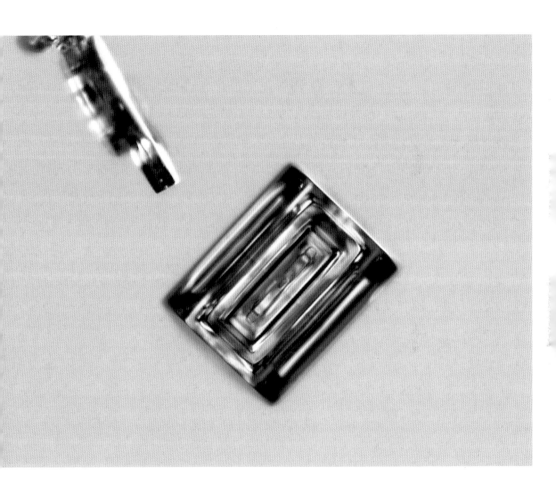

MY ATTENTION WAS CAUGHT BY A SNOWFLAKE ON MY COAT-SLEEVE. IT WAS ONE OF THOSE PERFECT LITTLE PINE TREES IN SHAPE, ARRANGED AROUND A CENTRAL SPANGLE. THIS LITTLE OBJECT, WHICH, WITH MANY OF ITS FELLOWS, RESTED UNMELTING ON MY COAT, SO PERFECT AND BEAUTIFUL, REMINDED ME THAT NATURE HAD NOT LOST HER PRISTINE VIGOR YET, AND WHY SHOULD MAN LOSE HEART?

—Henry David Thoreau (1817–1862)

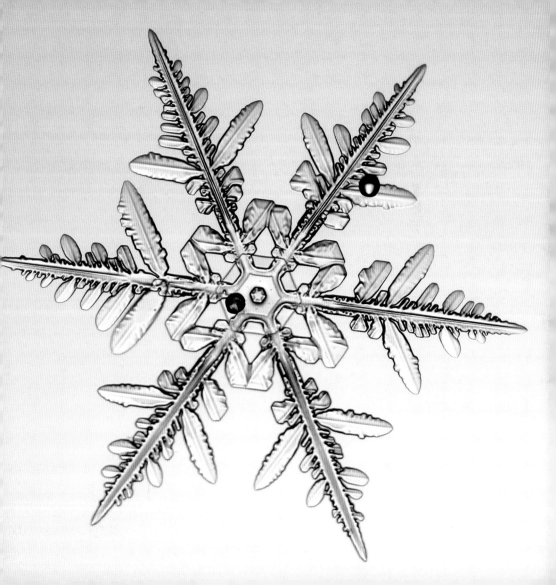

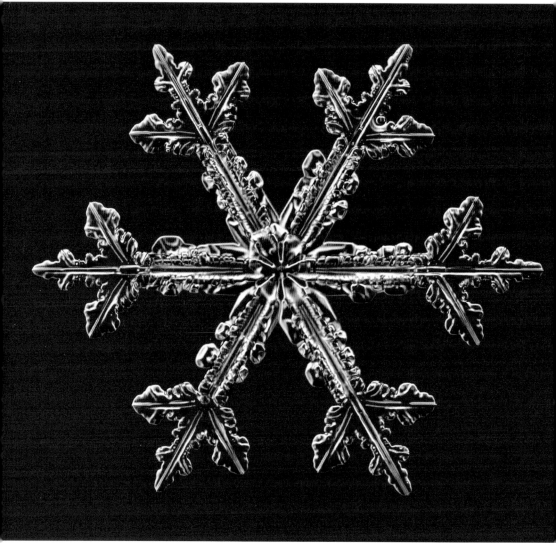

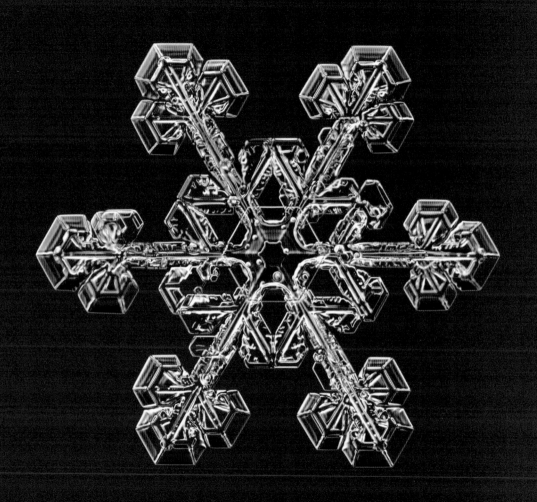

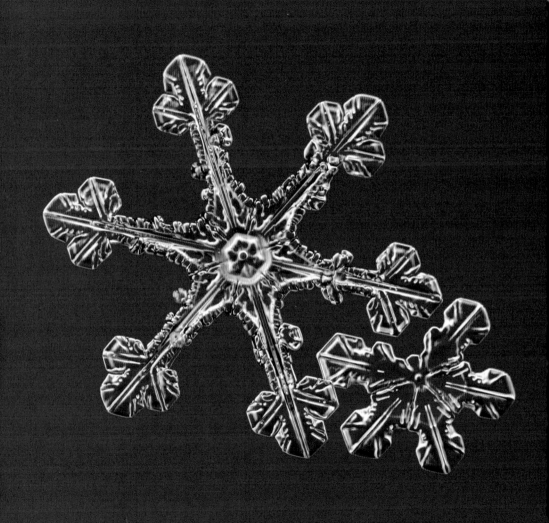

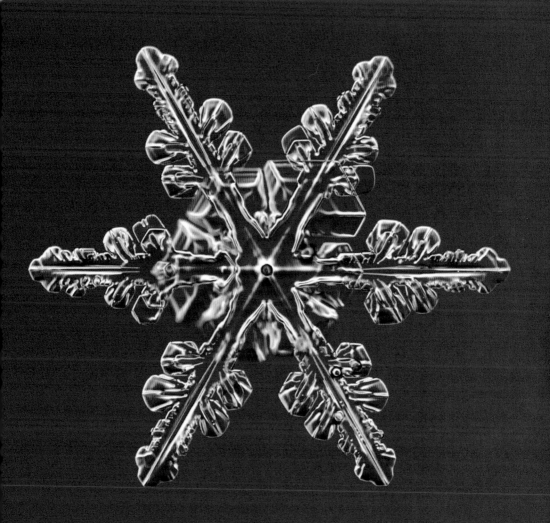

SIMPLE PLEASURES ARE THE LAST HEALTHY REFUGE IN A COMPLEX WORLD.

—Oscar Wilde (1854–1900)

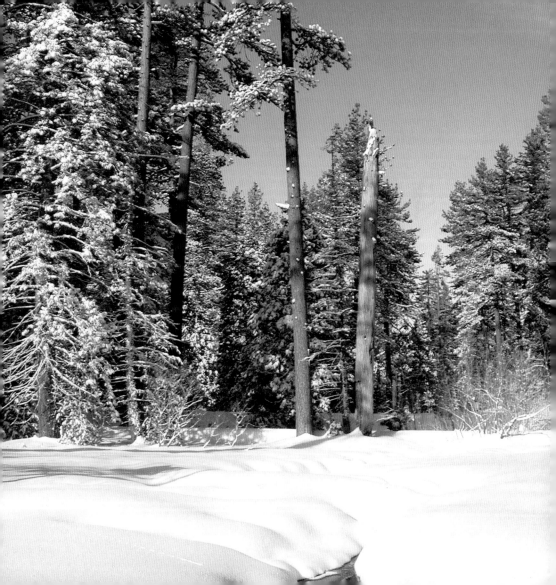

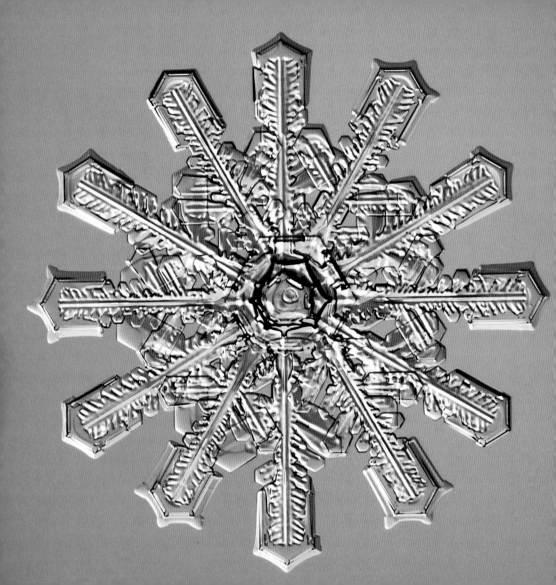

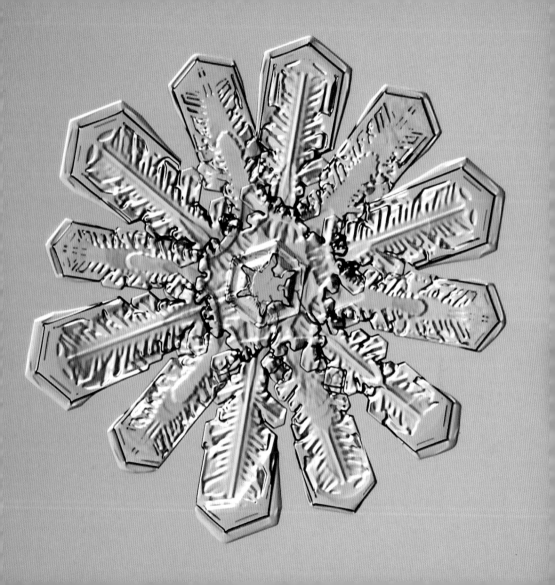

LIKE A GREAT POET, NATURE KNOWS HOW TO PRODUCE THE GREATEST EFFECTS WITH THE MOST LIMITED MEANS.

—Heinrich Heine (1797–1856)

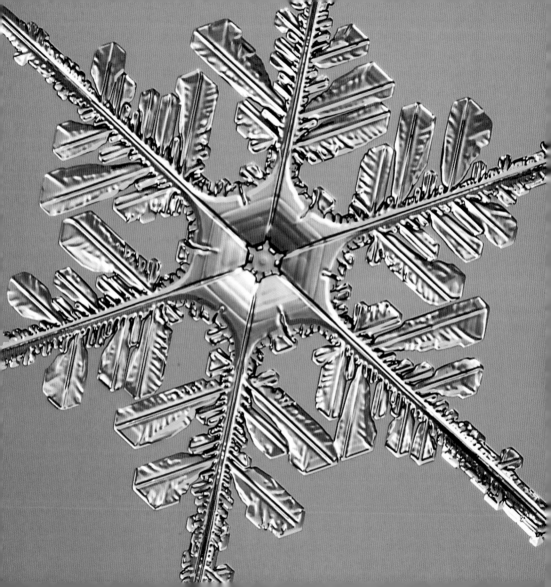

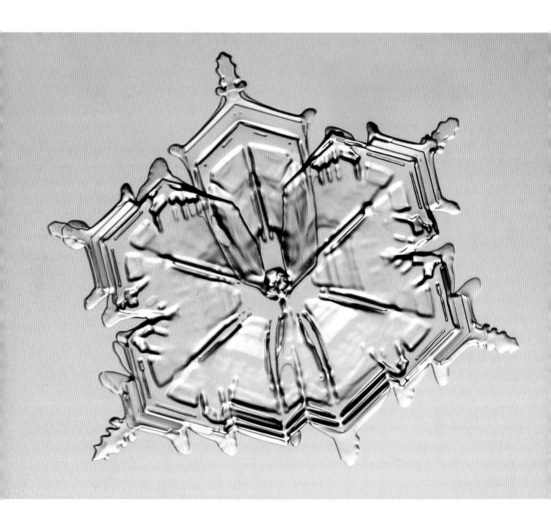

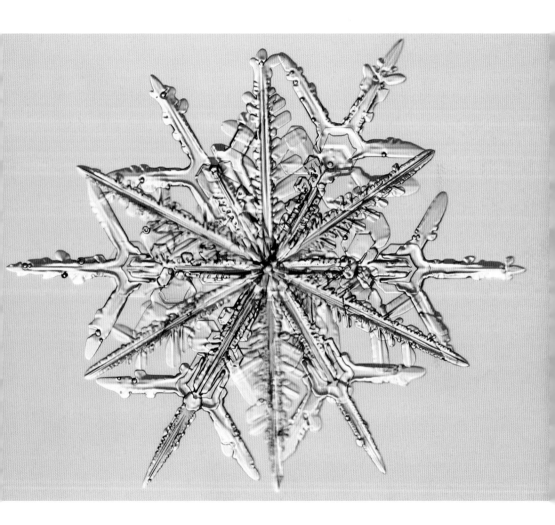

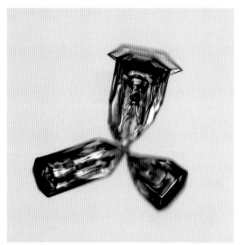
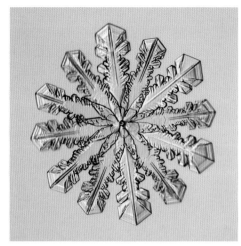
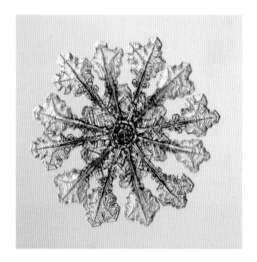
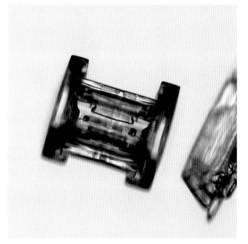

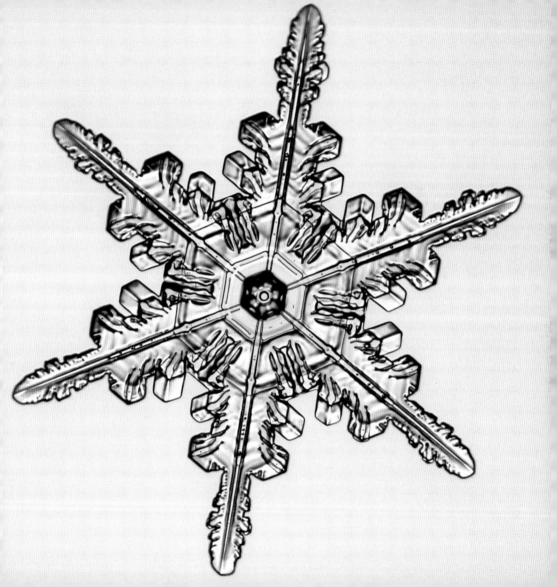

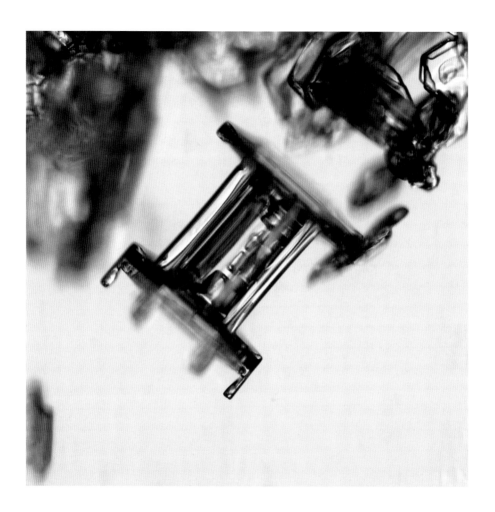

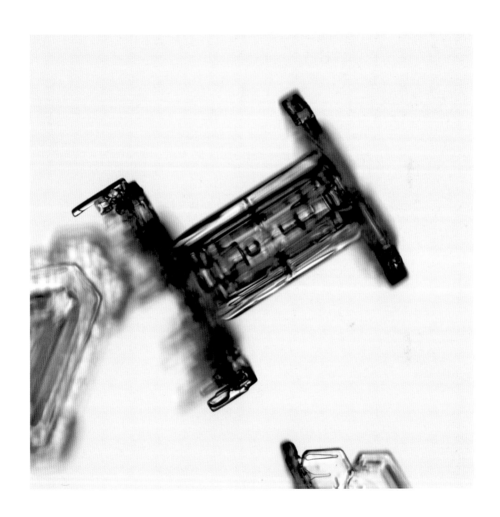

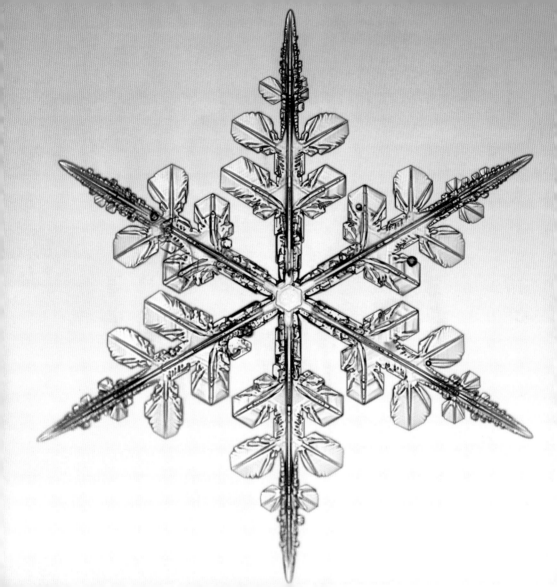

Before I melt,
Come look at me!
This lovely, icy filagree!
Of a great forest
In one night
I make a wilderness
Of white:
By skyey cold
Of crystals made,
All softly, on
Your finger laid,
I pause, that you
My beauty see:
Breathe, and I vanish
Instantly.

—Walter de la Mare (1873–1956)

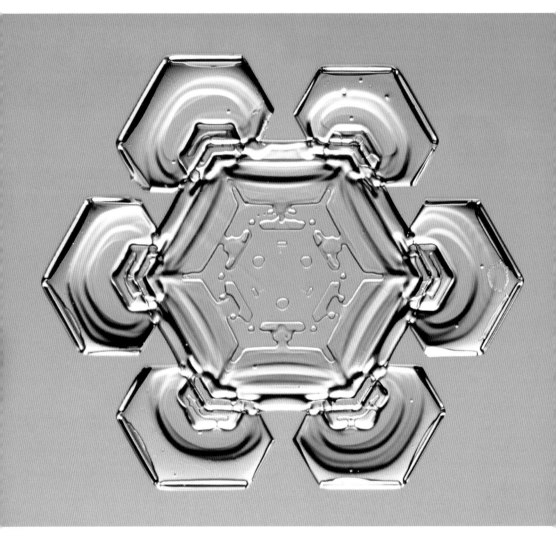

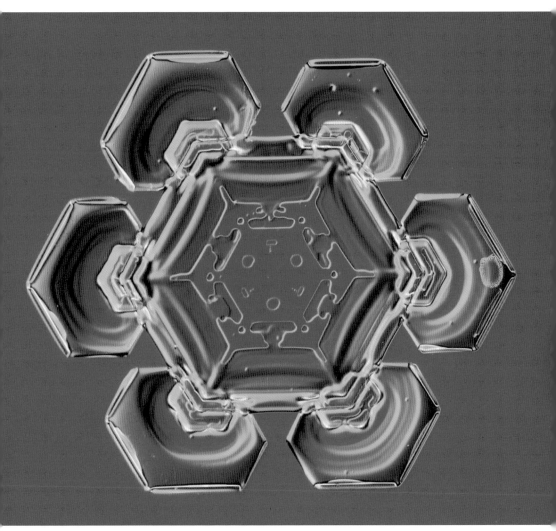

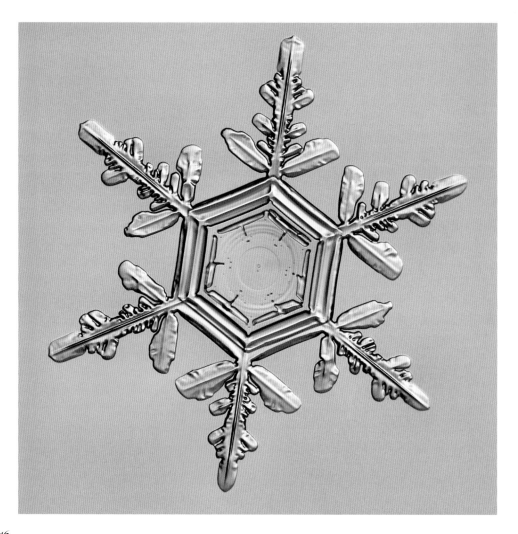

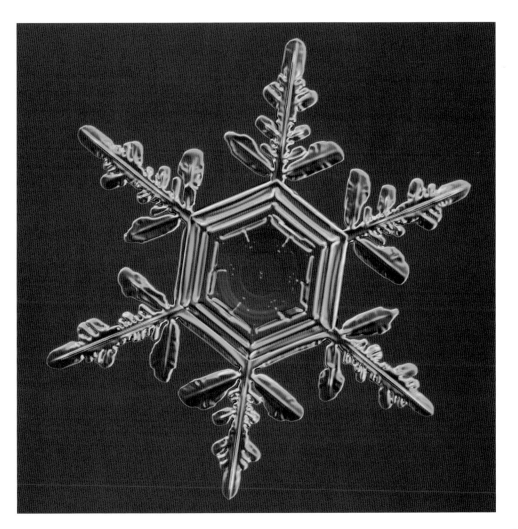

\mathcal{W}HEN THE TEMPERATURE OF THE AIR IS WITHIN A DEGREE OR TWO OF THE FREEZING POINT, AND MUCH SNOW FALLS, IT FREQUENTLY CONSISTS OF LARGE IRREGULAR FLAKES . . . BUT IN SEVERE FROSTS . . . THE MOST REGULAR AND BEAUTIFUL FORMS ARE ALWAYS SEEN FLOATING IN THE AIR, AND SPARKLING IN THE SUN-BEAMS; AND THE SNOW WHICH FALLS IN GENERAL IS OF THE MOST ELEGANT TEXTURE AND APPEARANCE.

—William Scoresby (1760–1829)

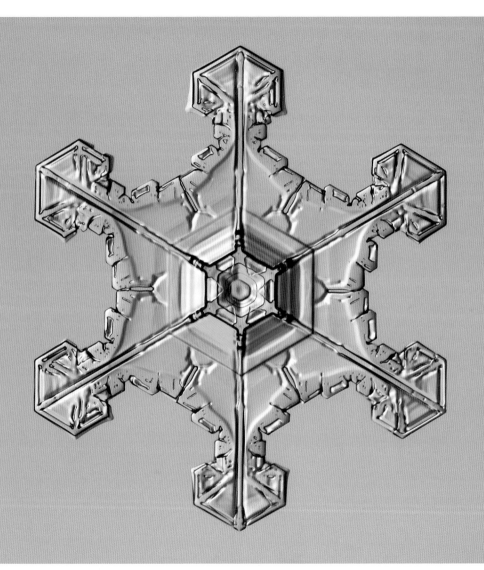

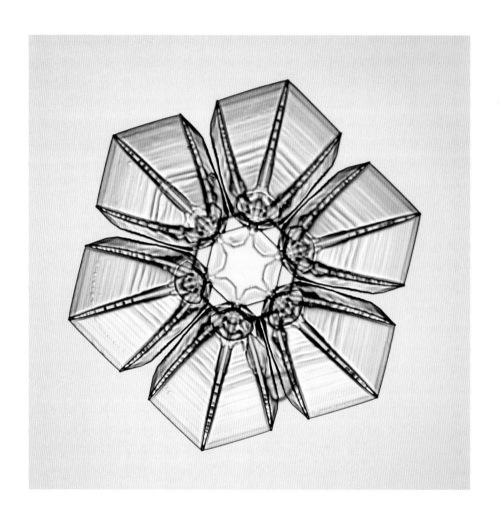

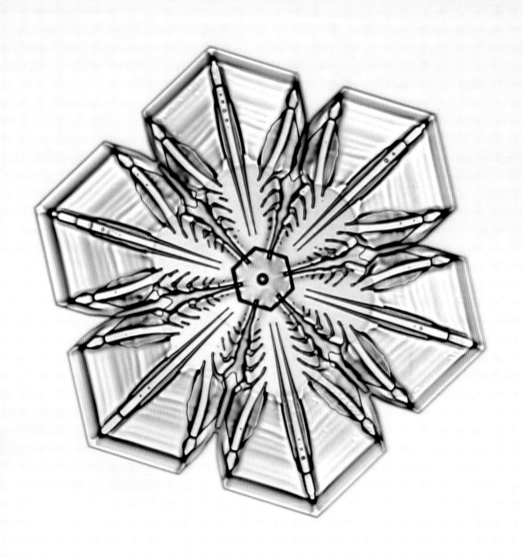

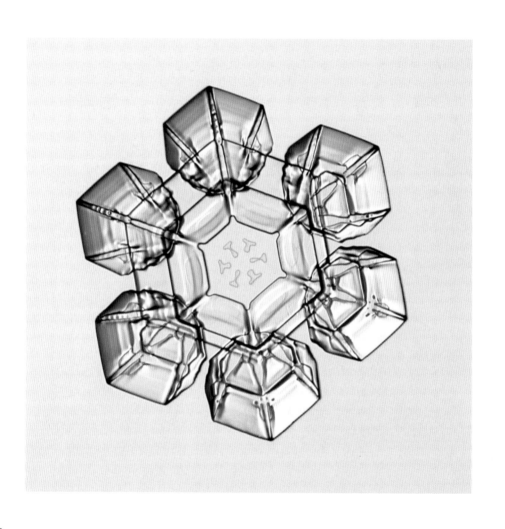

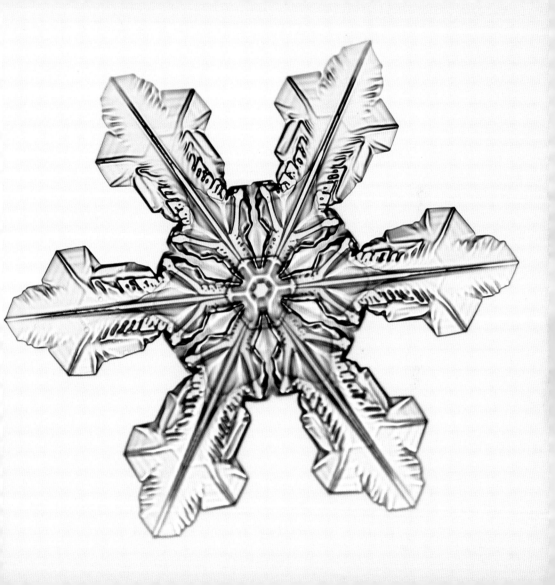

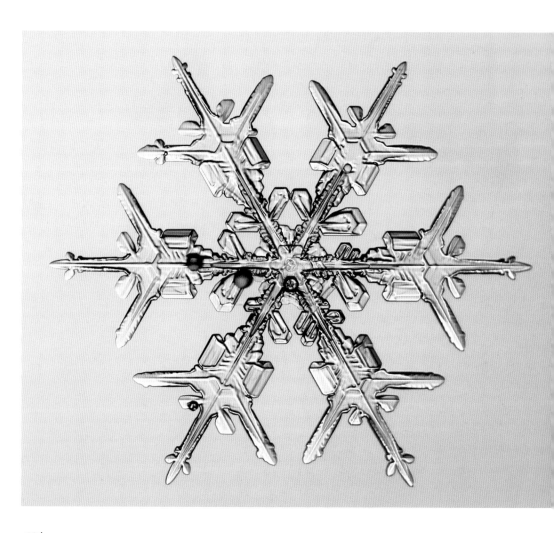

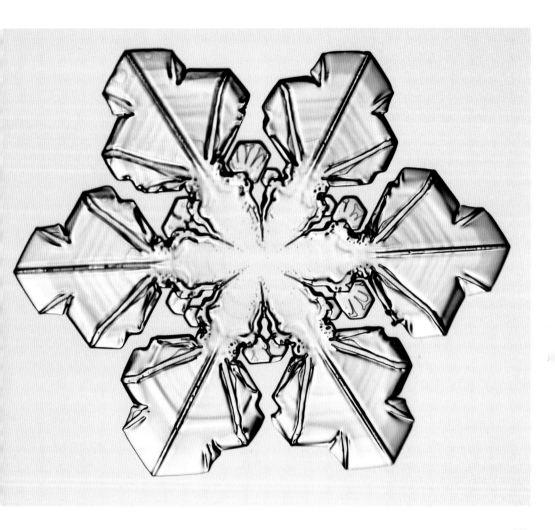

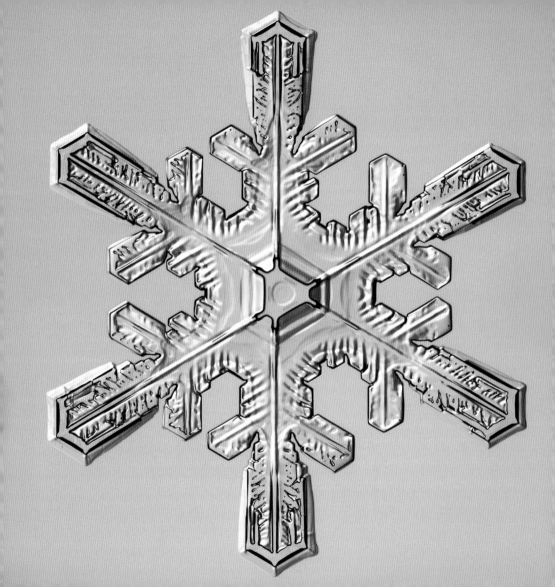

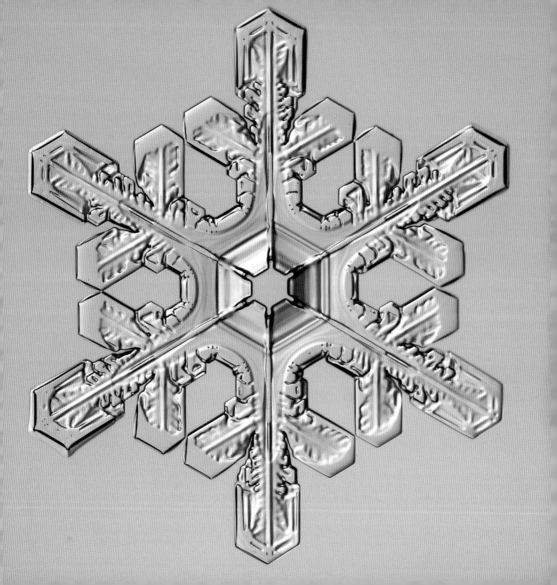

\mathcal{N}ATURE WILL BEAR THE CLOSEST INSPECTION. SHE INVITES US TO LAY OUR EYE LEVEL WITH HER SMALLEST LEAF, AND TAKE AN INSECT VIEW OF ITS PLAIN.

— Henry David Thoreau (1817–1862)

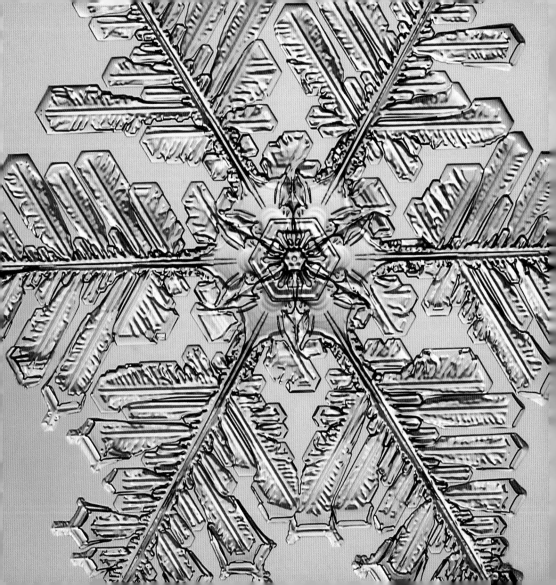

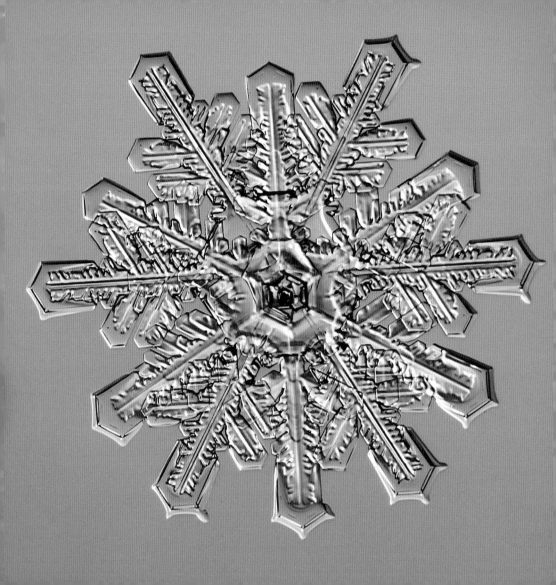

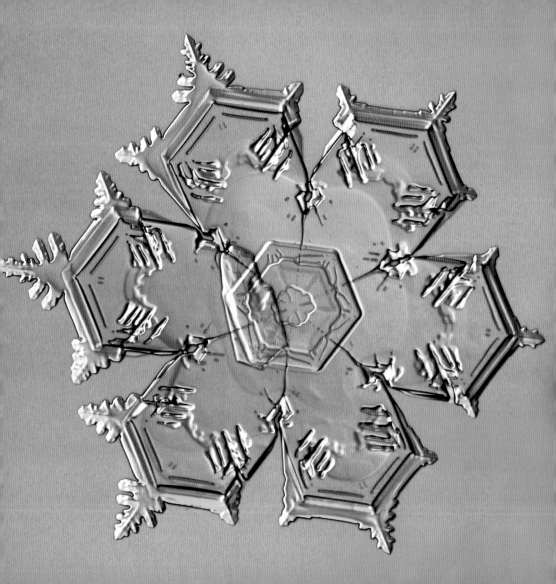

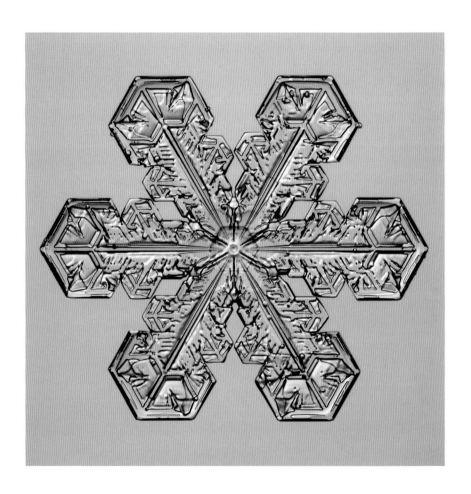

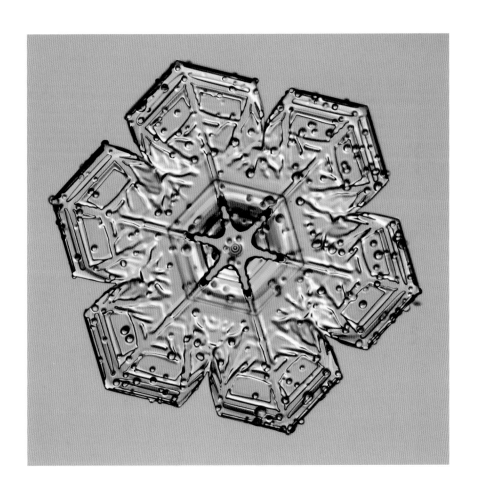

\mathcal{N}OT WHAT WE HAVE, BUT WHAT WE ENJOY, CONSTITUTES OUR ABUNDANCE.

—Jean Antoine Petit-Senn (1792–1870)

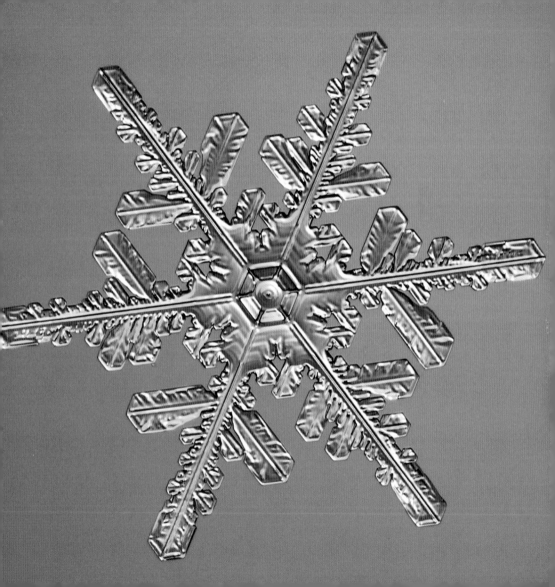

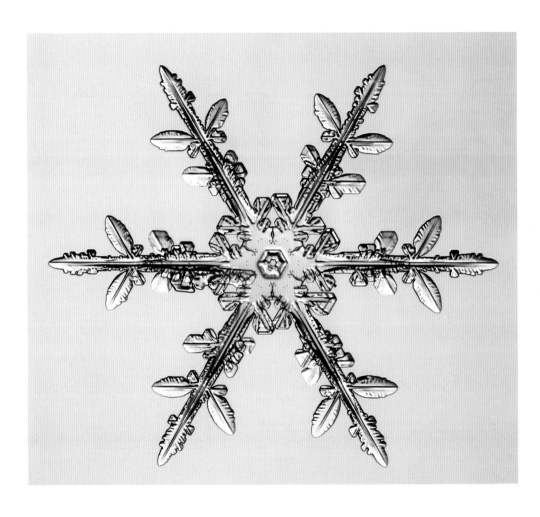

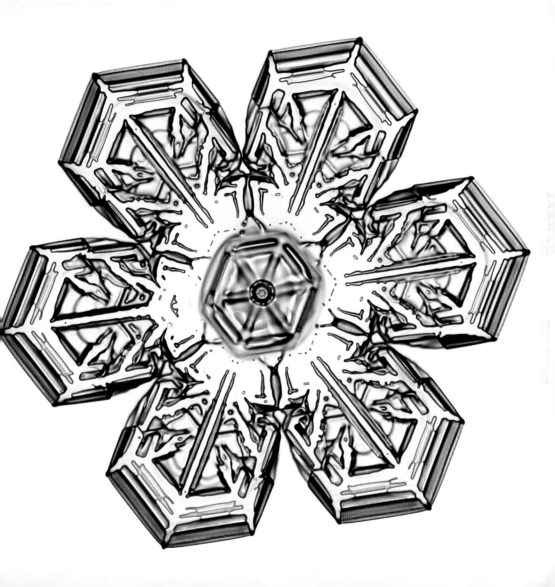

When men were all asleep the snow came flying,
In large white flakes falling on the city brown,
Stealthily and perpetually settling and loosely lying,
Hushing the latest traffic of the drowsy town.

—Robert Bridges (1844–1930)

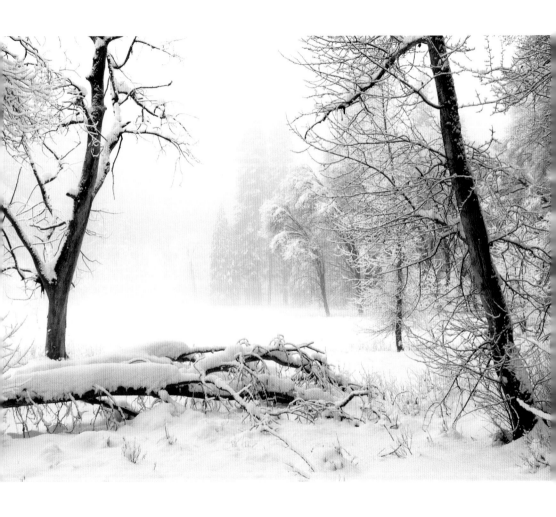

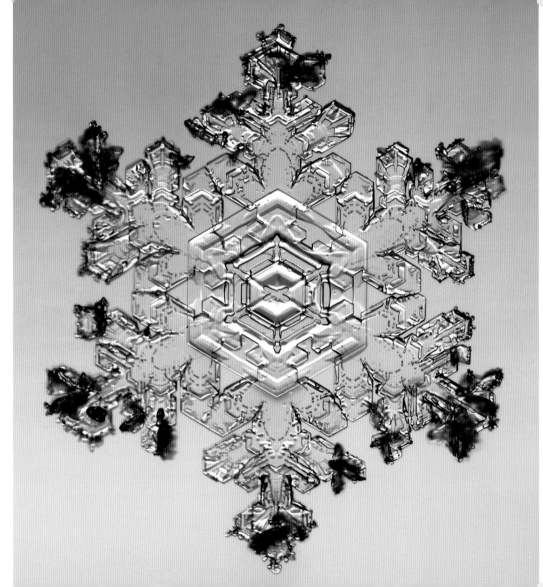

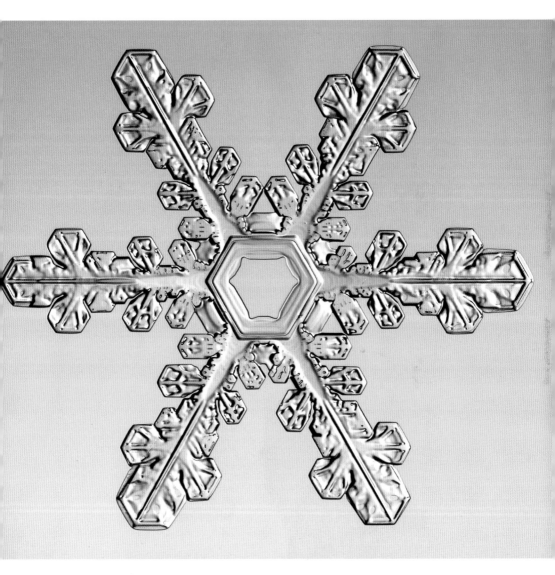

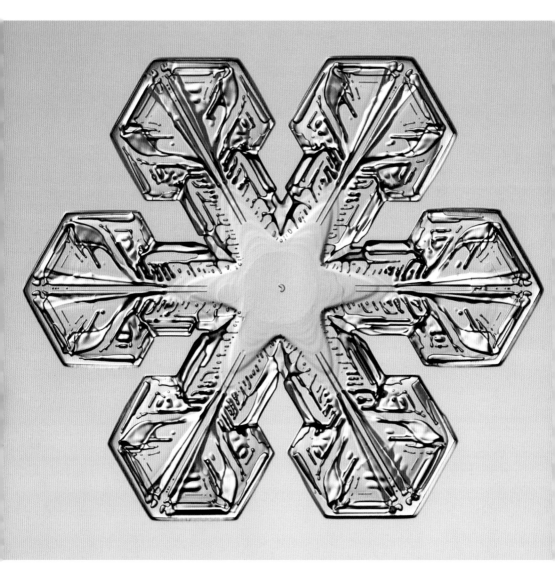

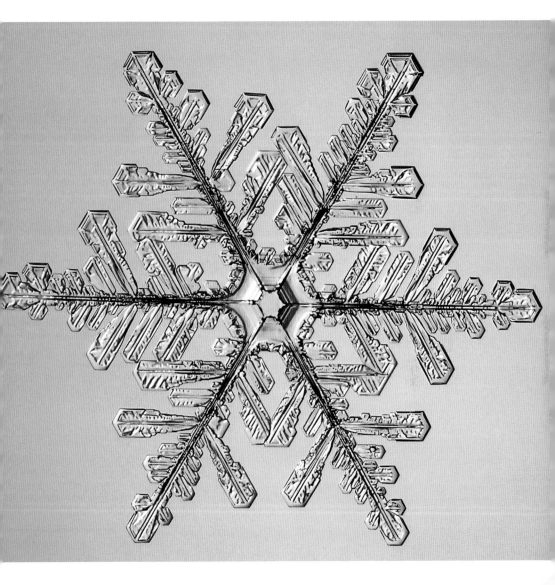

If the Lord Almighty had consulted me before embarking on Creation, I should have recommended something simpler.

—Alphonso the Wise (1221–1289)

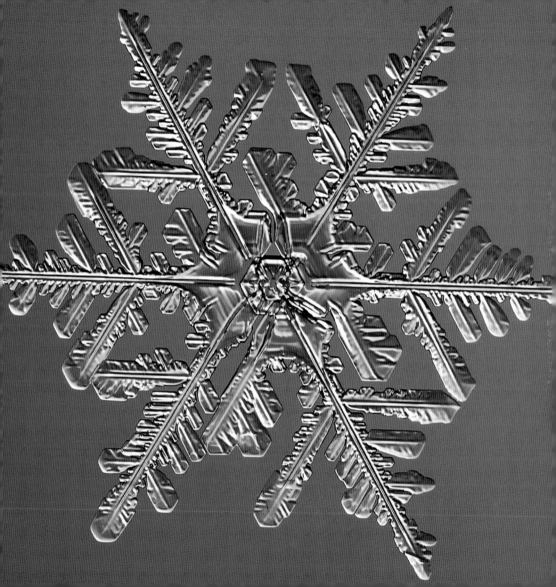

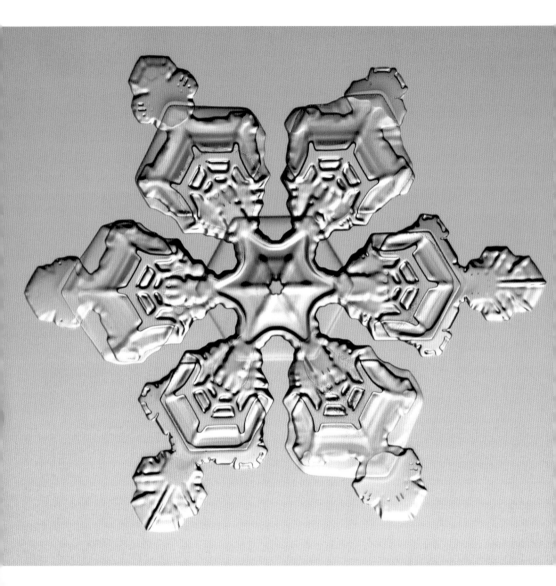

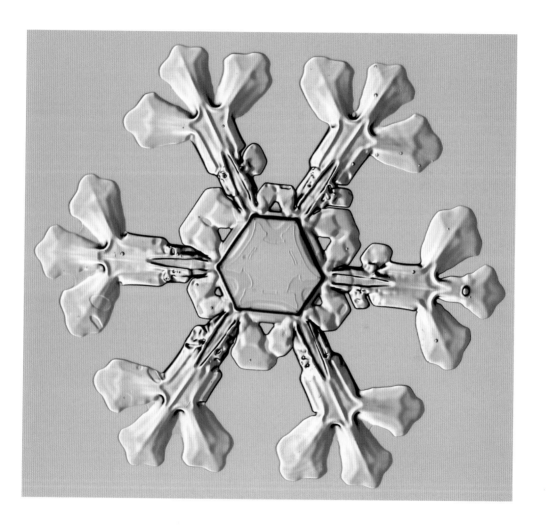

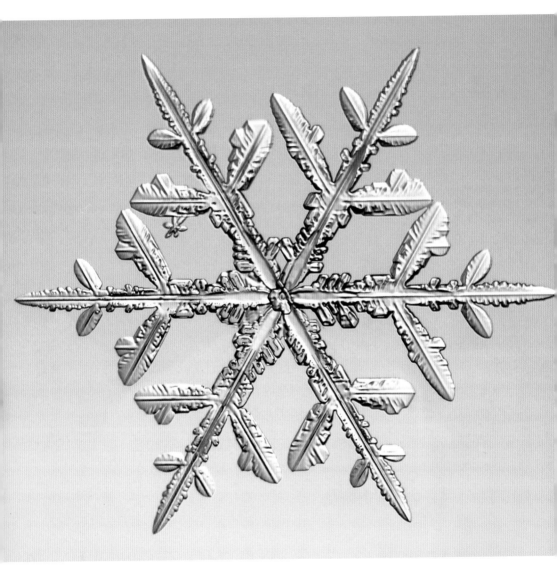

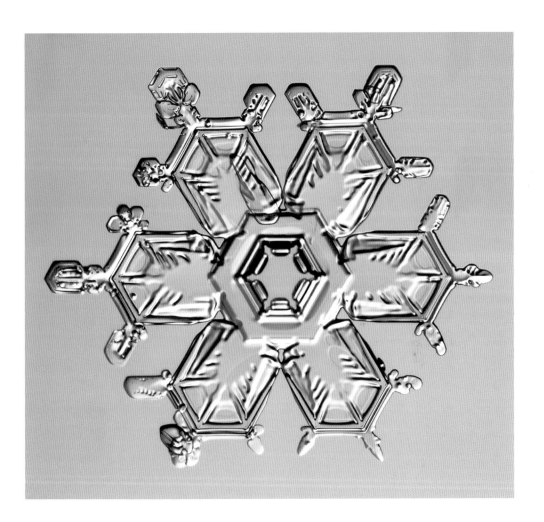

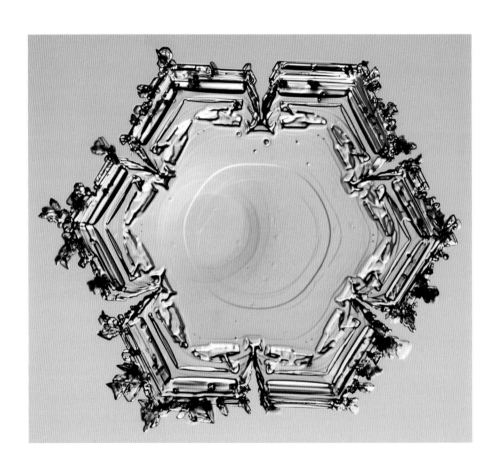

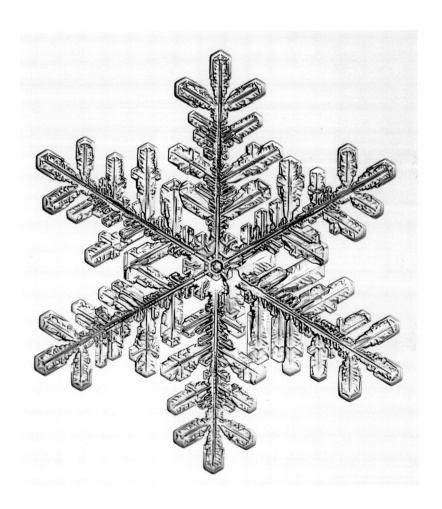

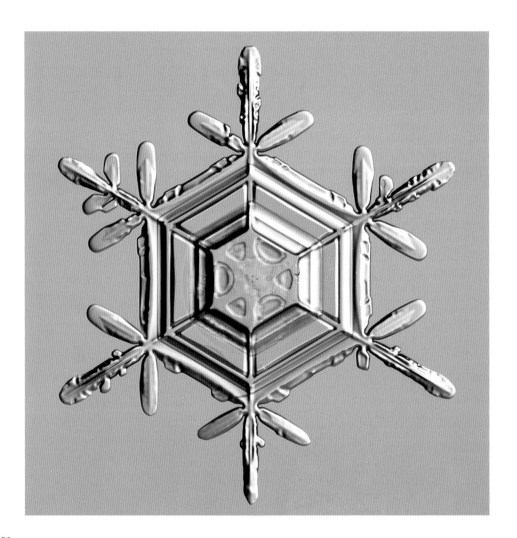

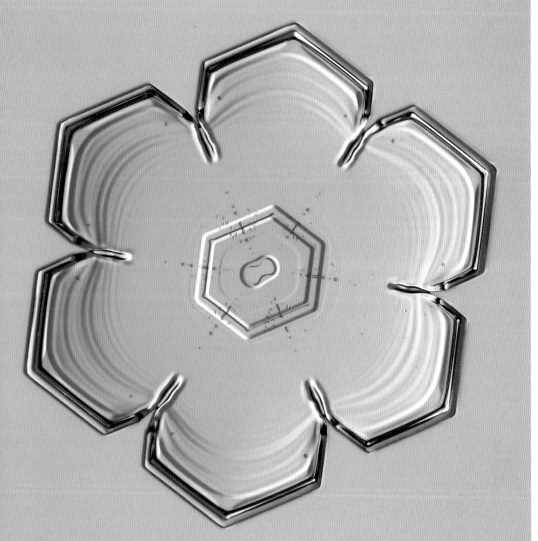

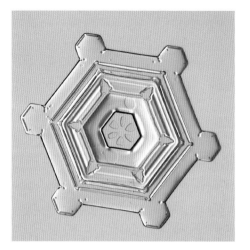
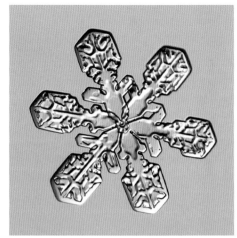
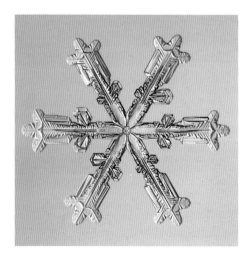
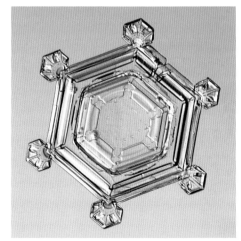

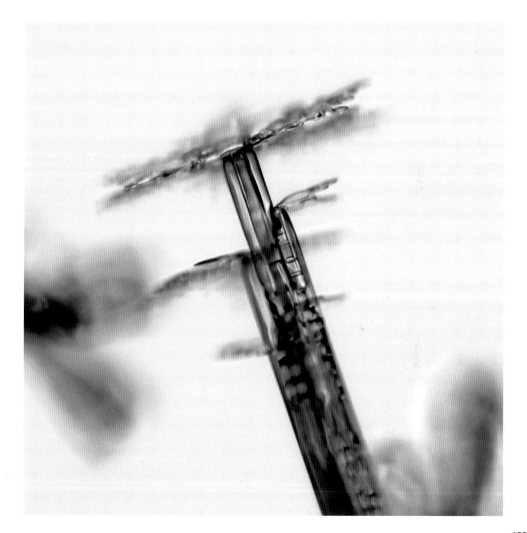

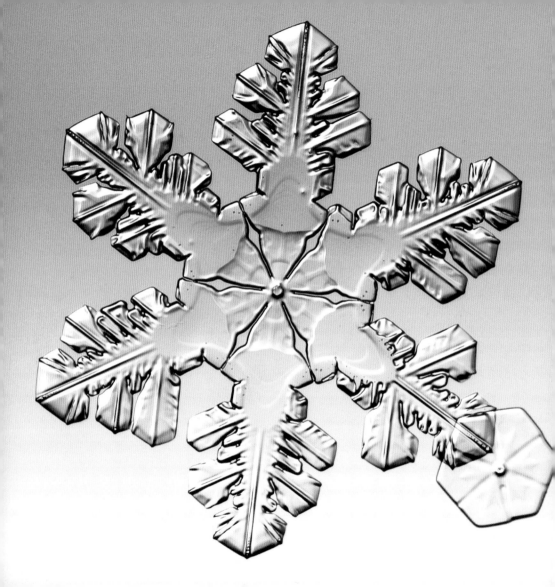

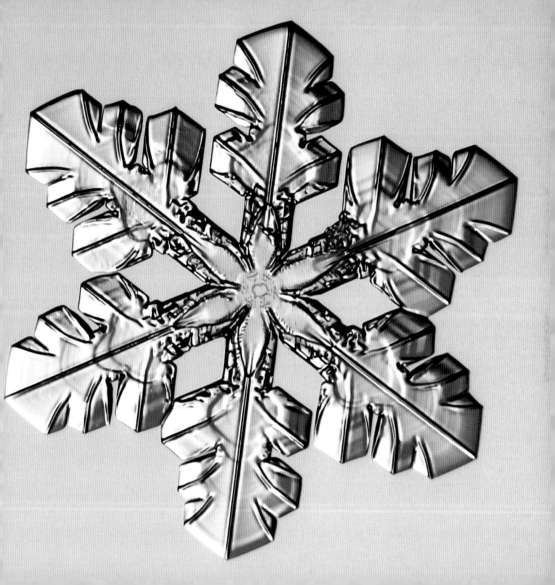

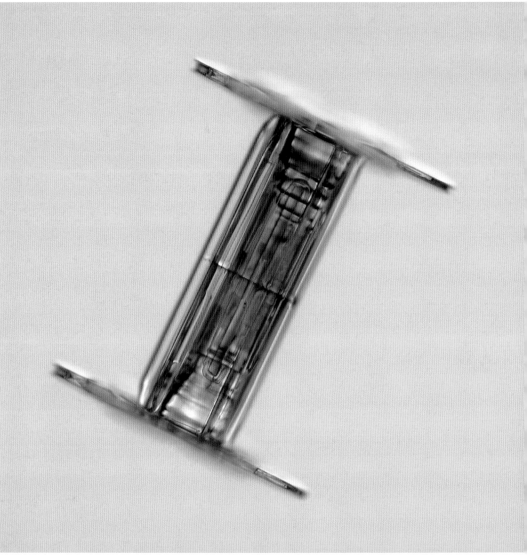

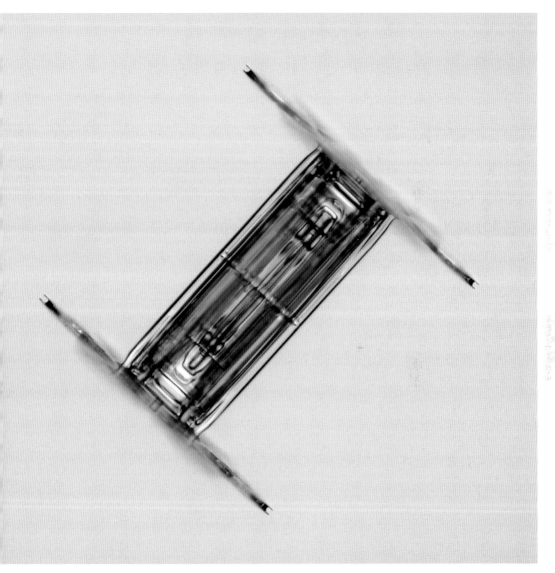

Everything is complicated; if that were not so, life and poetry and everything else would be a bore.

—Wallace Stevens (1879–1955)

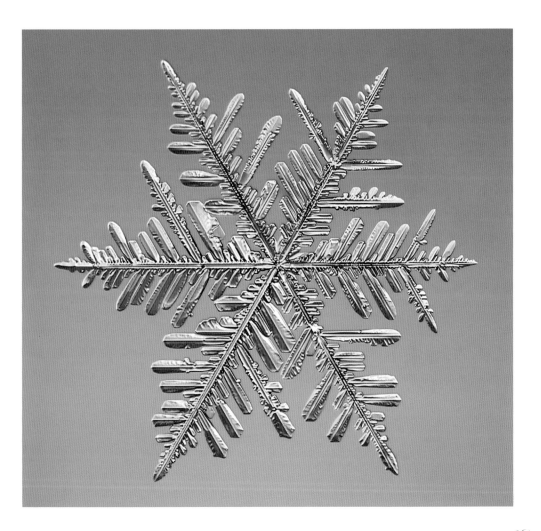

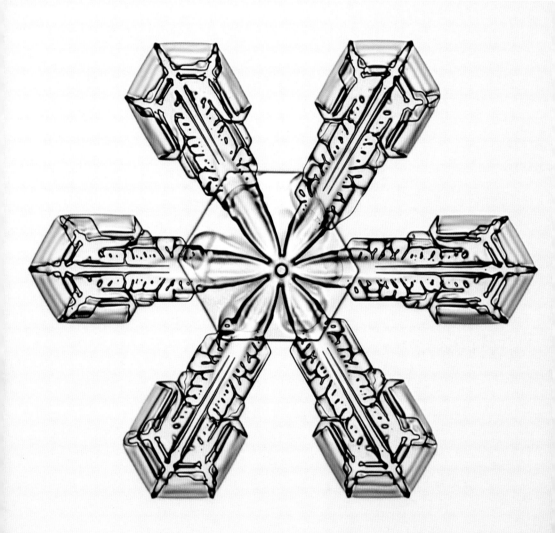

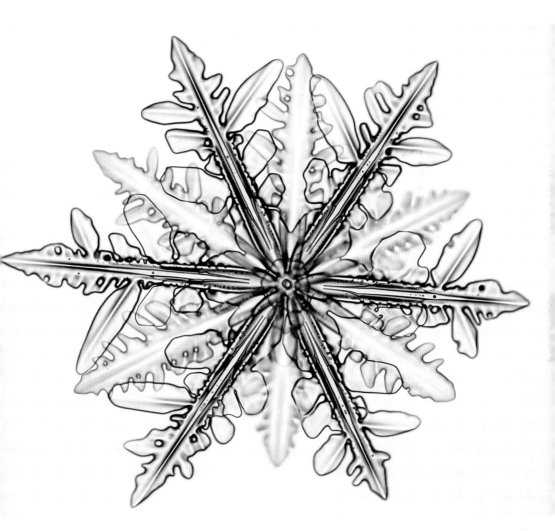

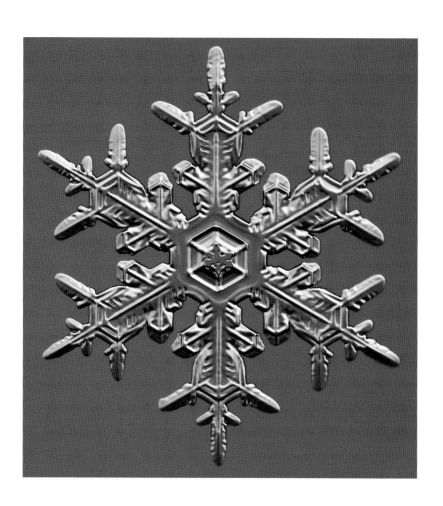

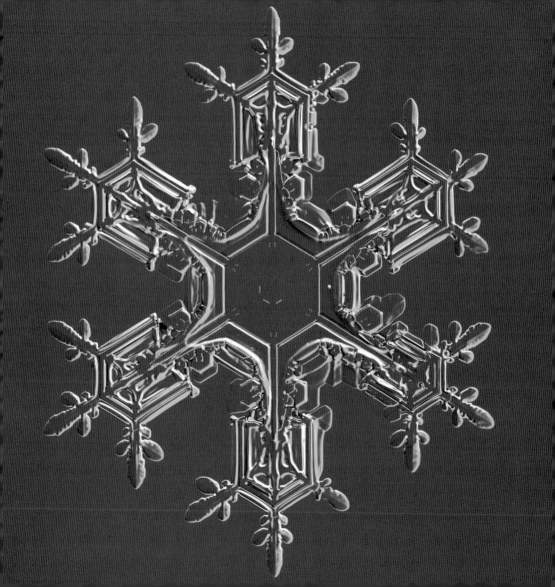

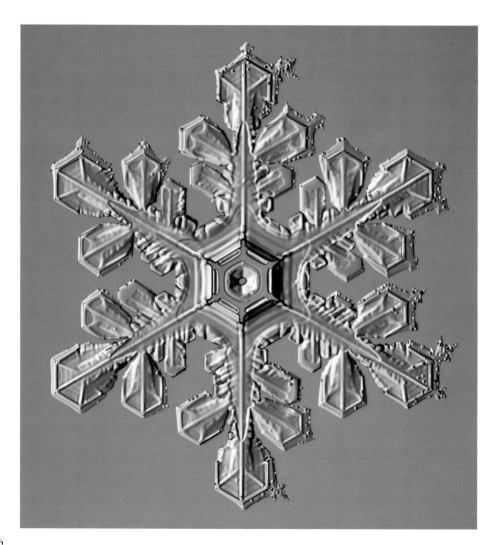

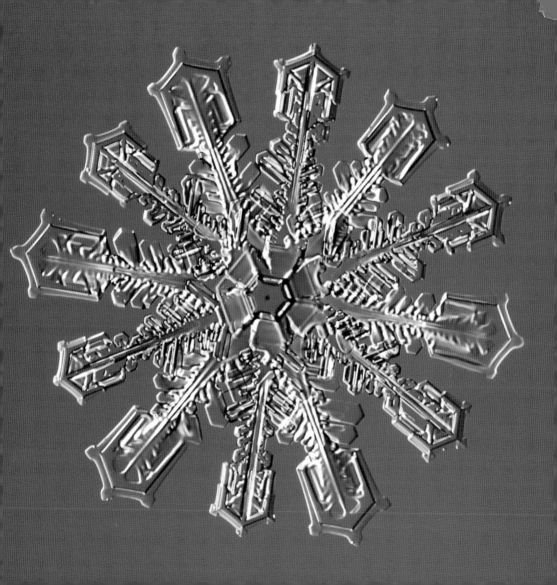

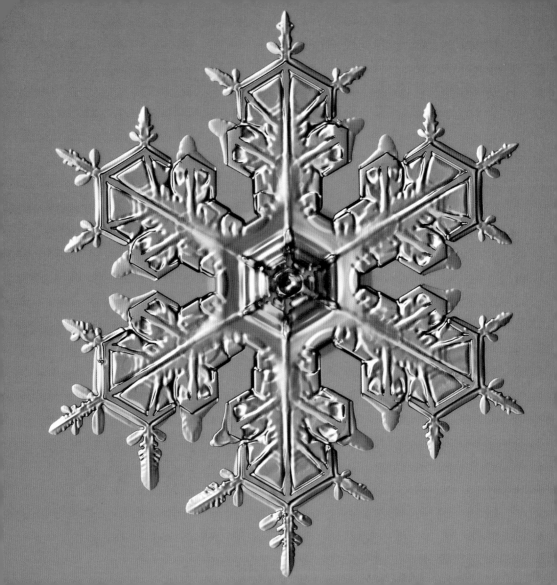

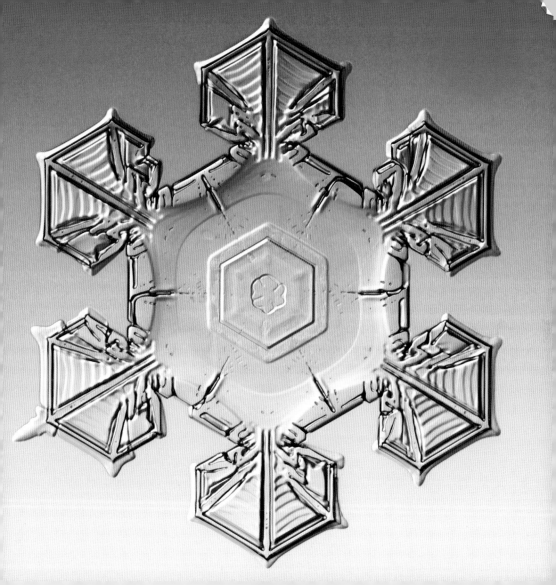

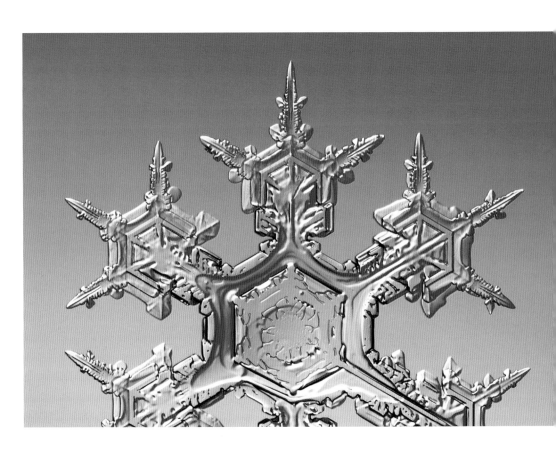

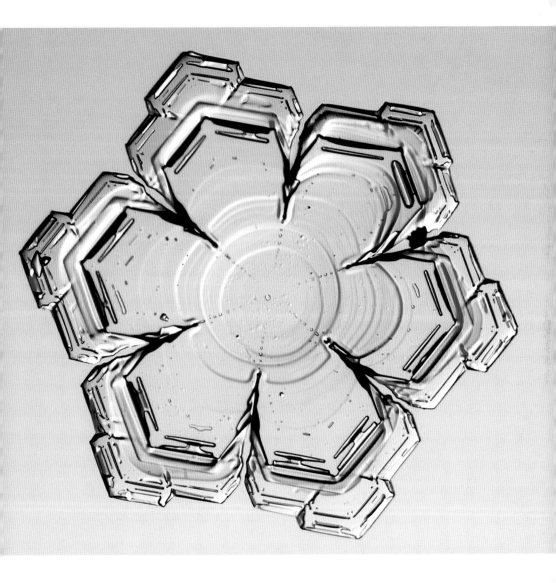

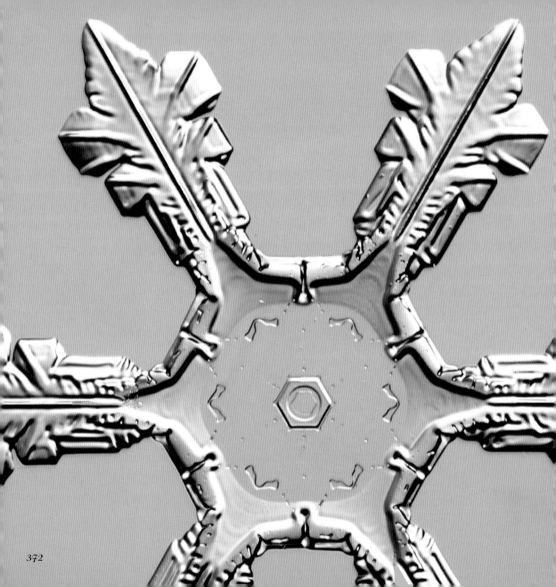

\mathcal{A} CAREFUL STUDY OF THIS INTERNAL STRUCTURE NOT ONLY REVEALS NEW AND FAR GREATER ELEGANCE OF FORM THAN THE SIMPLE OUTLINES EXHIBIT, BUT BY MEANS OF THESE WONDERFULLY DELICATE AND EXQUI-SITE FIGURES MUCH MAY BE LEARNED OF THE HISTORY OF EACH CRYSTAL, AND THE CHANGES THROUGH WHICH IT HAS PASSED IN ITS JOURNEY THROUGH CLOUDLAND. WAS EVER LIFE HISTORY WRITTEN IN MORE DAINTY HIEROGLYPHICS!

—Wilson Bentley (1865–1931)

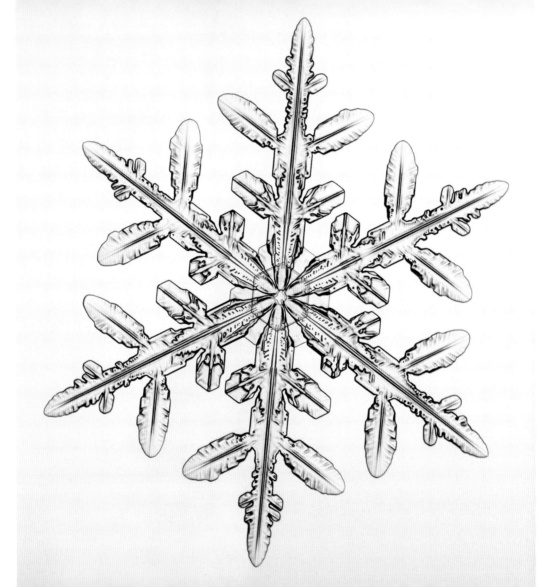

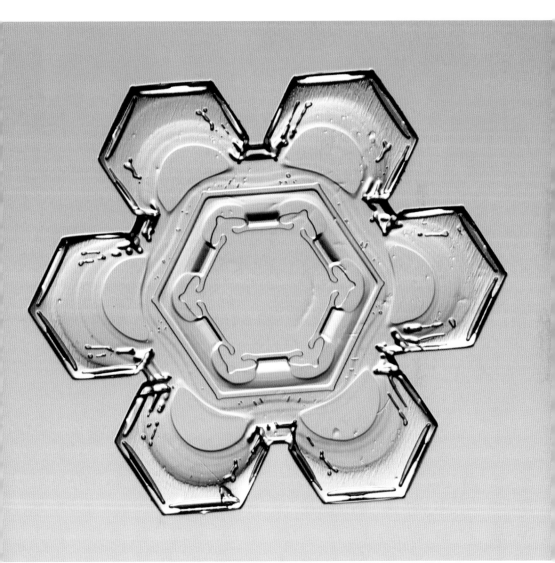

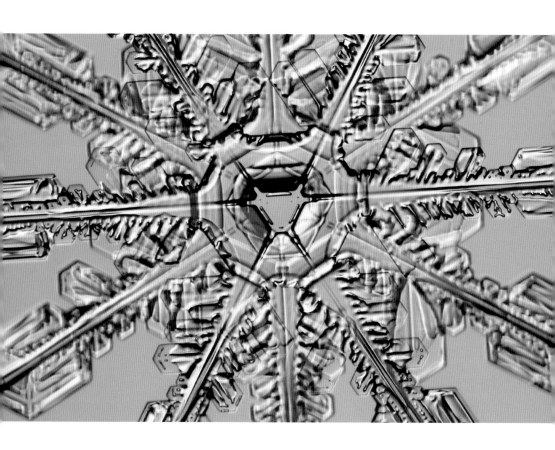

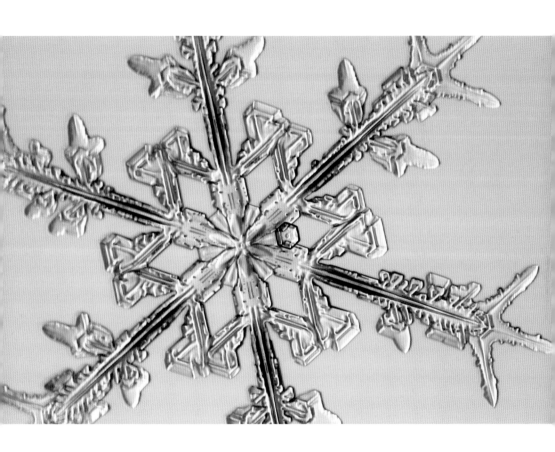

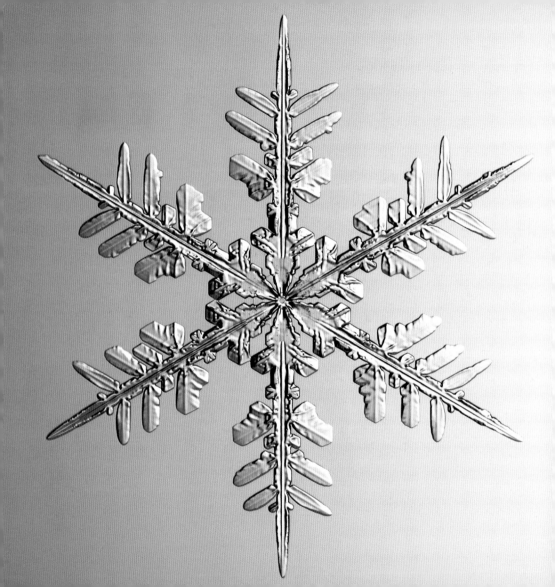

\mathscr{N}O WEARY JOURNEYS NEED BE TAKEN, NO EXPENSIVE MACHIN-ERY EMPLOYED. . . . A WINTER'S STORM, AN OPEN WINDOW, A BIT OF FUR OR VELVET, AND A COMMON MAGNIFIER, WILL BRING ANY CURIOUS INQUIRER UPON HIS FIELD OF OBSERVATION WITH ALL THE NECESSARY APPARATUS, AND HE HAS ONLY TO OPEN HIS EYES TO FIND THE GRAND AND BEAUTIFUL LABORATORY OF NATURE OPEN TO HIS INSPECTION.

—Frances E. Knowlton Chickering, *Cloud Crystals: A Snow Flake Album*, 1864

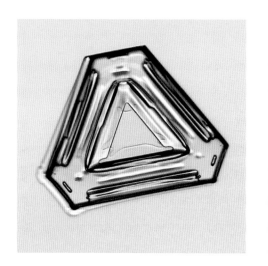
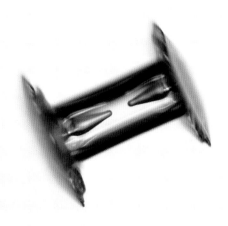
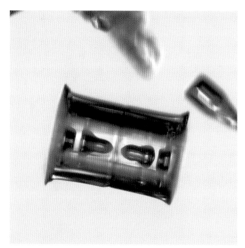
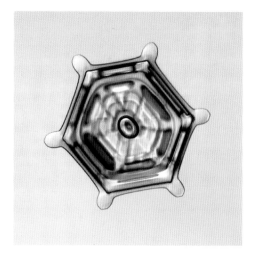

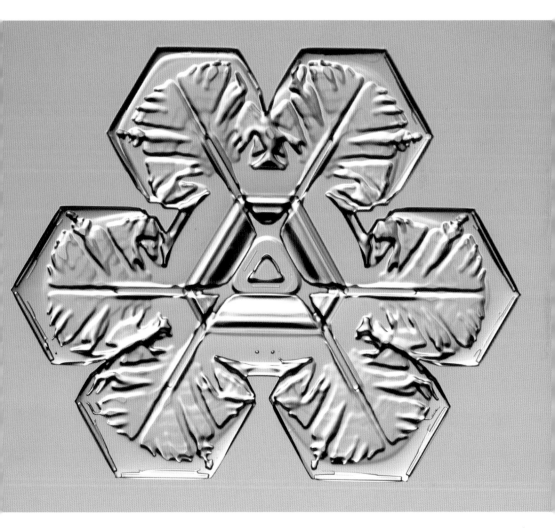

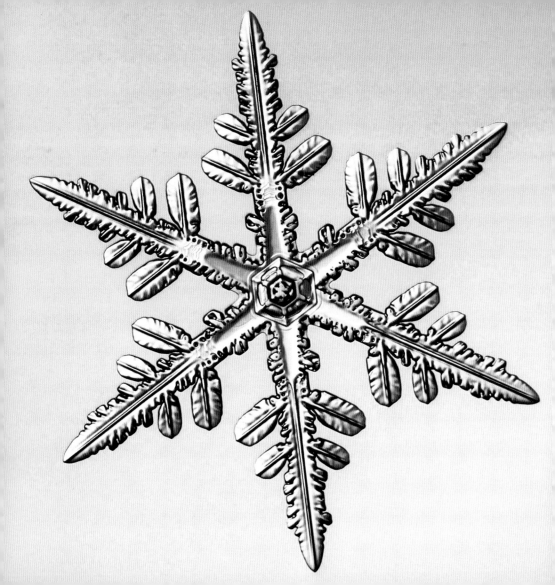

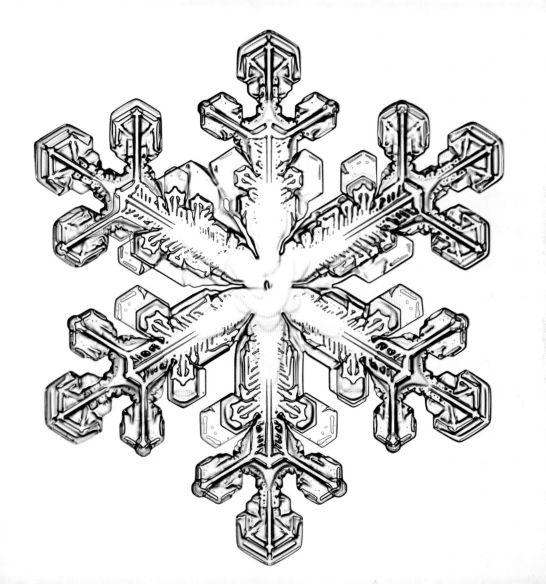

If the sages ask thee why
This charm is wasted on the earth and sky,
Tell them, dear,
That if eyes were made for seeing,
Then Beauty is its own excuse for Being.

—Ralph Waldo Emerson (1803–1882)

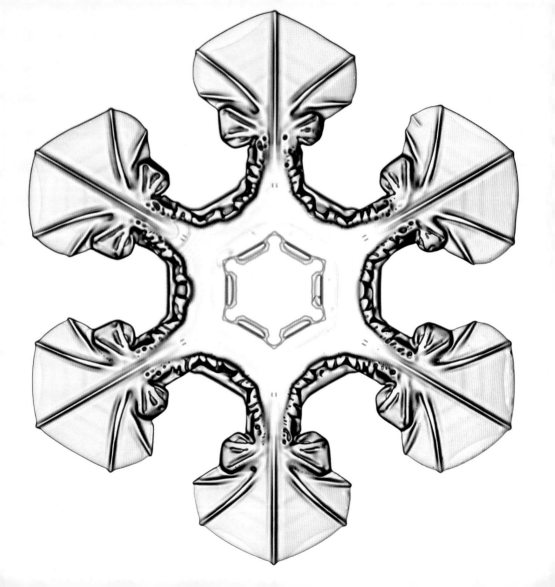

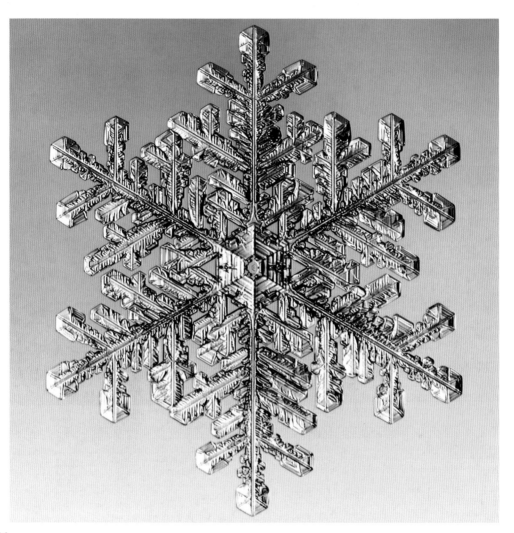

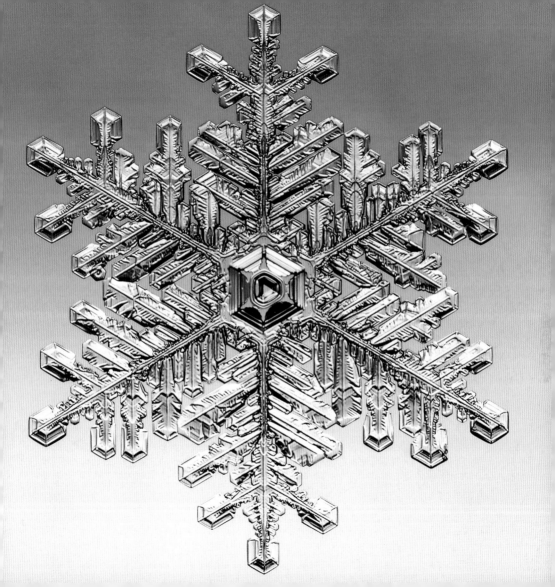

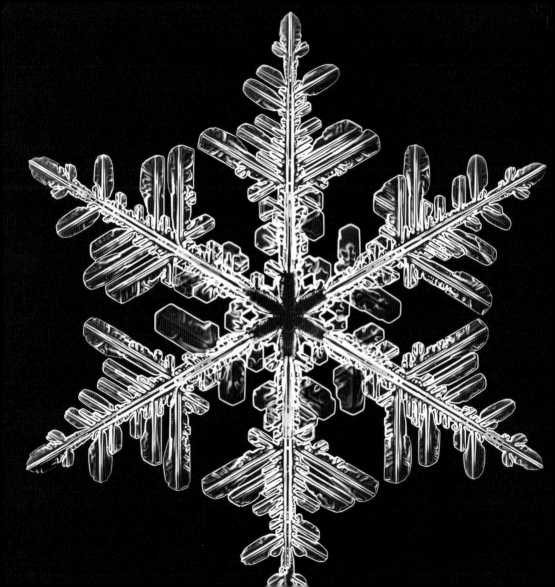

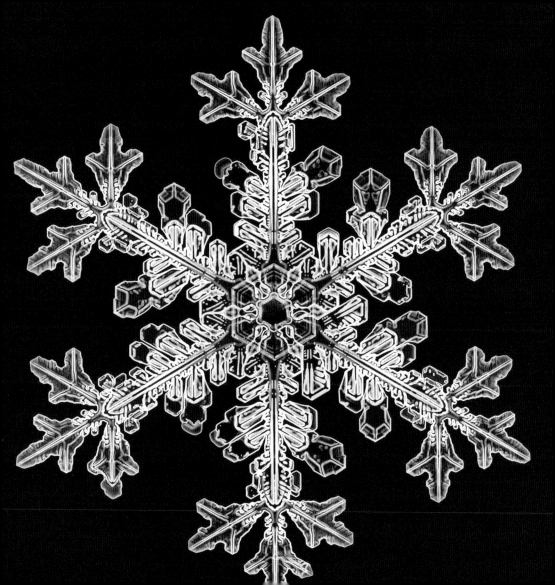

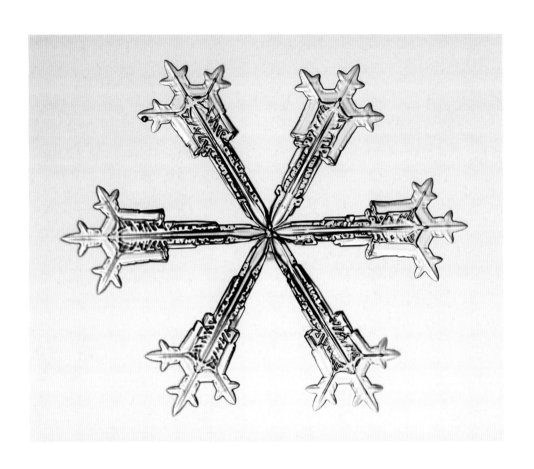

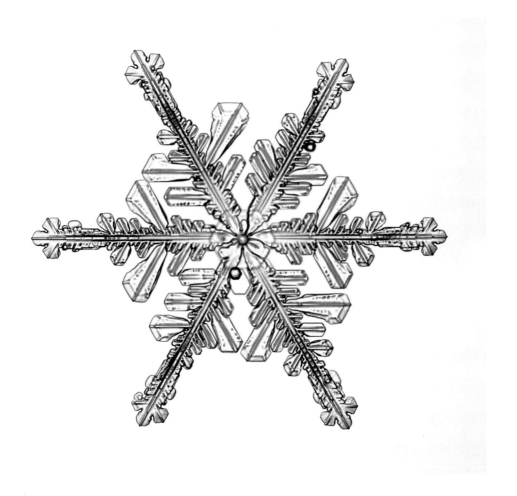

SUNSHINE IS DELICIOUS, RAIN IS REFRESHING, WIND BRACES US UP, SNOW IS EXHILARATING; THERE IS REALLY NO SUCH THING AS BAD WEATHER, ONLY DIFFERENT KINDS OF GOOD WEATHER.

—John Ruskin (1819–1900)

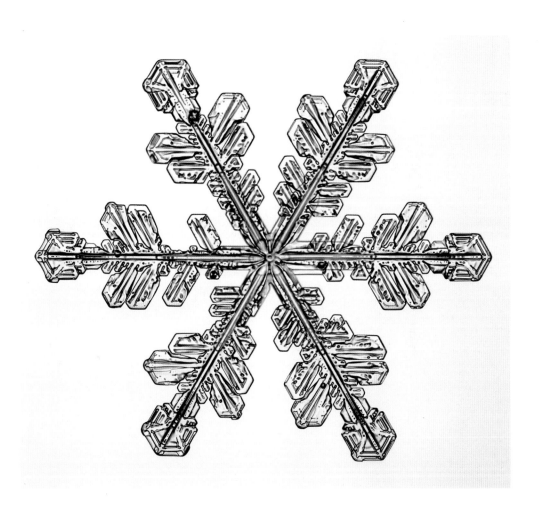

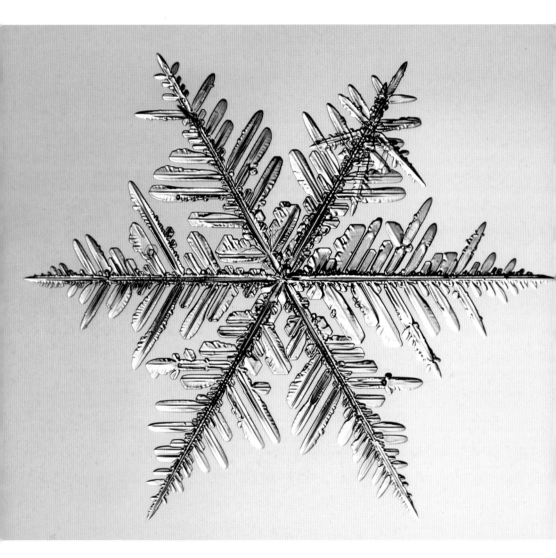

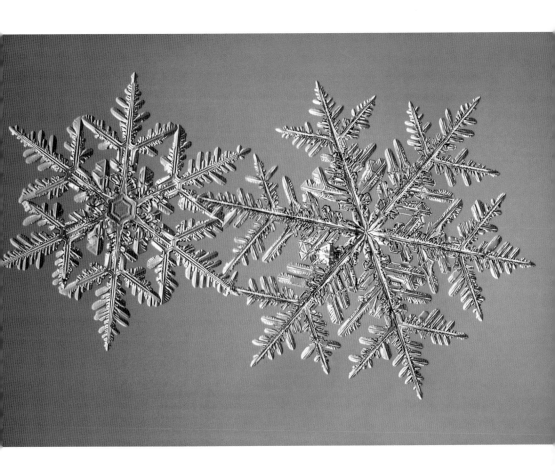

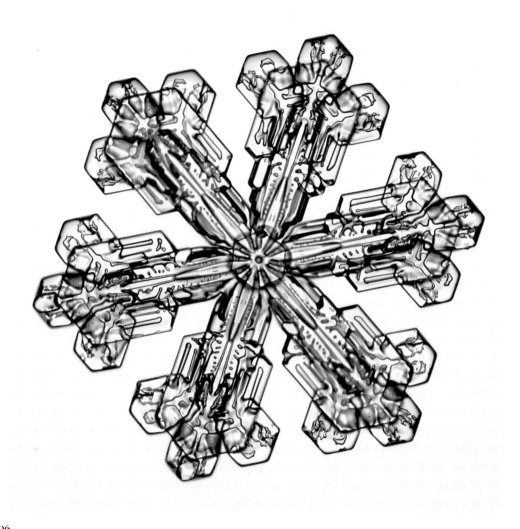

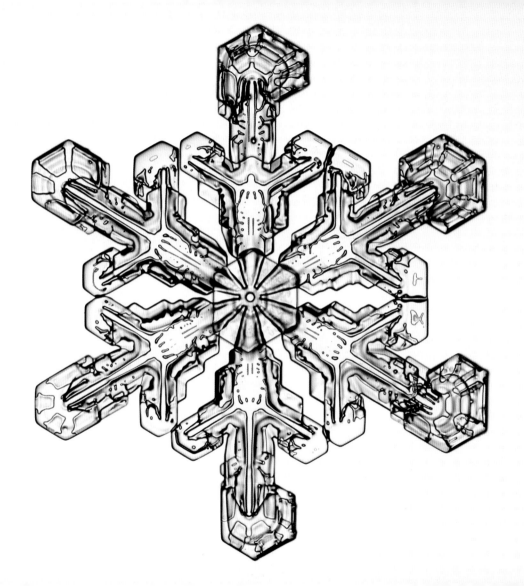

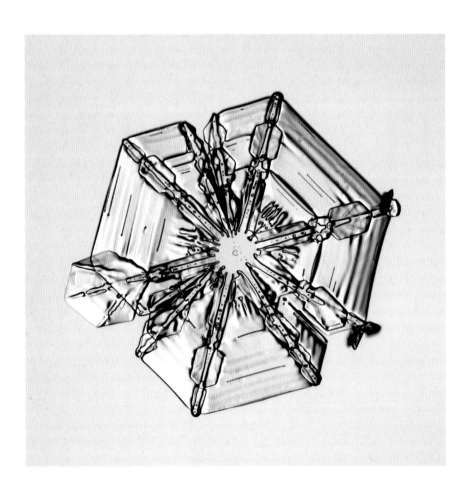

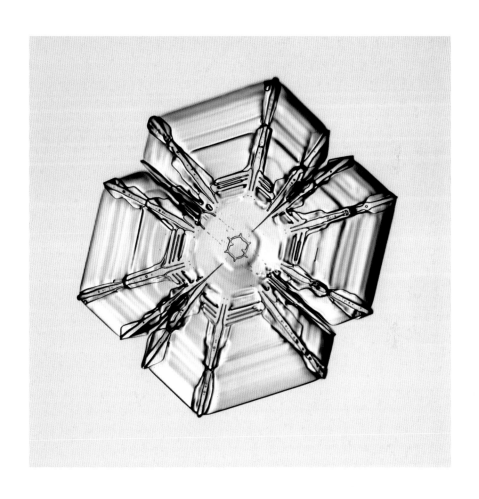

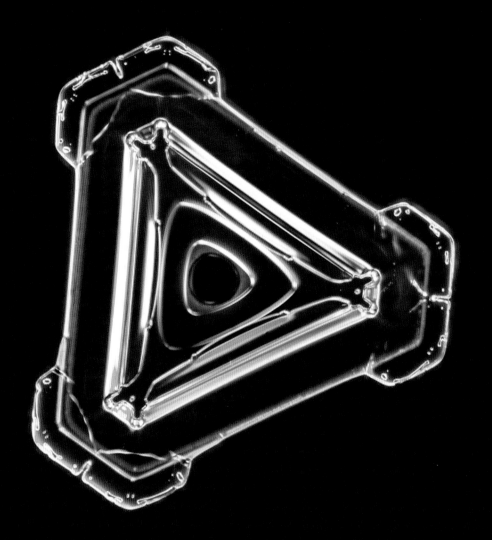

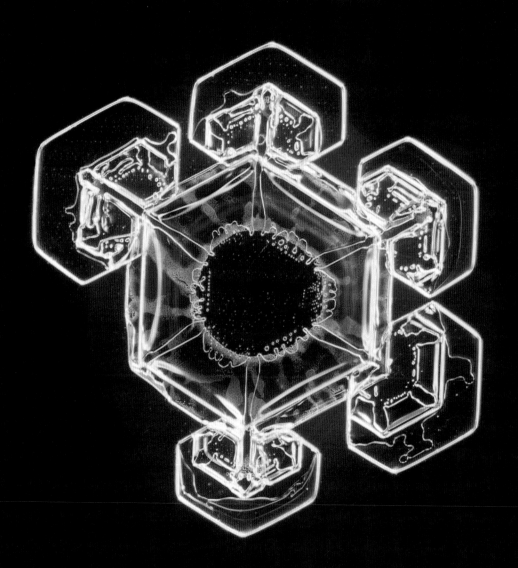

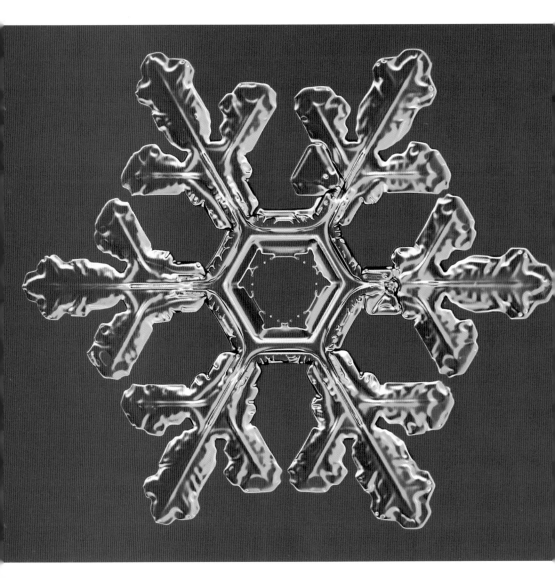

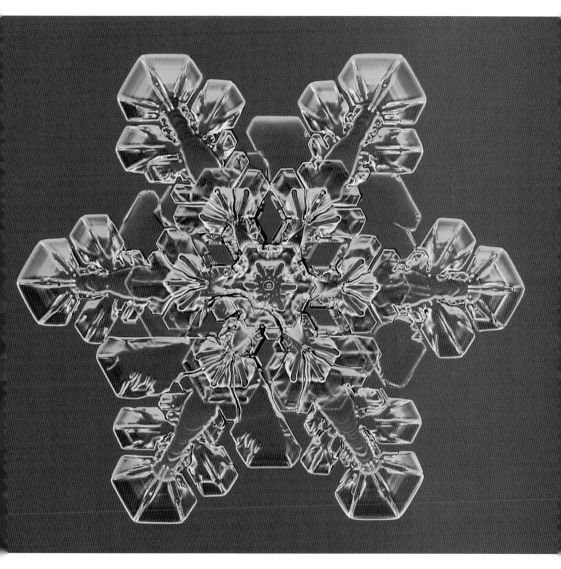

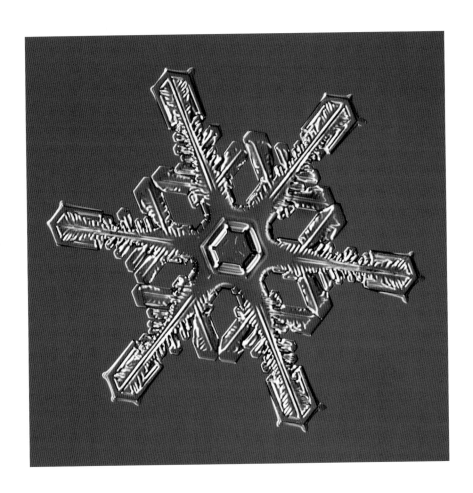

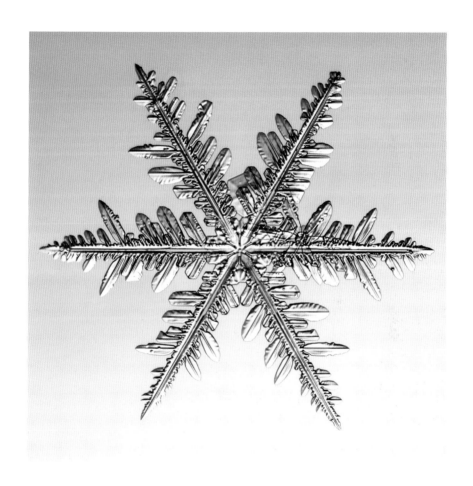

THE LONGER I LIVE THE MORE BEAUTIFUL LIFE BECOMES.
IF YOU FOOLISHLY IGNORE BEAUTY, YOU WILL SOON FIND
YOURSELF WITHOUT IT. YOUR LIFE WILL BE IMPOVERISHED.
BUT IF YOU INVEST IN BEAUTY, IT WILL REMAIN WITH YOU
ALL THE DAYS OF YOUR LIFE.

—Frank Lloyd Wright (1867–1959)

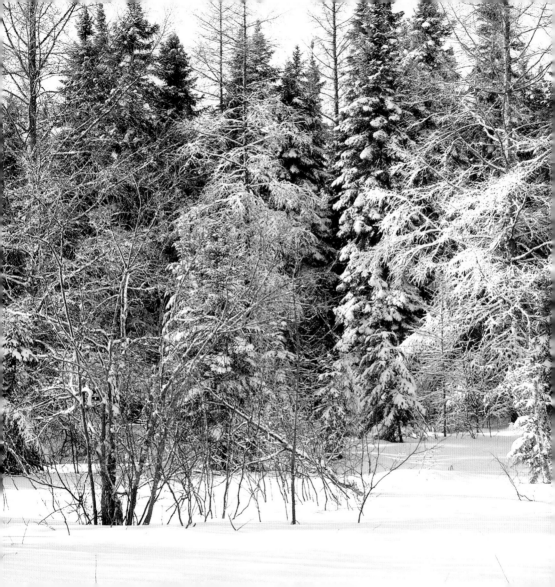

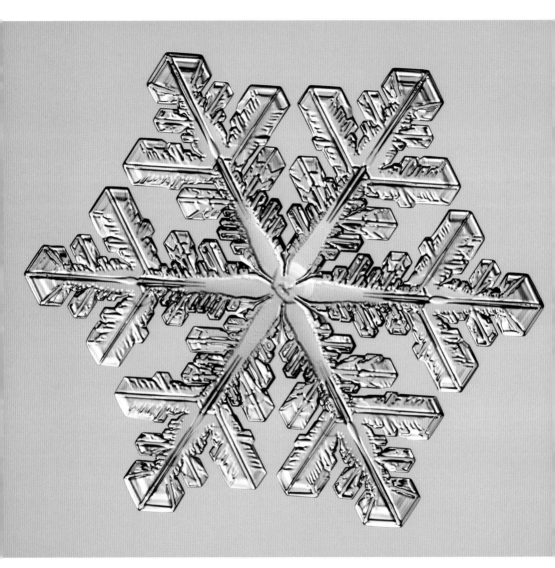

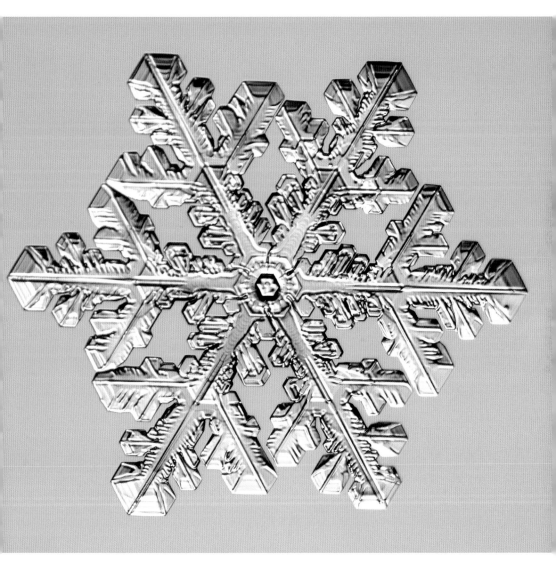

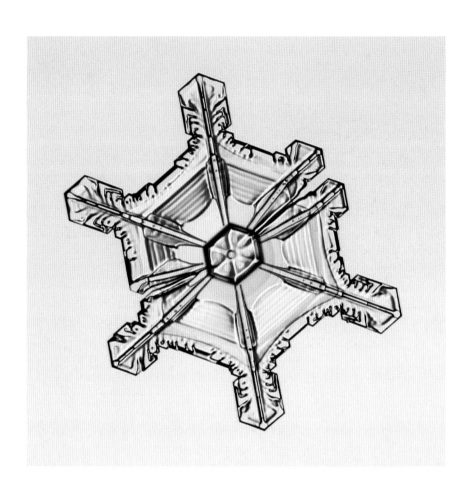

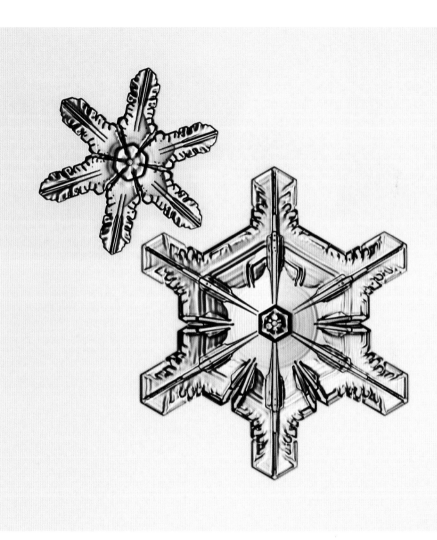

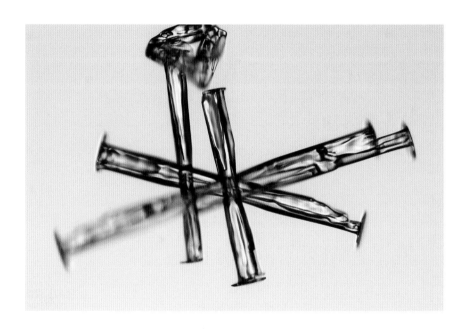

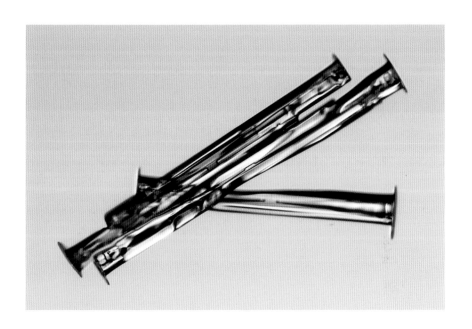

\mathcal{J}T IS EXTREMELY IMPROBABLE THAT ANYONE HAS AS YET FOUND, OR, INDEED, EVER WILL FIND, THE ONE PREEMINENTLY BEAUTIFUL AND SYMMETRICAL SNOW CRYSTAL THAT NATURE HAS PROBABLY FASHIONED WHEN IN HER MOST ARTISTIC MOOD.

—Wilson Bentley (1865–1931)

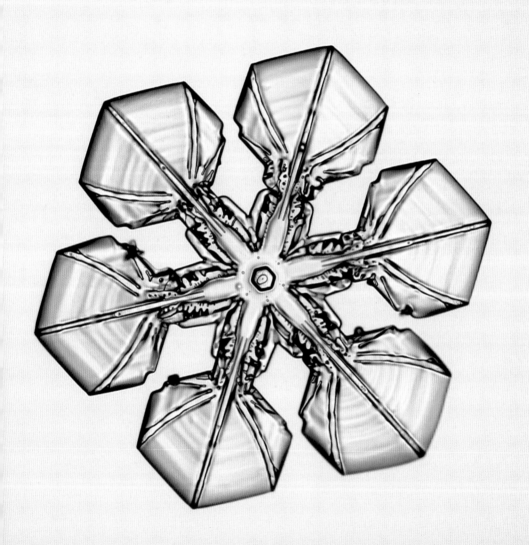

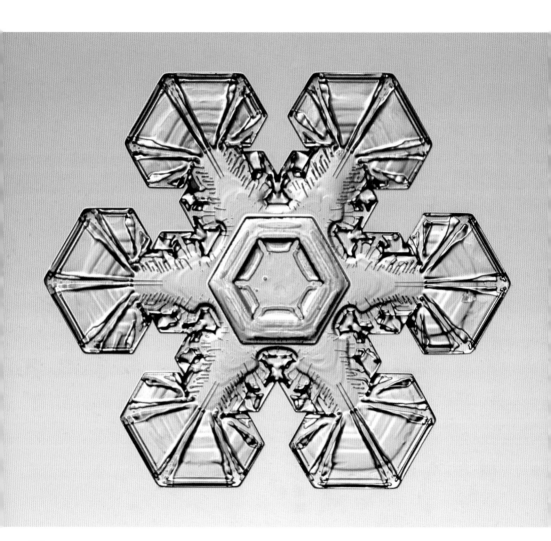

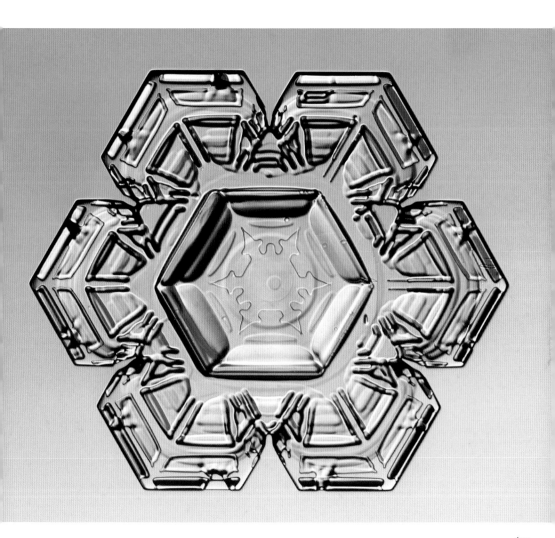

417

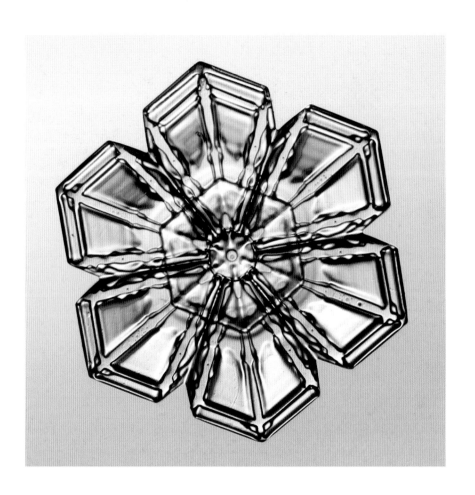

418

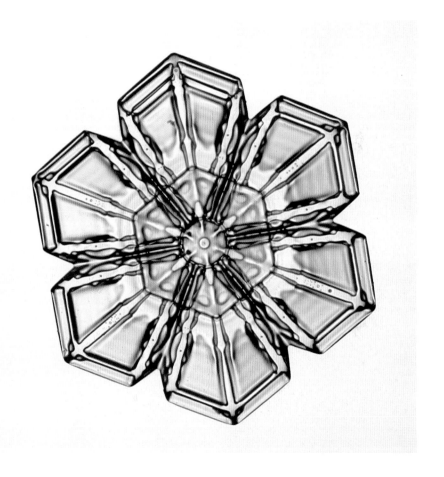

I used to be Snow White, but I drifted.

—Mae West (1892–1980)

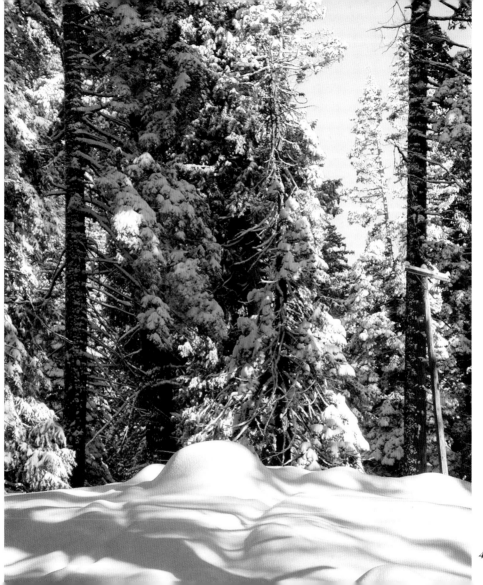

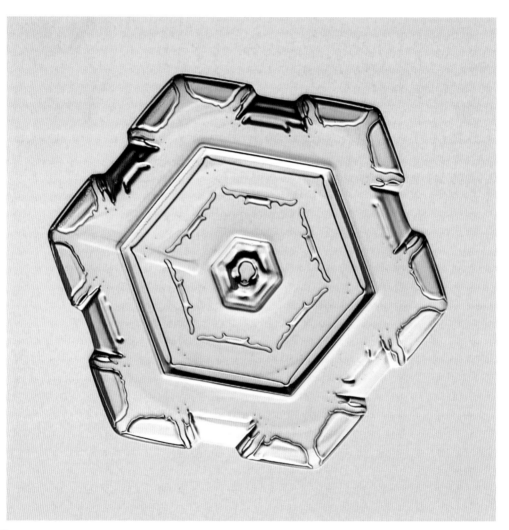

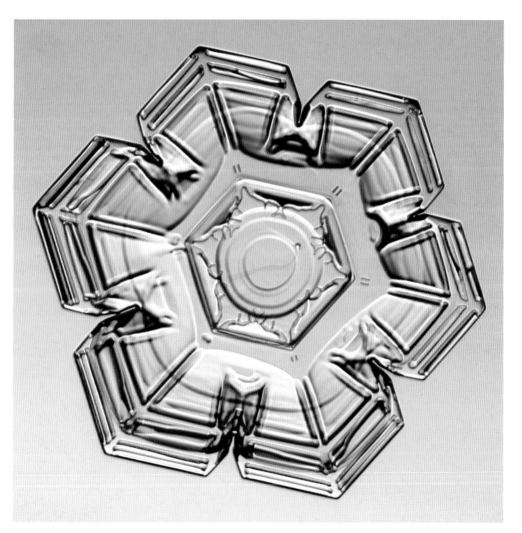

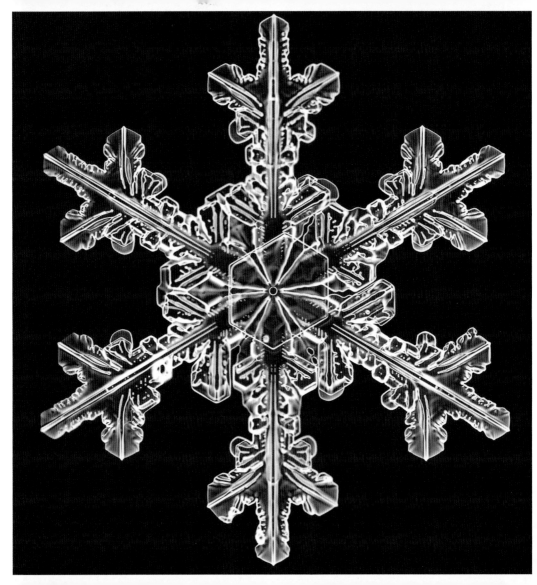

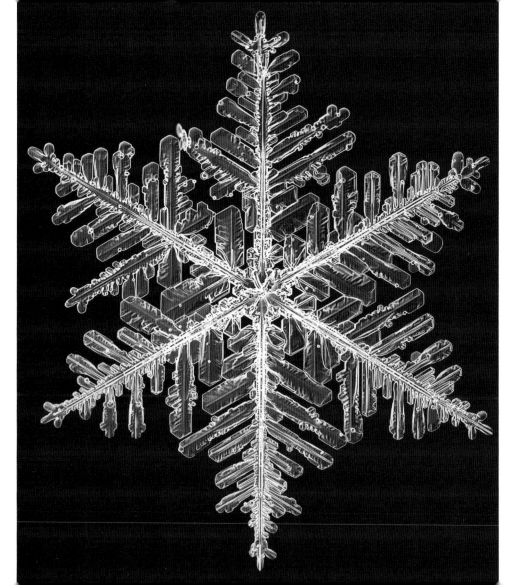

COLD! IF THE THERMOMETER HAD BEEN AN INCH
LONGER WE'D ALL HAVE FROZEN TO DEATH.

—Mark Twain (1835–1910)

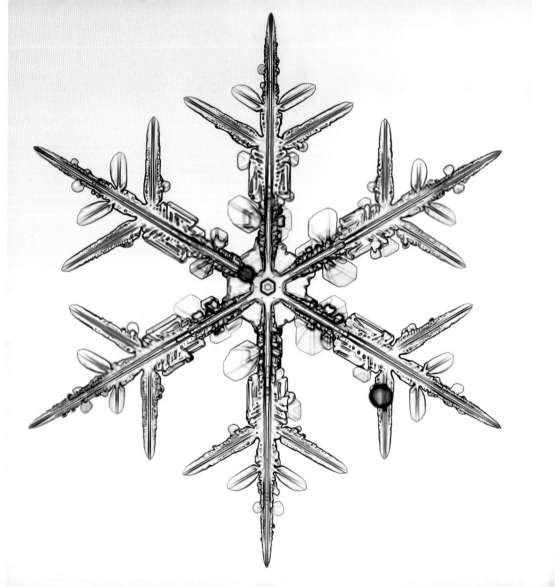

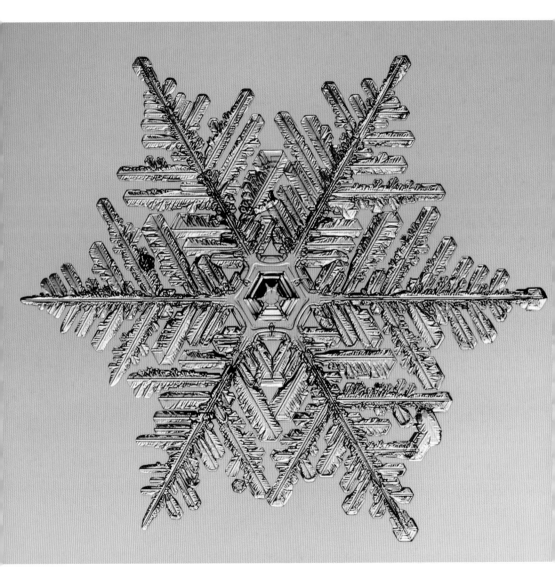

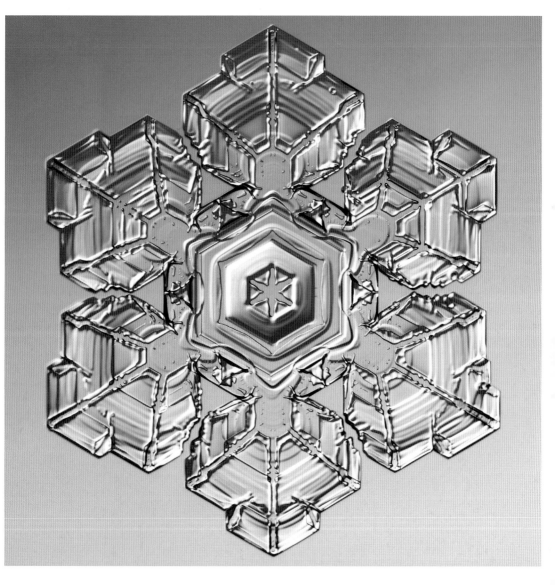

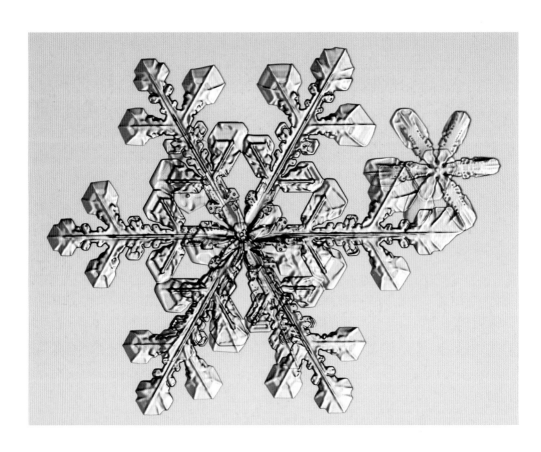

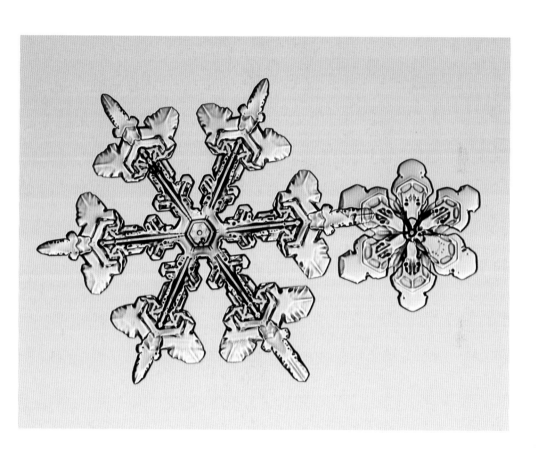

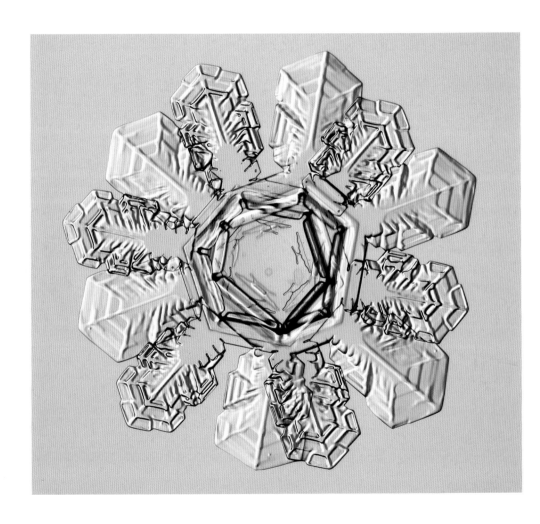

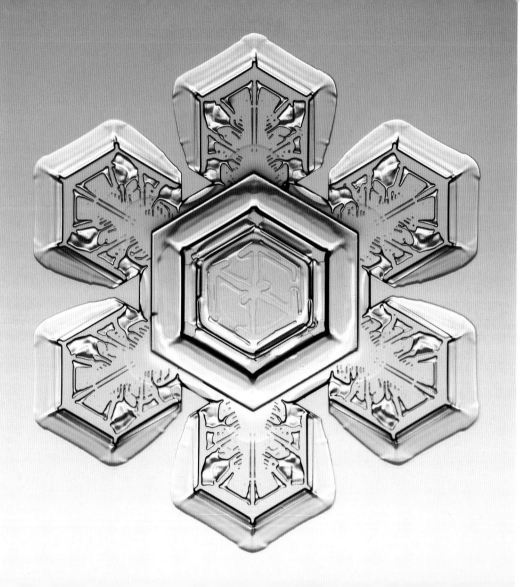

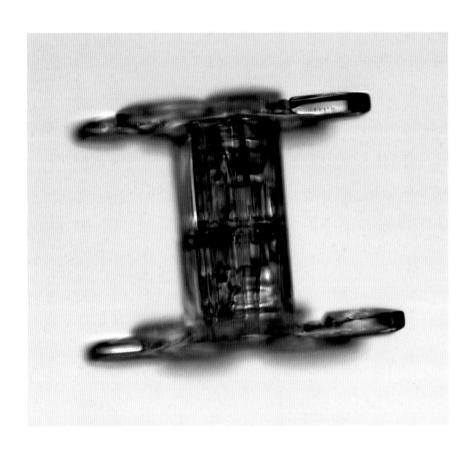

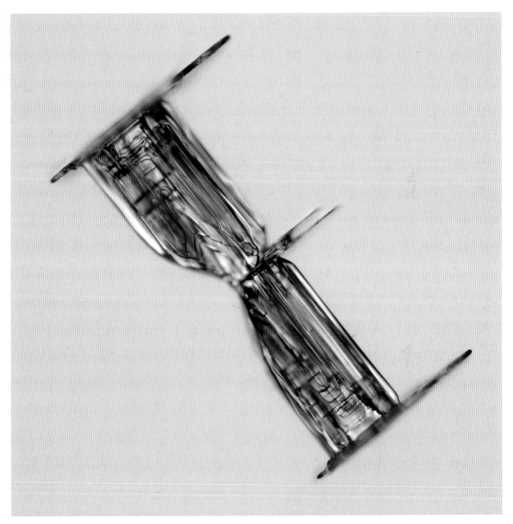

THE UNIVERSE IS FULL OF MAGICAL THINGS PATIENTLY
WAITING FOR OUR WITS TO GROW SHARPER.

—Eden Phillpotts (1862–1960)

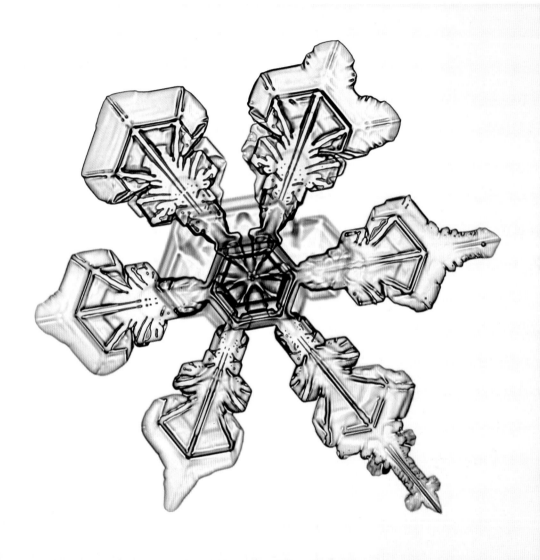

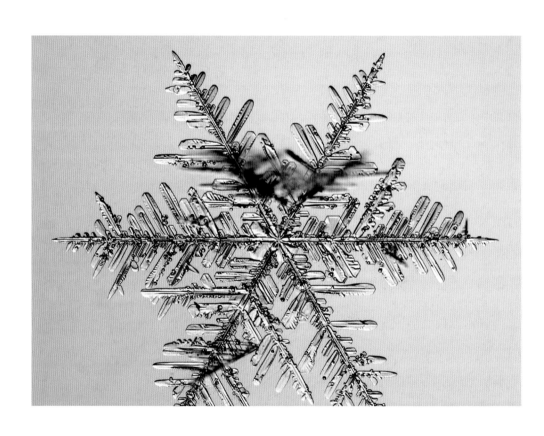

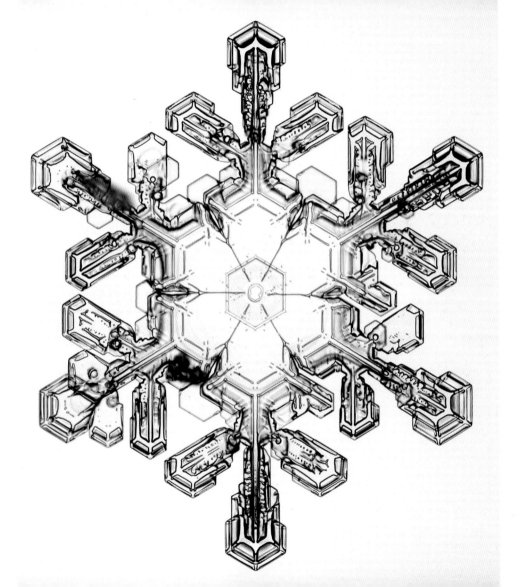

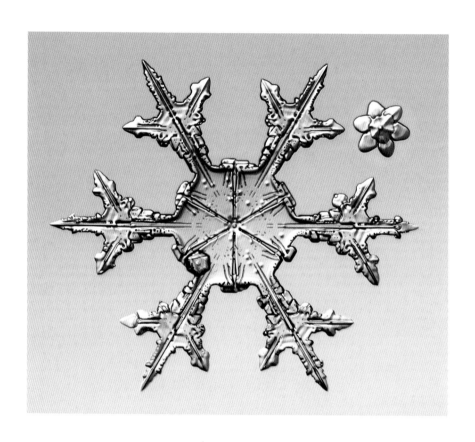

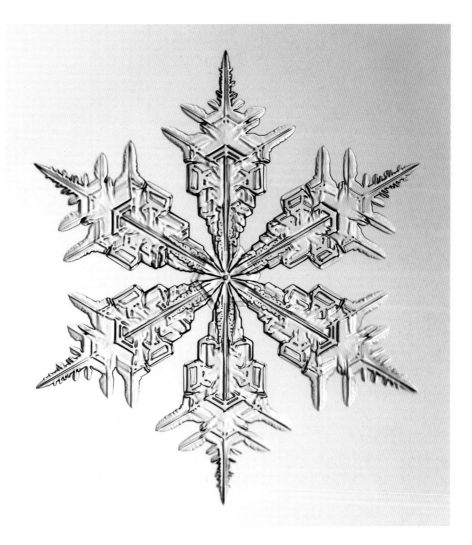

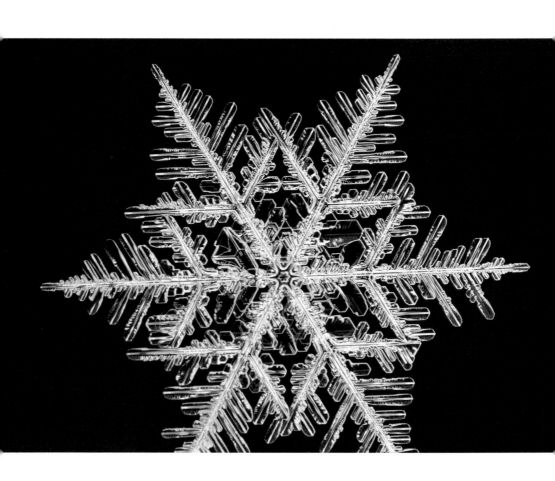

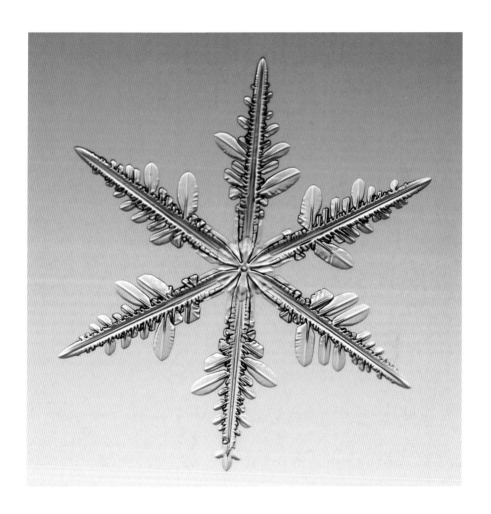

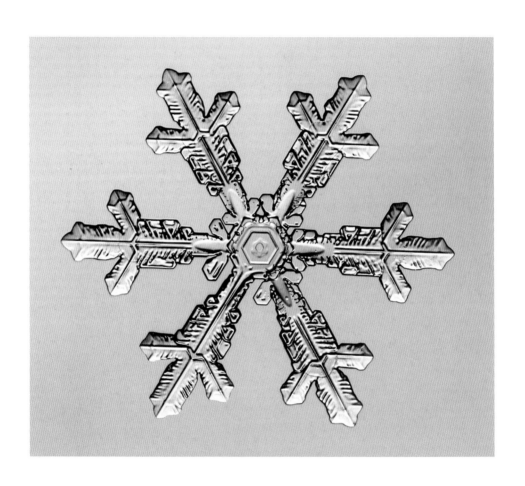

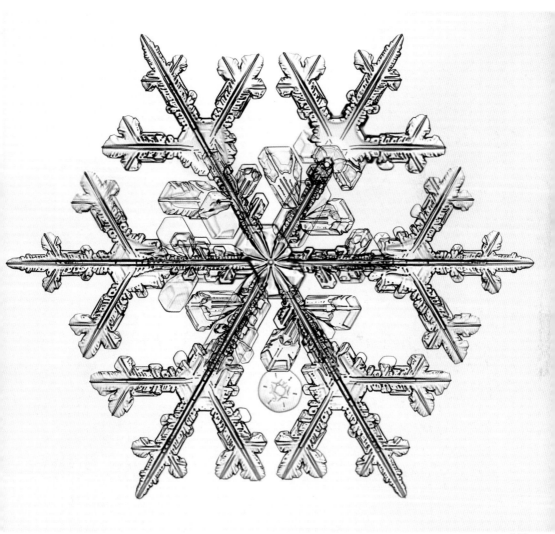

445

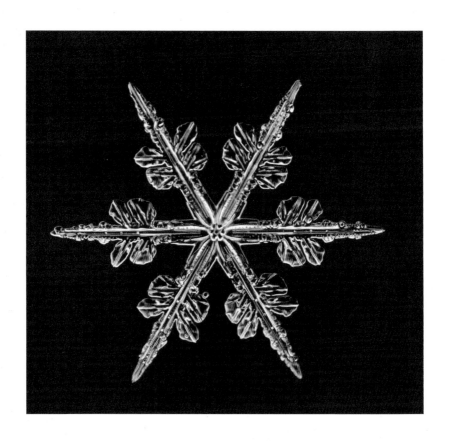

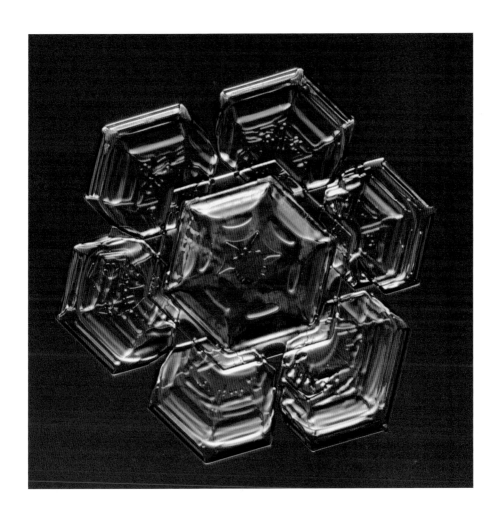

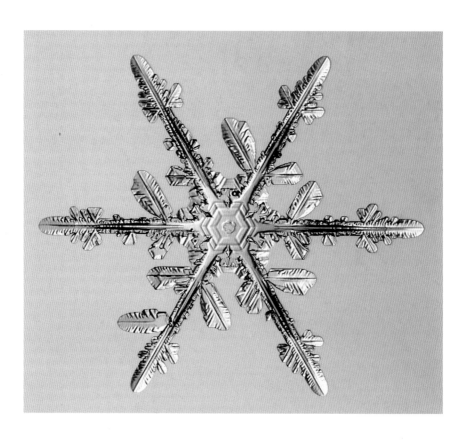

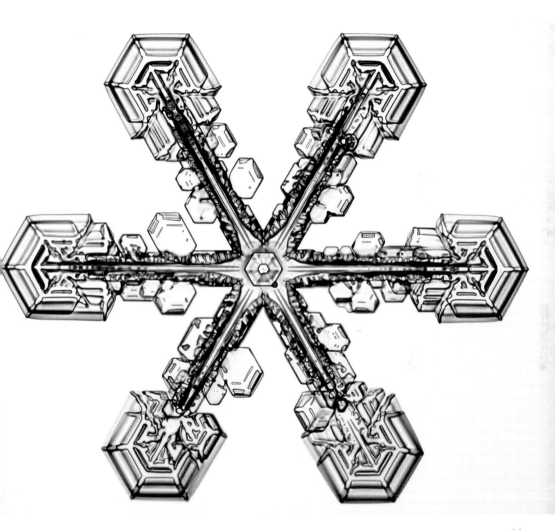

ONE TOUCH OF NATURE MAKES THE WHOLE WORLD KIN.

— William Shakespeare (1564–1616)

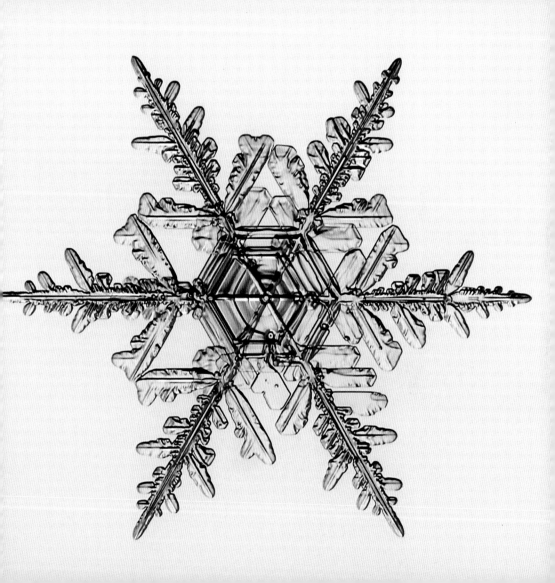

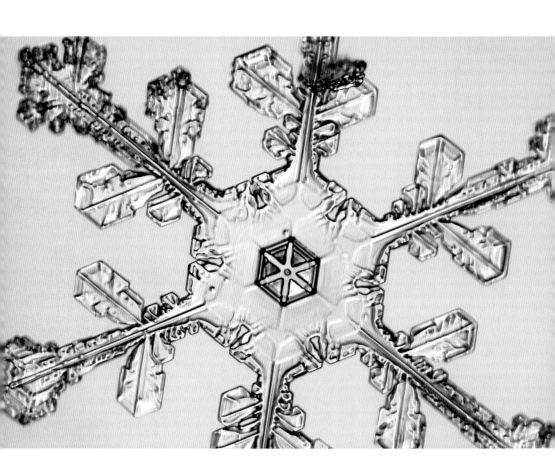

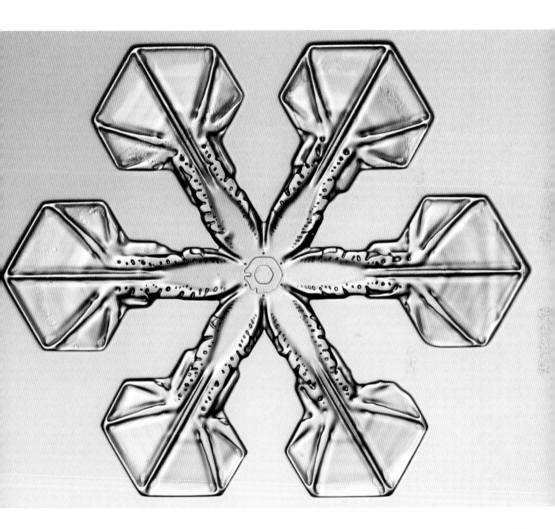

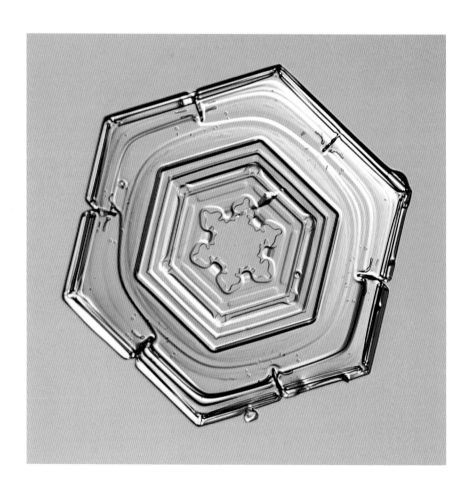

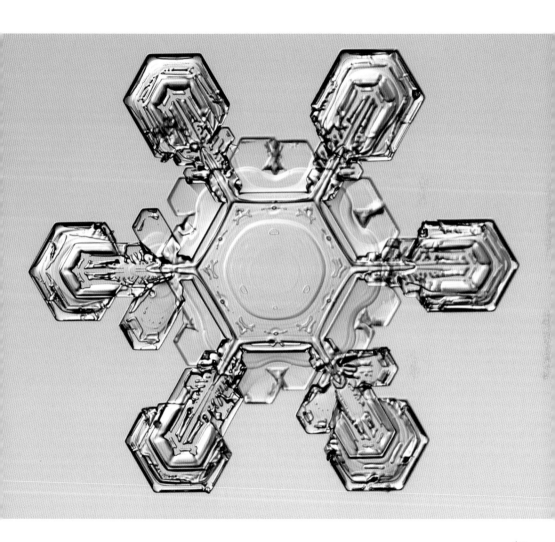

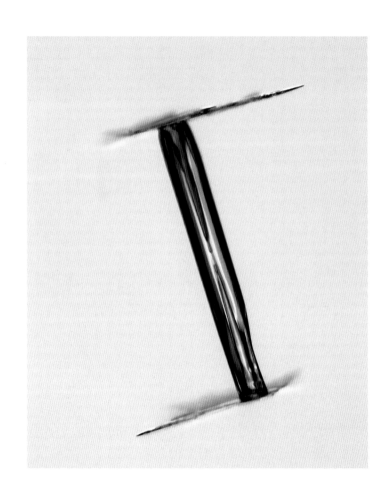

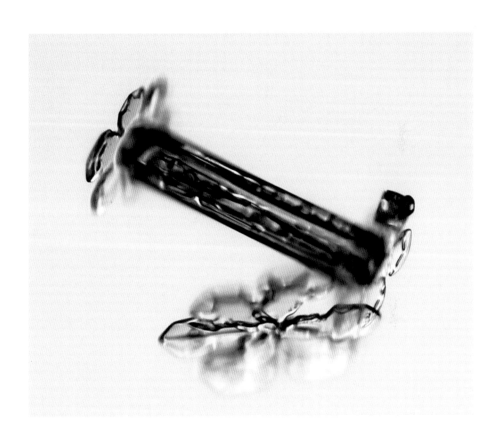

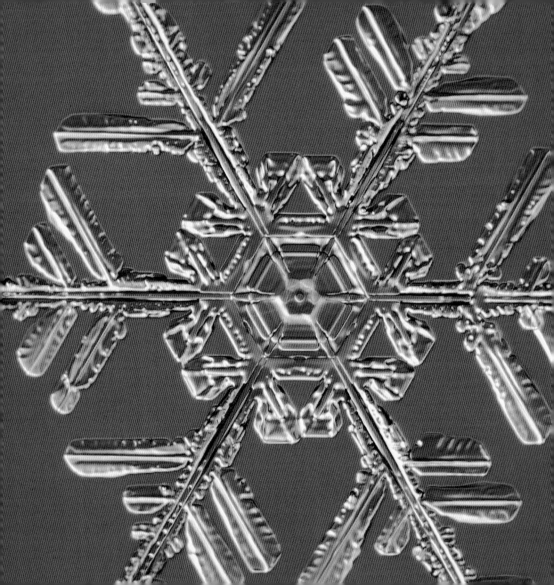

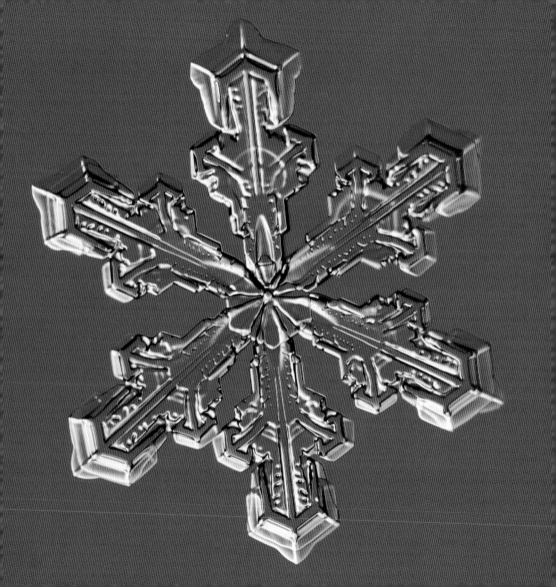

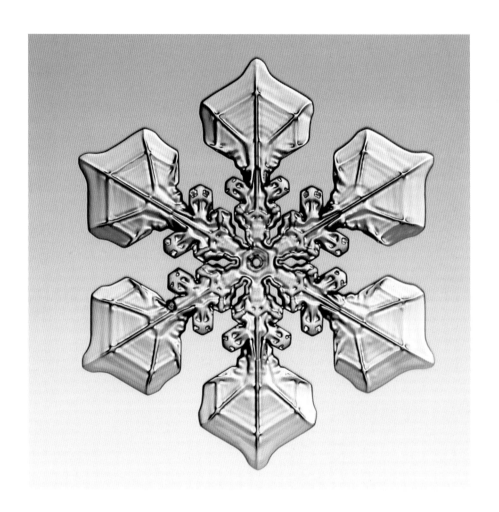

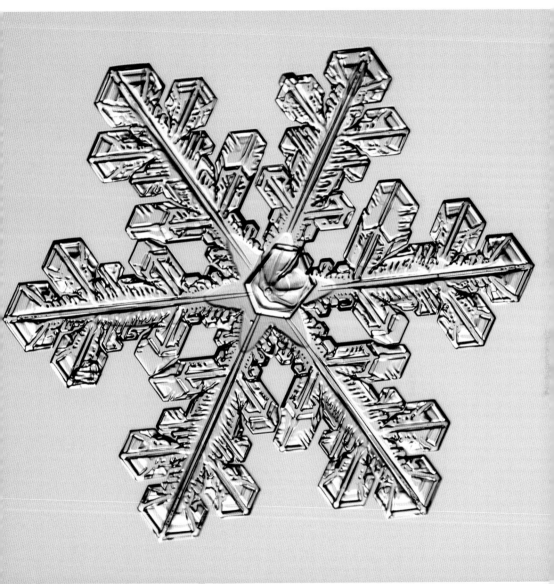

\mathcal{N}O SNOWFLAKE IN AN AVALANCHE EVER FEELS RESPONSIBLE.

— Voltaire (1694–1778)

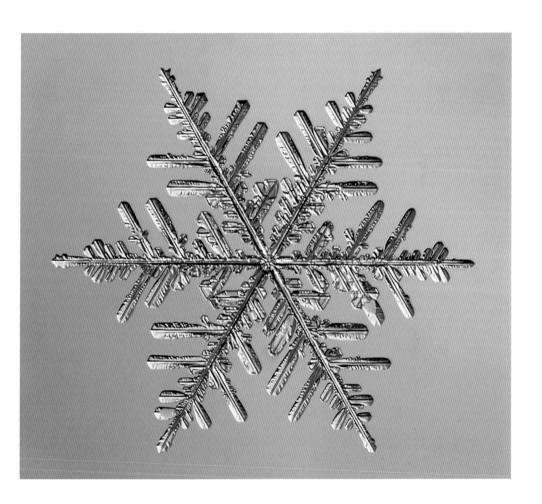

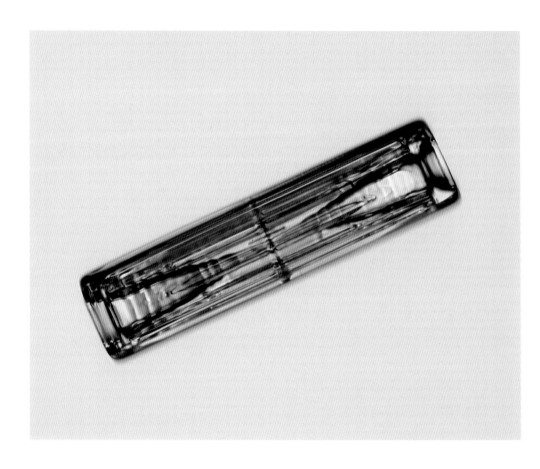

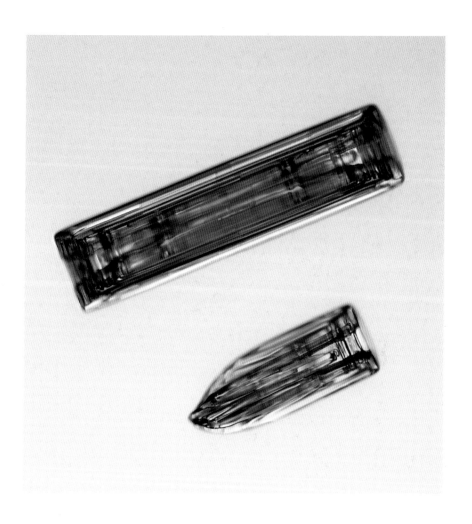

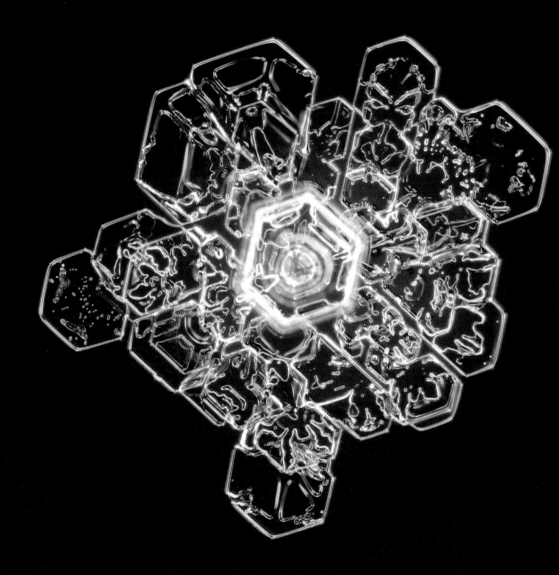

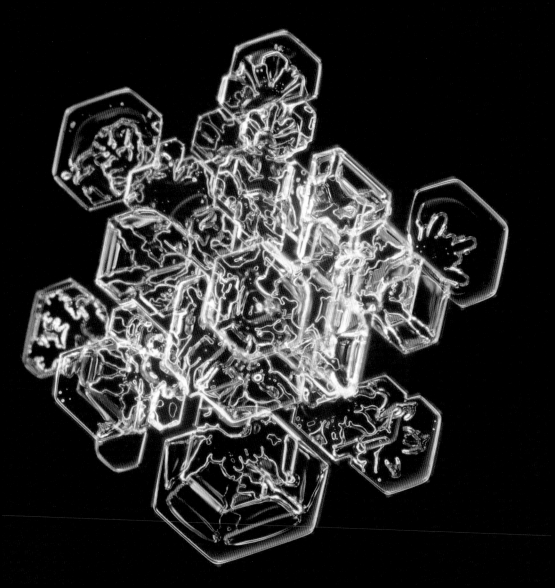

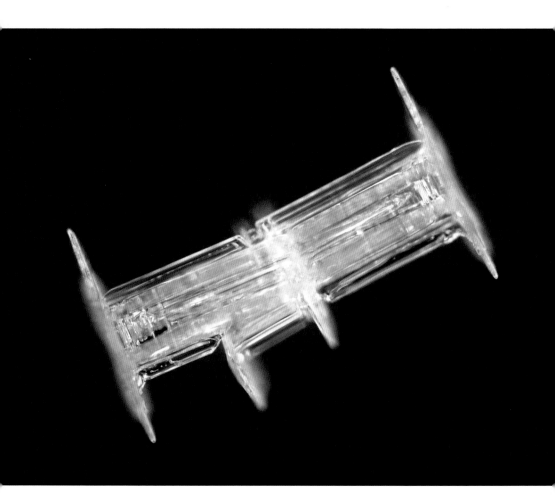

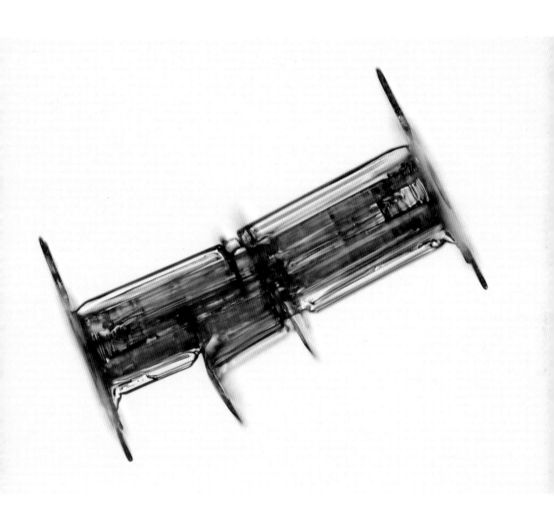

THE FIRST FALL OF SNOW IS NOT ONLY AN EVENT, IT IS
A MAGICAL EVENT.

— John Boynton Priestley (1894-1984)

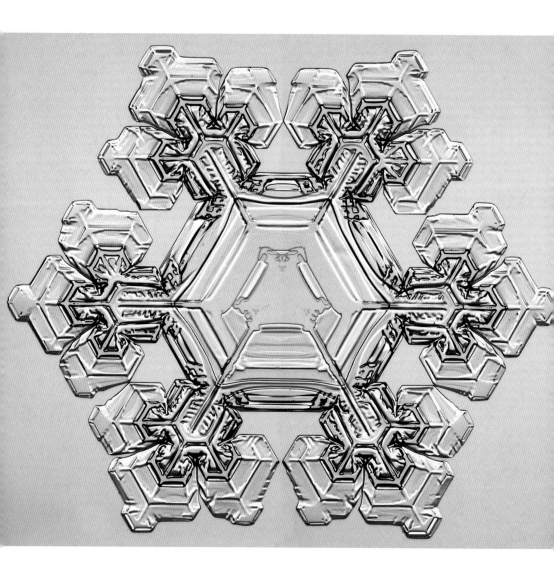

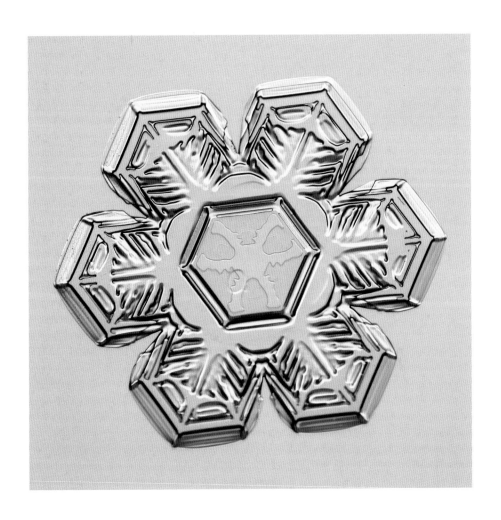

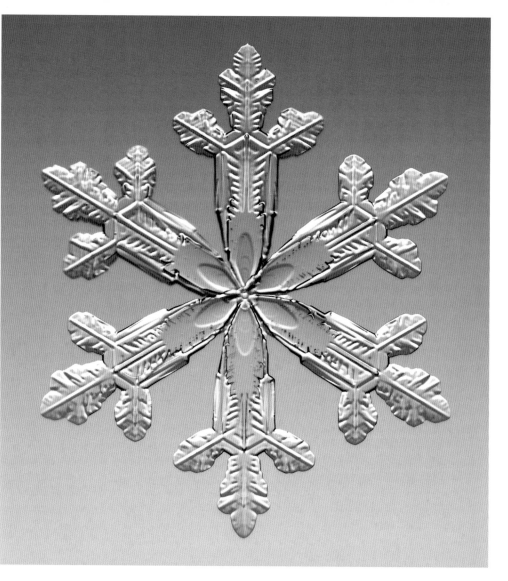

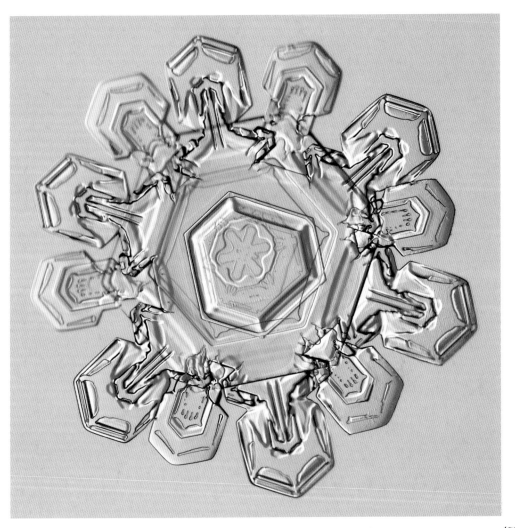

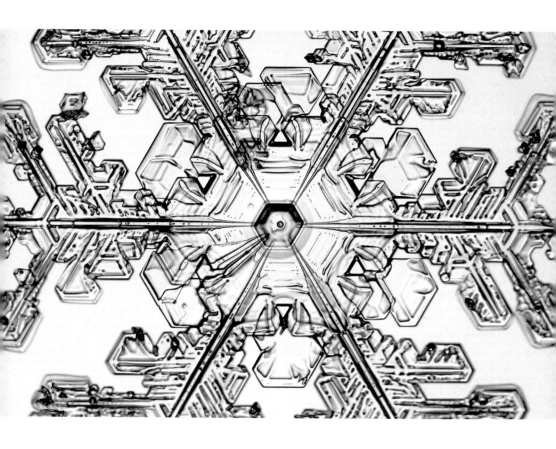

Everything is flowing—going somewhere, animals and so-called lifeless rocks as well as water. Thus the snow flows fast or slow in grand beauty—making glaciers and avalanches; the air in majestic floods carrying minerals, plant leaves, seeds, spores, with streams of music and fragrance; water streams carrying rocks. . . . While the stars go streaming through space pulsed on and on forever like blood . . . in Nature's warm heart.

— John Muir (1838–1914)

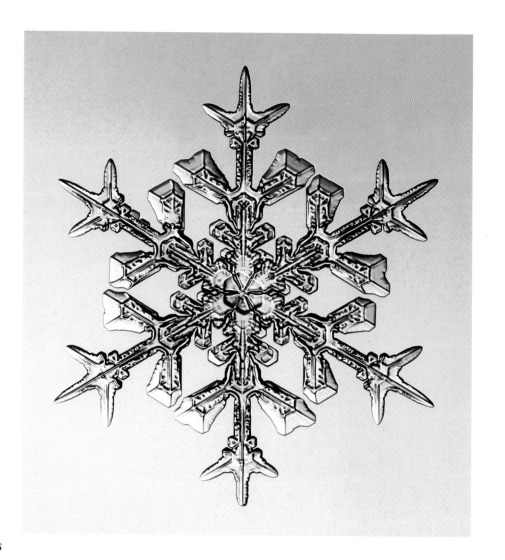

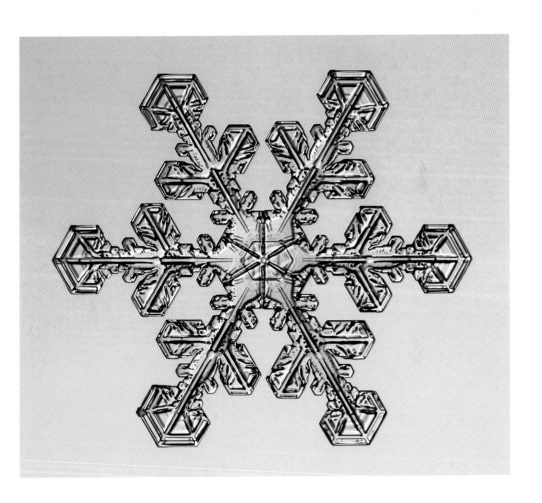

479

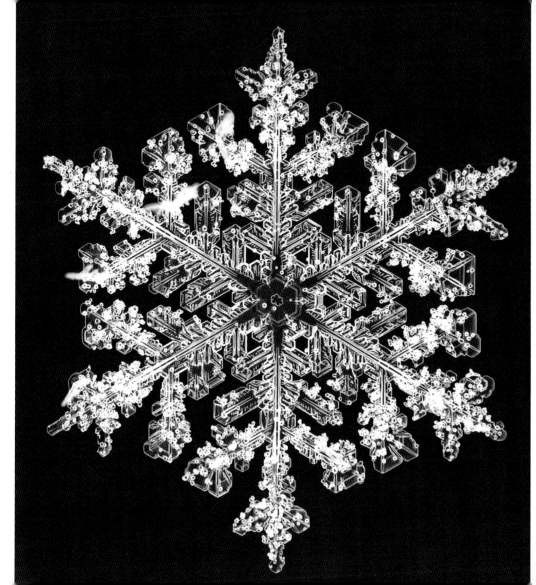

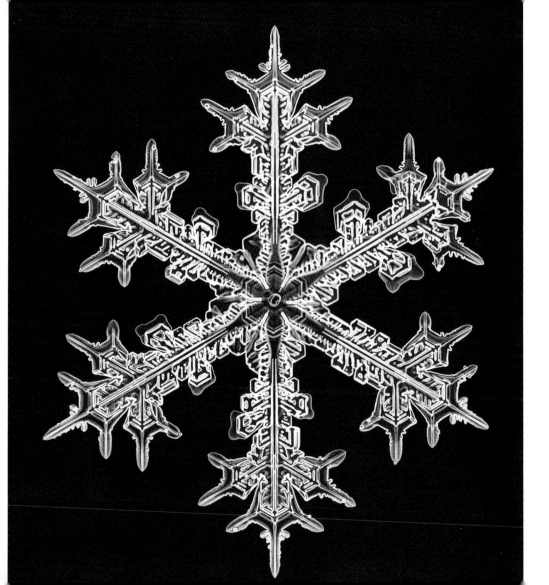

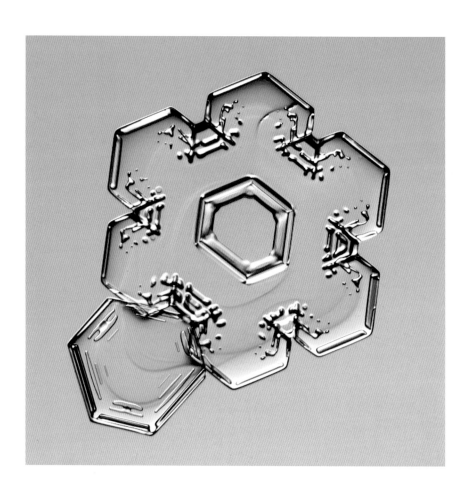

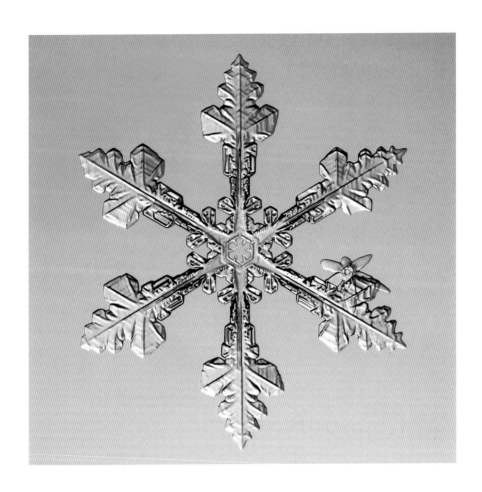

483

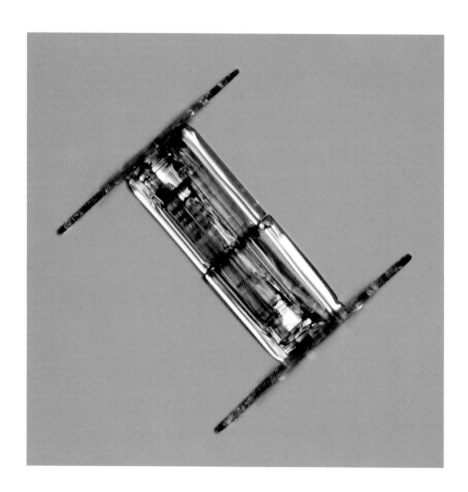

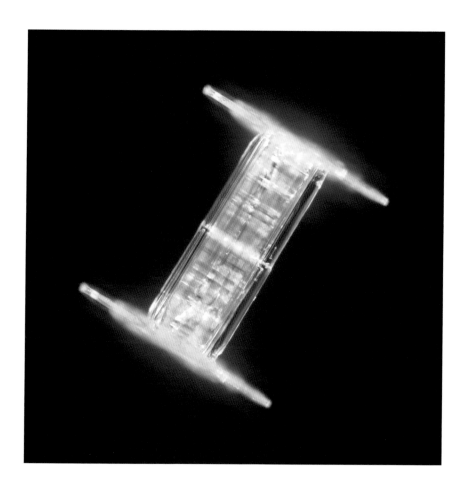

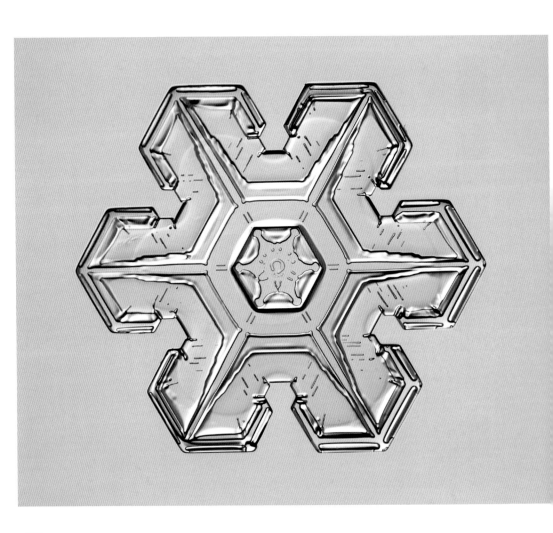

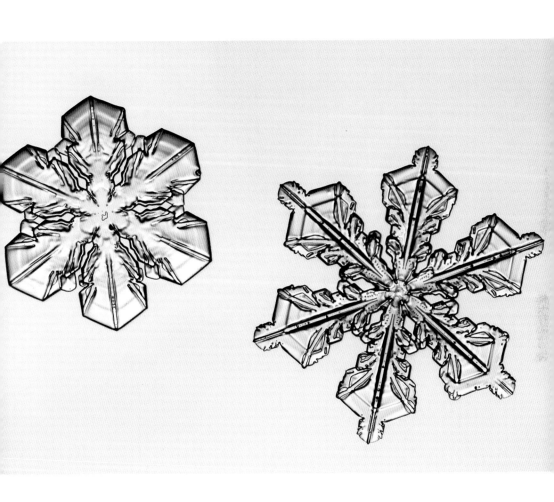

487

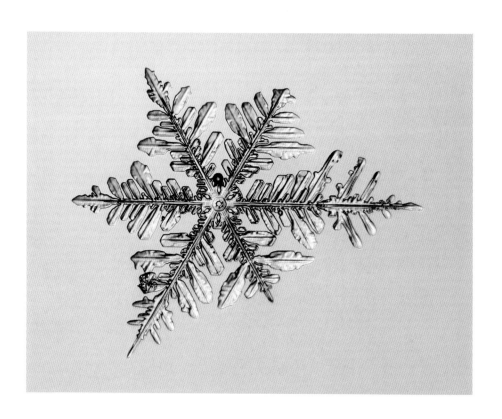

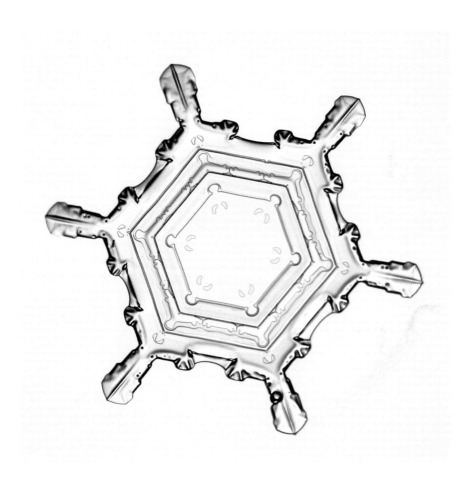

489

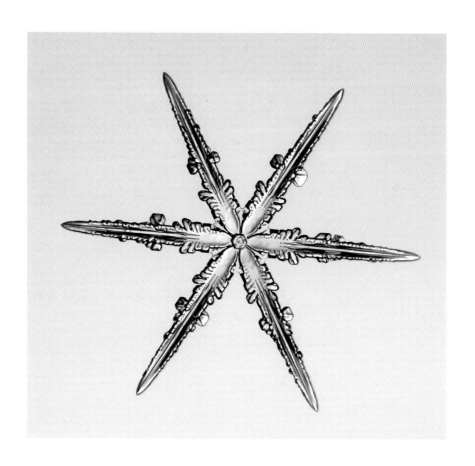

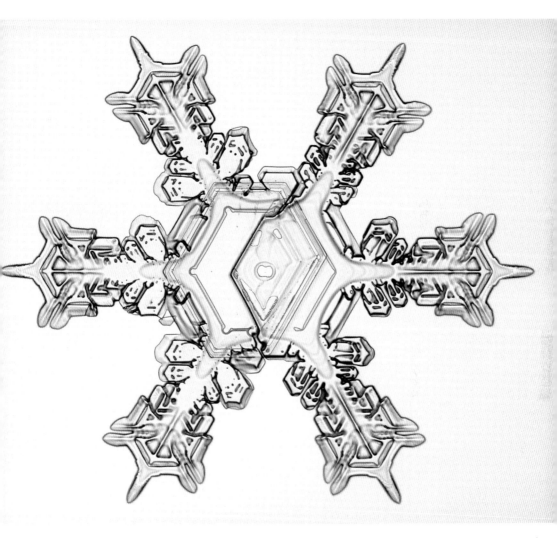

\mathcal{N}ATURE IS AN ENDLESS COMBINATION AND REPETITION OF A VERY FEW LAWS. SHE HUMS THE OLD WELL-KNOWN AIR THROUGH INNUMERABLE VARIATIONS.

—Ralph Waldo Emerson (1803–1882)

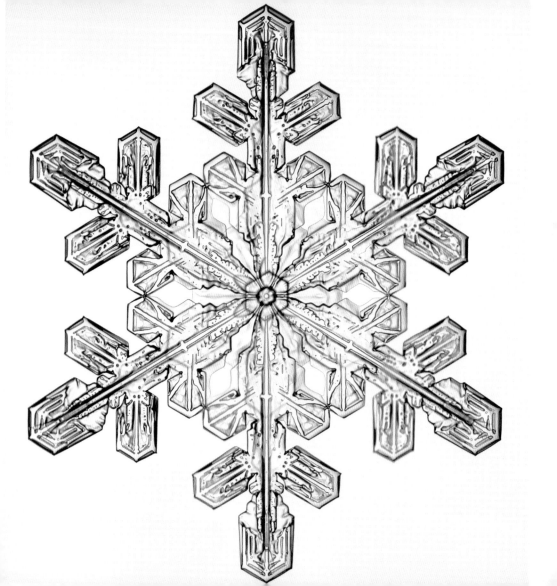

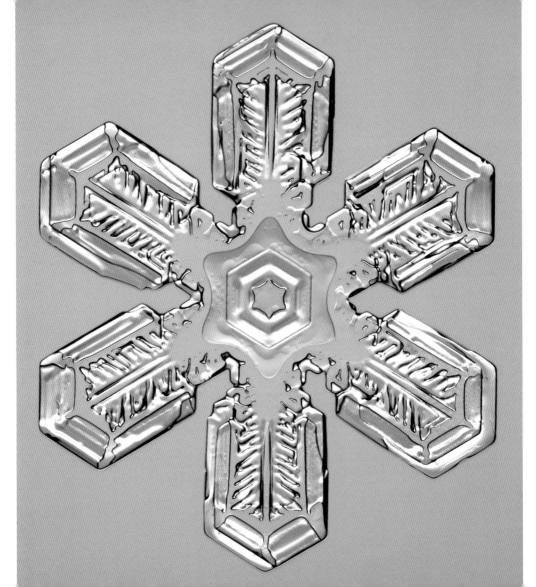

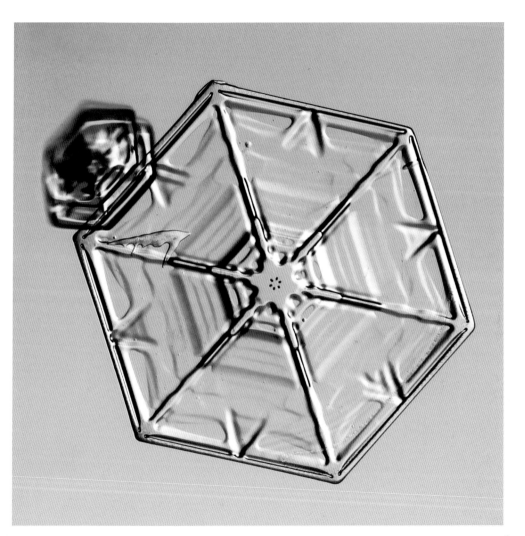

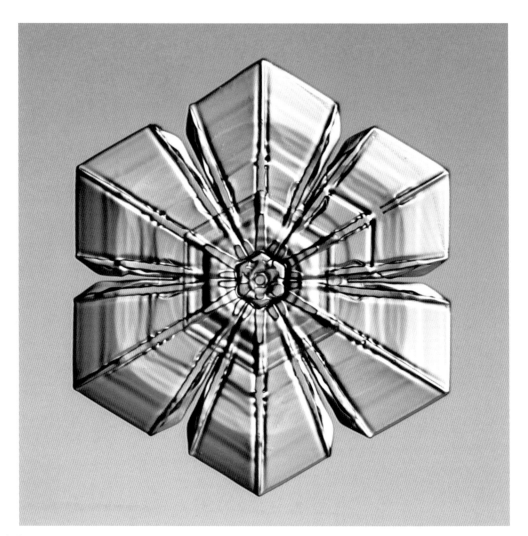

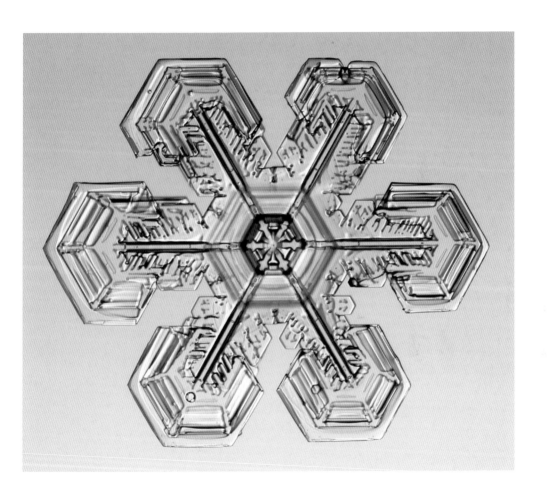

GO TO THE WINTER WOODS; LISTEN THERE, LOOK, WATCH, AND "THE DEAD MONTHS" WILL GIVE YOU A SUBTLER SECRET THAN ANY YOU HAVE YET FOUND IN THE FOREST.

—Fiona Macleod (1855–1905)

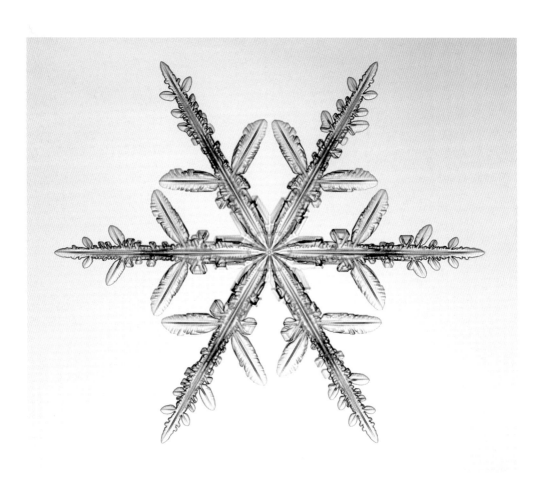

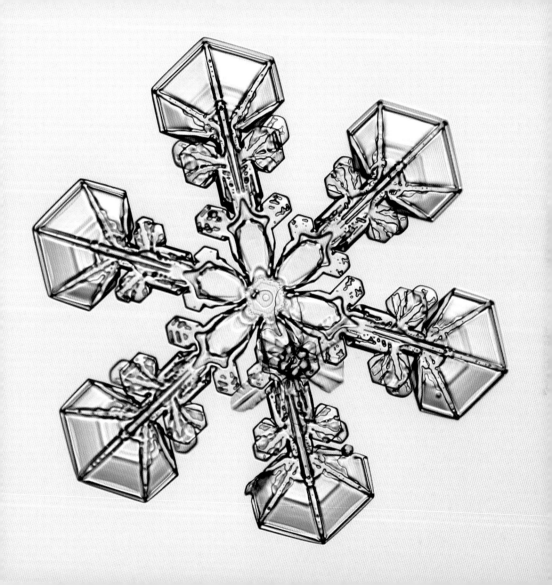

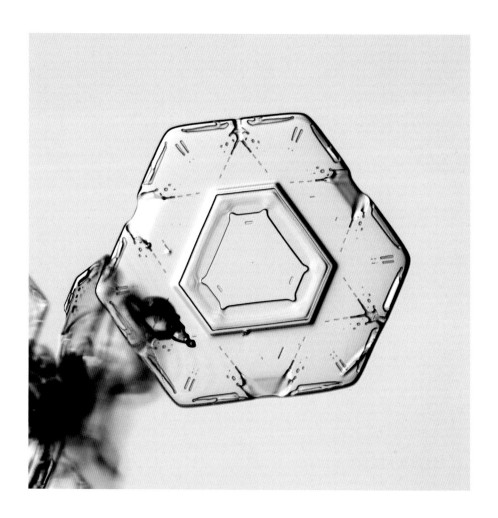

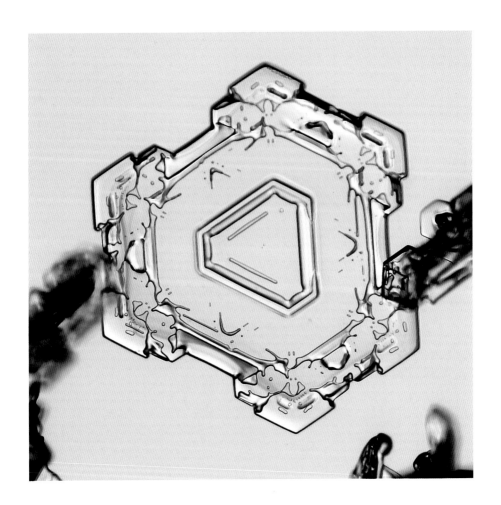

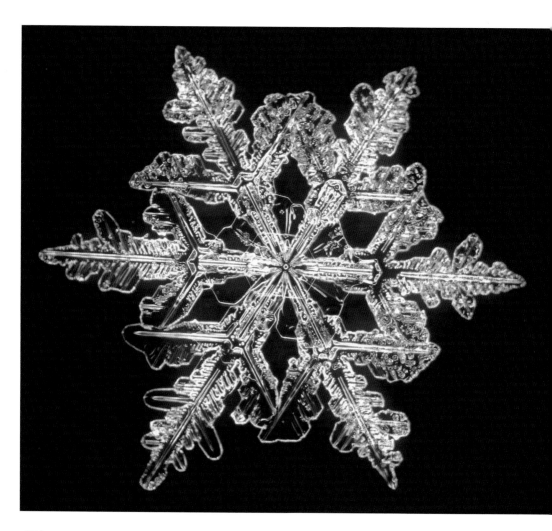

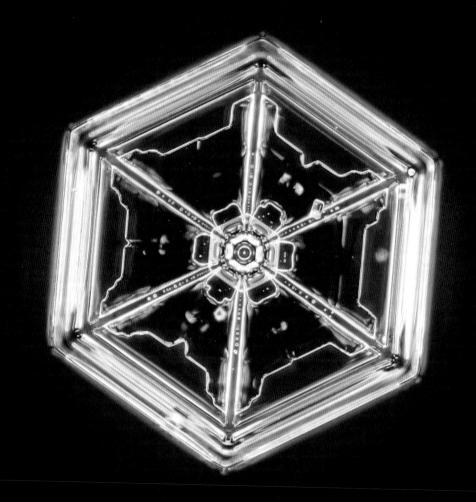

\mathcal{W}HEN CHRISTMAS BELLS ARE SWINGING ABOVE THE FIELDS OF SNOW, WE HEAR SWEET VOICES RINGING FROM LANDS OF LONG AGO, AND ETCHED ON VACANT PLACES ARE HALF-FORGOTTEN FACES OF FRIENDS WE USED TO CHERISH, AND LOVES WE USE TO KNOW.

—Ella Wilber Wilcox (1850–1919)

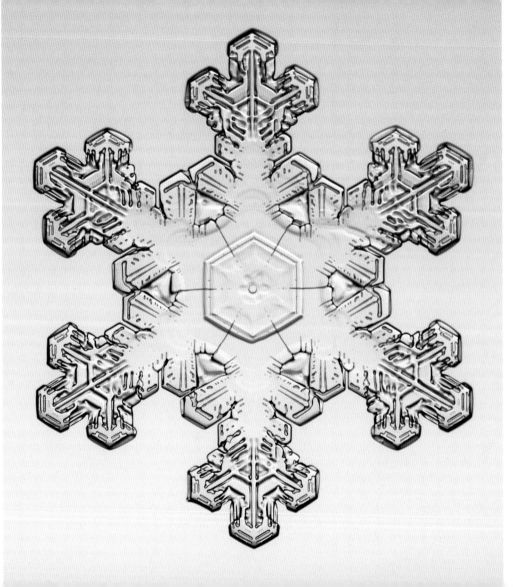

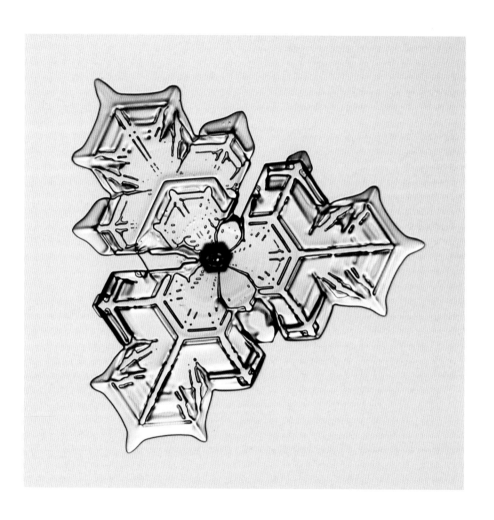

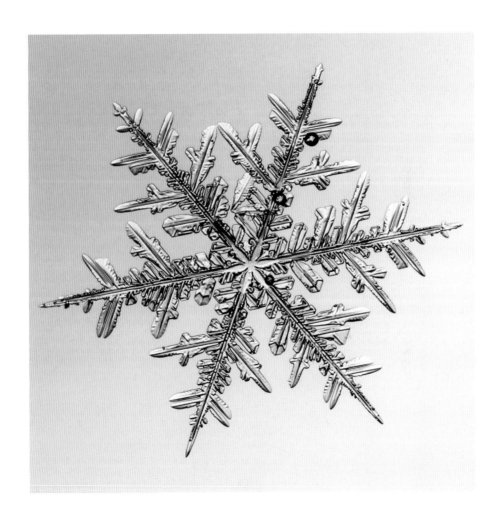

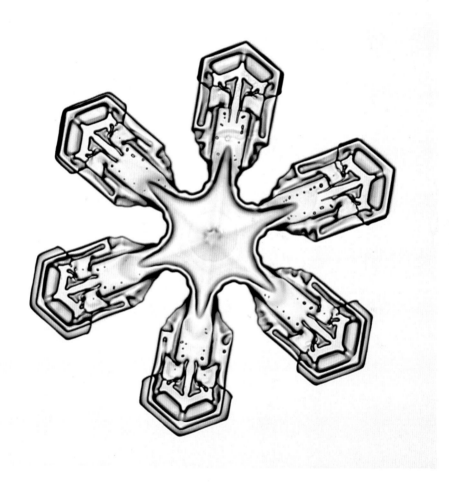

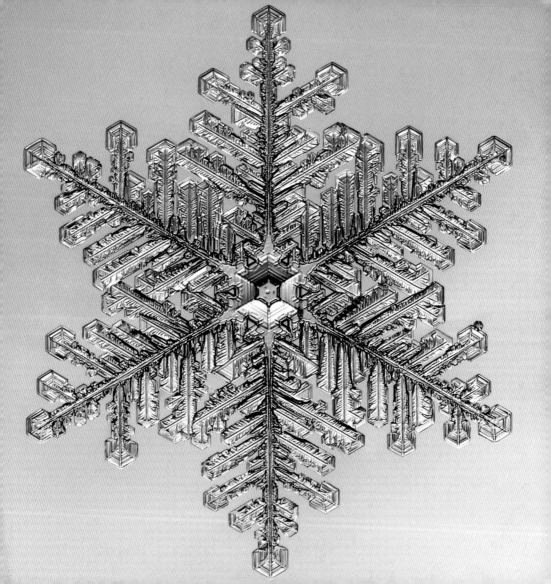

Kenneth Libbrecht grew up on a farm in North Dakota, where he learned about the many delightful and not-so-delightful aspects of snow. He is currently chairman of the physics department at Caltech, where he studies how complex structures arise during crystal growth, including snowflakes. His books include *The Snowflake: Winter's Secret Beauty*, *The Little Book of Snowflakes*, *Ken Libbrecht's Field Guide to Snowflakes*, and *The Art of the Snowflake*, all published by Voyageur Press. The latest news and views on snowflakes can be found at his website, *SnowCrystals.com*.